Belleville Public Library

3 1000 00269638 6

DEC - - 2009

P9-DEH-977

Digital Portrait Photography
FOR
DUMMIES®

by Doug Sahlin

WILEY

Wiley Publishing, Inc.

BELLEVILLE PUBLIC LIBRARY

Digital Portrait Photography For Dummies®

Published by
Wiley Publishing, Inc.
111 River Street
Hoboken, NJ 07030-5774

www.wiley.com

Copyright © 2010 by Wiley Publishing, Inc., Indianapolis, Indiana

Published by Wiley Publishing, Inc., Indianapolis, Indiana

Published simultaneously in Canada

No part of this publication may be reproduced, stored in a retrieval system or transmitted in any form or by any means, electronic, mechanical, photocopying, recording, scanning or otherwise, except as permitted under Sections 107 or 108 of the 1976 United States Copyright Act, without either the prior written permission of the Publisher, or authorization through payment of the appropriate per-copy fee to the Copyright Clearance Center, 222 Rosewood Drive, Danvers, MA 01923, (978) 750-8400, fax (978) 646-8600. Requests to the Publisher for permission should be addressed to the Permissions Department, John Wiley & Sons, Inc., 111 River Street, Hoboken, NJ 07030, (201) 748-6011, fax (201) 748-6008, or online at http://www.wiley.com/go/permissions.

Trademarks: Wiley, the Wiley Publishing logo, For Dummies, the Dummies Man logo, A Reference for the Rest of Us!, The Dummies Way, Dummies Daily, The Fun and Easy Way, Dummies.com, Making Everything Easier, and related trade dress are trademarks or registered trademarks of John Wiley & Sons, Inc. and/or its affiliates in the United States and other countries, and may not be used without written permission. All other trademarks are the property of their respective owners. Wiley Publishing, Inc., is not associated with any product or vendor mentioned in this book.

LIMIT OF LIABILITY/DISCLAIMER OF WARRANTY: THE PUBLISHER AND THE AUTHOR MAKE NO REPRESENTATIONS OR WARRANTIES WITH RESPECT TO THE ACCURACY OR COMPLETENESS OF THE CONTENTS OF THIS WORK AND SPECIFICALLY DISCLAIM ALL WARRANTIES, INCLUDING WITHOUT LIMITATION WARRANTIES OF FITNESS FOR A PARTICULAR PURPOSE. NO WARRANTY MAY BE CREATED OR EXTENDED BY SALES OR PROMOTIONAL MATERIALS. THE ADVICE AND STRATEGIES CONTAINED HEREIN MAY NOT BE SUITABLE FOR EVERY SITUATION. THIS WORK IS SOLD WITH THE UNDERSTANDING THAT THE PUBLISHER IS NOT ENGAGED IN RENDERING LEGAL, ACCOUNTING, OR OTHER PROFESSIONAL SERVICES. IF PROFESSIONAL ASSISTANCE IS REQUIRED, THE SERVICES OF A COMPETENT PROFESSIONAL PERSON SHOULD BE SOUGHT. NEITHER THE PUBLISHER NOR THE AUTHOR SHALL BE LIABLE FOR DAMAGES ARISING HEREFROM. THE FACT THAT AN ORGANIZATION OR WEBSITE IS REFERRED TO IN THIS WORK AS A CITATION AND/OR A POTENTIAL SOURCE OF FURTHER INFORMATION DOES NOT MEAN THAT THE AUTHOR OR THE PUBLISHER ENDORSES THE INFORMATION THE ORGANIZATION OR WEBSITE MAY PROVIDE OR RECOMMENDATIONS IT MAY MAKE. FURTHER, READERS SHOULD BE AWARE THAT INTERNET WEBSITES LISTED IN THIS WORK MAY HAVE CHANGED OR DISAPPEARED BETWEEN WHEN THIS WORK WAS WRITTEN AND WHEN IT IS READ.

For general information on our other products and services, please contact our Customer Care Department within the U.S. at 877-762-2974, outside the U.S. at 317-572-3993, or fax 317-572-4002.

For technical support, please visit www.wiley.com/techsupport.

Wiley also publishes its books in a variety of electronic formats. Some content that appears in print may not be available in electronic books.

Library of Congress Control Number: 2009937838

ISBN: 978-0-470-52763-4

Manufactured in the United States of America

10 9 8 7 6 5 4 3 2 1

WILEY

About the Author

Doug Sahlin is an author and photographer living in Venice, Florida. He has written 21 books on computer applications such as Adobe Flash and Adobe Acrobat. He has written books on digital photography and co-authored 13 books on applications such as Adobe Photoshop and Photoshop Elements. Recent titles include *Flash Website For Dummies, Digital Photography Quicksteps* (2nd edition), and *Digital Photography Workbook For Dummies*. Many of his books have been best sellers at Amazon.com.

He is president of Superb Images, Inc., a wedding and event photography company. Doug teaches Adobe Acrobat to local businesses and government institutions. He uses Flash and Acrobat to create Web content and multimedia presentations for his clients. He also hosts Pixelicious (`www.pixelicious.info`), a weekly podcast on digital photography, Photoshop, and Lightroom.

Dedication

This book is dedicated to Roxanne, my photo buddy and best friend.

Author's Acknowledgments

Thanks to all the talented people at Wiley for putting this book together. Special thanks to Steve Hayes for making this project possible. Kudos to Christopher Morris for overseeing this project and lending a helping hand when needed. I am grateful to agent extraordinaire Margot Hutchison for ironing out the fine details between author and publisher.

As always, special thanks to my friends, family, and mentors. Extra special thanks are reserved for Karen, Ted, and Roxanne. And I would be remiss if I didn't recognize my social secretary, Niki the Cat.

Publisher's Acknowledgments

We're proud of this book; please send us your comments through our online registration form located at http://dummies.custhelp.com. For other comments, please contact our Customer Care Department within the U.S. at 877-762-2974, outside the U.S. at 317-572-3993, or fax 317-572-4002.

Some of the people who helped bring this book to market include the following:

Acquisitions, Editorial

Sr. Project Editor: Christopher Morris

Sr. Acquisitions Editor: Steve Hayes

Copy Editor: Heidi Unger

Technical Editor: Eamon Hickey

Editorial Manager: Kevin Kirschner

Editorial Assistant: Amanda Graham

Sr. Editorial Assistant: Cherie Case

Cartoons: Rich Tennant
(www.the5thwave.com)

Composition Services

Project Coordinator: Lynsey Stanford

Layout and Graphics: Carrie A. Cesavice, Samantha K. Cherolis, Joyce Haughey

Proofreader: ConText Editorial Services, Inc.

Indexer: Valerie Haynes Perry

Publishing and Editorial for Technology Dummies

Richard Swadley, Vice President and Executive Group Publisher

Andy Cummings, Vice President and Publisher

Mary Bednarek, Executive Acquisitions Director

Mary C. Corder, Editorial Director

Publishing for Consumer Dummies

Diane Graves Steele, Vice President and Publisher

Composition Services

Debbie Stailey, Director of Composition Services

Contents at a Glance

Table of Contents

Introduction

*P*ortrait photography is not rocket science. Photographers have been capturing portraits of people since cameras were invented. When you create a portrait of someone, your goal is to create a likeness of the person at his best. But how do you capture a portrait of someone at his best when he's camera shy, for instance?

Another goal of portrait photography is to tell the viewer something about your subject. In addition to capturing a digital image that looks like the person, you're also capturing the person's essence. When someone looks at a portrait of a person she knows and says that the image captures the subject's true essence, the photographer has done his job perfectly.

Capturing a person's likeness and essence in the same photograph may sound like a daunting task. Buy it really isn't if you take lots of pictures of people using the techniques in this book. In fact, when you practice portrait photography and start getting some great shots, portrait photography is an incredible amount of fun.

A Peek at the Road Ahead

This book is divided into four parts, each devoted to a specific aspect of portrait photography. The chapters flow logically from one subject to the next to take you from digital portrait photography neophyte to experienced photographer. You can read the book from cover to cover, or if you need quick information about a specific topic, peruse the table of contents or index until you find the desired topic. Most of the sections in this book don't require reading additional material.

The following sections offer a brief overview of each part of the book.

Part 1: Introducing Portrait Photography

Part I contains four chapters that familiarize you with portrait photography:

- Chapter 1, "Exploring Portrait Photography," introduces you to the different aspects of digital portrait photography.
- Chapter 2, "Choosing Your Equipment," shows you how to choose equipment for digital portrait photography. You'll find information on point-and-shoot cameras, digital SLRs, lighting equipment, and accessories.

✔ Chapter 3, "Getting to Know Digital Photography," discusses camera settings you use for portrait photography. In this chapter, you'll find information about shooting modes, ISO settings, formatting your cards, and much more.

✔ Chapter 4, "Becoming a Portrait Photographer" is designed to inspire you to think about what you're photographing instead of blindly pointing the camera at your subject and pressing the shutter button. I show you concepts for working like a photojournalist, visualizing your image, and much more.

Part II: Portrait Photography Techniques

In this part of the book, I cut to the chase and show you how to become a better portrait photographer.

✔ Chapter 5, "Composing Your Portraits," shows you how to use some time-honored rules of photography to create more compelling images. In this chapter, I show you which camera settings to use for portrait photography. Then I discuss rules of composition as they apply to portrait photography. I show you which rules work for specific types of images and tell you when you should break the rules.

✔ Chapter 6, "Working with Your Subjects," shows you how to establish rapport with your subjects, how to pose them, and also discusses makeup and wardrobe. In this chapter, I also discuss photographing pets with their humans and how to capture portraits of pets by themselves.

✔ Chapter 7, "Lighting Your Portraits," discusses lighting techniques for digital portrait photography. In this chapter, I show you how to work with available light, light modifiers, camera flash, and more.

✔ Chapter 8, "Photographing Portraits on Location," discusses shooting portraits at different locations, such as at a beach and in your home town. I also devote sections to photographing wildlife at zoos and wildlife preserves.

✔ Chapter 9, "Photographing Portraits in Your Home or Office," shows you techniques for creating formal and informal portraits in your home or office. I also discuss working with backdrops and creating a makeshift studio.

Part III: Editing and Sharing Your Portraits

This part of the book shows you how to organize, edit, and share your images using Photoshop Elements 8.

✔ Chapter 10, "Editing with Photoshop Elements," introduces you to Photoshop Elements 8 and guides you through the process of downloading images to your computer. I also show you how to organize your images and work with RAW files.

✔ Chapter 11, "Retouching Your Portraits," shows you how to digitally remove blemishes and enhance your subject's eyes. I also show you how to remove your subject from the background and edit portraits of older subjects.

✔ Chapter 12, "Sharing Your Images," shows you how to create prints of your portraits from Photoshop Elements. I also show you how to create print packages and contact sheets, and introduce you to a resource that turns your digital files into wall art.

Part IV: The Part of Tens

The book concludes with three top ten lists, written by yours truly, who happens to have a gap between his teeth like David Letterman, who is famous for his top ten lists. The lists are grouped according to subject matter. A splendid time is guaranteed for all. And tonight, Mr. Kite is topping the bill.

✔ Chapter 13, "Ten Editing Tips and Tricks," shows you how to replace a solid-color background, how to create a painting from an image, and how to create a vignette. You'll also find seven other cool editing tips that are designed to make your images shine.

✔ Chapter 14, "Ten Photography Tips and Tricks," shows you how to become a better photographer. I show you how to develop a style, create a self-portrait, and improvise when you don't have everything with you but the kitchen sink.

✔ Chapter 15, "Ten Resources for Portrait Photographers," shows you ten places where you can get stuff such as equipment, photo books, and much more.

Icons and Other Delights

For Dummies books have icons that contain important bits of information. You can hopscotch from icon to icon and get a lot of information. But when in doubt, read the text associated with the icon. In this book, you'll find the following icons:

✔ A Tip icon contains information designed to save you time — and in some instances, your very sanity.

✔ This icon warns you about something you shouldn't do, something your fearless author has already done and decided it's not a good thing to do again.

✔ When you see this icon, it's the equivalent of a virtual piece of string tied around your finger. This is information you may want to commit to memory.

You'll also find icons in the margin that show you controls on your camera and Photoshop Elements tools you use to edit your image.

About the Software Shown in This Book

The software I recommend for downloading your images and editing them is Photoshop Elements 8. This is the baby brother to Photoshop. Photoshop Elements is bundled with many cameras. If you don't have Photoshop Elements 8, which as of this writing is the latest and greatest version of the software, you'll be glad to know you can still do many of the same techniques with earlier versions of the software. If you own a different image-editing application, you can still benefit from Part III, as many other photo-editing applications use the same tools.

Shoot Lots of Pictures and Enjoy!

As I mention at the start of this introduction, portrait photography is not rocket science. The old adage "practice makes perfect" does apply, though. Don't expect to give this book a casual reading, try the techniques once or twice, and then park your camera in the closet until the next time someone asks you to take her picture. The only way to become a better photographer is to apply what you know and shoot as many pictures as you can. While you're working your way through this book, keep your camera close at hand. When your wife or significant other pokes her head into the room, grab your camera and start practicing your craft. Take one picture, then another, and another, and so on. With practice, you'll know your camera like the back of your hand. You'll also know which rules of photography and composition work for you, and you'll start to develop your own style. With practice, portrait photography will become second nature, and you'll amaze your friends and relatives with the quality of your work. For that matter, you'll probably amaze yourself, too.

Part I
Introducing Portrait Photography

The 5th Wave By Rich Tennant

"My God! I've gained 9 pixels!"

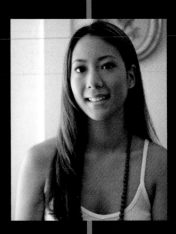

In this part . . .

People have been taking pictures of people since the invention of photography. Photographers have been taking pictures of people on crowded city streets, pictures of friends and family, and pictures that tell you something about a person. And when you capture a person's essence with a photograph, you have truly taken a portrait of that person.

Many amateur photographers and some professionals think portrait photography is a daunting task, but it doesn't have to be that way. In this part of the book, I introduce you to the different aspects of portrait photography. In addition, I discuss digital cameras and the settings you should use when shooting a portrait.

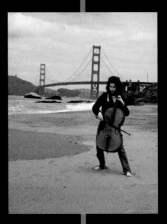

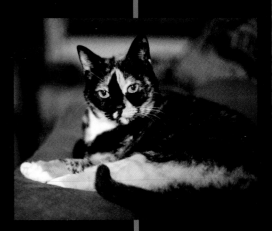

Exploring Portrait Photography

*P*ortrait photography is fun and can become downright addictive. Armed with a good digital camera and a little or a lot of knowledge, portrait photography gives you the chance to capture a slice of history in a person's life. When you photograph someone, you're telling a story. Done right, portrait photography reveals a lot about a person. Whether you're shooting a formal portrait with a background, photographing someone on location, or capturing a candid portrait, you're telling your viewers something about your subject. A portrait should be a flattering likeness of your subject, which can be a bit of work. Portrait photography may seem like a daunting task, but it's extremely rewarding. In this chapter, I show you the various facets of portrait photography and give you an inkling of what's to come.

Becoming a Portrait Photographer

A portrait is a picture that conveys a likeness of a person, especially his face. When someone views a good portrait of someone they know, the subject is instantly recognizable. When someone views a great portrait of anybody, even a stranger knows something about the subject. A great portrait reveals a person's character, attitude, outlook on life, and so much more. When you create a portrait, your job is to reveal something about the person you photograph. When someone else looks at the photo and says you really captured the person's essence, you know you've done your job.

Capturing a portrait that reveals more than a person's physical likeness is easier if you know the person you're photographing. However, you can still create a great portrait of a relative stranger if you take your time and establish rapport with the person. Creating a compelling portrait is more than just taking a picture. Talking with your subjects will reveal things they're interested in. When you see the person's expression change after talking about something they're interested in, ask a couple of questions about the topic, and then start photographing.

After you engage your subject to bring out her best, another task you must tackle is getting your subject to relax. Unless your subject is a professional model, she's going to be shy in front of the camera. The smiles may end up looking forced, the facial expressions phony, and so on. It's like trying to get someone to smile after they've received a letter from the IRS telling them to report for a tax audit. Unless you're shooting candid portraits of people at work or play, a portrait photography session takes time. As a portrait photographer, you must slow down, relax, and take your time. Give your subject the time she deserves. If your subject can't seem to relax and is preoccupied with other thoughts, reschedule the shoot at a time that's convenient for your subject.

Your job as a portrait photography is twofold: getting your subject to put on a happy face and knowing how to capture that happy face digitally for posterity. To do those things, you must get to know your equipment — know how to light your subject, choose the right camera settings, and so on.

Your first foray into portrait photography may be an outright disaster. If you're not familiar with your equipment, you won't be able to devote time to your subject. If you spend too much time fiddling with your equipment, your subject will quickly lose interest, and you won't be able to capture a natural portrait. Let's face it, some people need to be the center of attention, and this is especially true when you're capturing a portrait of a person. Be prepared ahead of time, and your photo shoot will flow.

If you're shooting a formal portrait, always set up your equipment and backdrop before your subject arrives.

Photographing Friends and Family

Photographing people you know and love may seem like a piece of cake, but sometimes knowing the people you're photographing makes the job harder. They may trivialize your interest in photography. They may look at you and think, "There he is with the camera again." This is when you need to take control and let your subjects know that you're a serious photographer, and your goal is to make them look their best. In these situations, you end up being coach, cheerleader, and task master.

Anybody can take a picture of a person. All you need to do is grab a camera, point it at the person, click the shutter, and you've got the shot. (Hmmm . . . guess that's why some digital cameras are called *point-and-shoot*.) The way to get a good portrait is to find a great location, use the proper equipment with the right settings, and work with your subject(s). You're the artist. You'll have to tell your subject how to pose, tilt her head, and get her to put her best face forward. Natural smiles are a good thing. Forced grimaces do not make good portraits. When you're shooting a portrait of a person on location, you need to pick the best area based on the scenery and available lighting. This may involve taking lots of pictures to get a few good ones. But that's the beauty of digital photography. You can see what you've got on the LCD monitor and know whether you've captured the quintessential portrait of your subject or a picture that's a candidate for the trash bin.

If you're shooting a formal portrait of someone you know, you need to set up the shot, arrange the lighting, and choose the proper camera settings. In addition, you need to tell your subject what to do, pose him in a pleasing manner, and then put him at ease. Yes, it is a daunting task. That's why the pros get big bucks for creating professional portraits.

Relax your subject and get her to laugh by telling her that the area in front of your camera is a "No Blink" zone.

When you decide to pursue portrait photography seriously, let your friends and family know your goals. They'll be more supportive and won't think you're being a nuisance when you ask to take their pictures. In exchange for a portrait session, tell your subject he'll get an 8 x 10 print of his favorite picture from the shoot. You can get quality prints from online printing companies such as Mpix and Shutterfly. Another good idea is to create a small photo book of your best shots. Then when a photogenic family moves into the neighborhood, you can introduce yourself as the neighborhood portrait photographer. You can also use your brag book at parties and social functions. When you show people a photo book of your best work, they'll know you're a serious photographer. Sweeten the deal with a free print and you've got another subject. I carry a 4-x-4-inch book of my portrait work with me at all times. Showing it to friends and colleagues has resulted in many interesting photo opportunities. For online printing and photo book resources, see Chapter 15.

Your best shots generally come at the end of a session. Let your subject know ahead of time how long your session will run. As the session moves to a conclusion, your subject will become more comfortable in front of the camera.

Creating candid portraits

Candid portraits are wonderful. You capture people doing what they do best, having fun or just being themselves. When you shoot candid portraits,

you're like a fly on the wall. You've got the camera ready to go with all the right settings dialed in. Then when you see your subject doing something interesting, compose your picture, click the shutter button, and you've got an interesting photo.

You can create a candid portrait anywhere. If it's your nephew's first birthday party, make sure you've got your camera ready when he gets a piece of his birthday cake. You'll end up with wonderful portraits of a laughing child with a mouthful of cake, frosting-streaked hair, and gooey fingers. Remember to capture a photo of the tyke's parents hosing him off after the party. When the child grows older, his parents will appreciate the portrait, and the now-grown child may be interested in it — or embarrassed beyond belief.

To capture good candid portraits, take your camera with you wherever you go. In time, your family and friends will get used to the fact that you've always got a camera tethered to your neck, so they won't always be on guard, which makes it much easier to catch them in the act of being themselves.

If you have a digital SLR (single-lens reflex) with a zoom lens that looks like a bazooka, you'll have a hard time being the fly on the wall. If you fall into this category, I suggest getting a good point-and-shoot camera as a second camera. My Canon digital SLR looks quite intimidating with a telephoto zoom attached, so I have a small Canon point-and-shoot that I take with me when I'm running errands, or visiting friends. The point-and-shoot is relatively innocuous, so I carry it with me wherever I go, even into restaurants. You never know when something interesting will happen. When I see something that piques my curiosity, I capture it digitally with my trusty point-and-shoot. I show you all you need to know about buying a second camera in Chapter 3.

Creating formal portraits

Formal portraits are used for many things. Sometimes your subject wants a formal portrait to hang on the wall. At other times, a formal portrait is used for business purposes, such as a company brochure or business card. If one of your friends or relatives needs a portrait for business purposes, you can get the job done. A head shot or head-and-shoulders shot is the accepted format for formal business pictures. You can create formal portraits using a makeshift studio in your home, on location, or in your subject's office. (See Figure 1-1.)

When you photograph any portrait, it's important to light your subject correctly. An on-camera flash is never a good option for formal portraits. If you must use a flash, it's best to bounce the flash off a white surface such as a nearby wall or the ceiling. You can also use a bounce card. Better yet, use two light sources. Portrait lighting is covered in detail in Chapter 7.

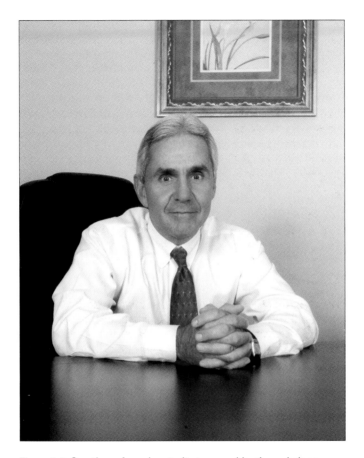

Figure 1-1: Creating a formal portrait at your subject's workplace.

Capturing a slice-of-life portrait

Sometimes you can tell a lot about a person by photographing possessions that are special to the person. When you create this type of portrait, you don't even need the person in the photograph. People who know the person will automatically connect her with the photograph based on what's in the photo. I call this a slice-of-life portrait. In essence, it's a still life that tells a lot a person, without really showing the person. I show you some techniques for creating a slice-of-life portrait in Chapter 9.

Photographing children

Kids do the darndest things, especially the young ones. But they can also be like a bull in a China shop, moving every which way but where you want them to move. Getting a child to sit still is like getting a straight answer from

your congressman. And forget about the bit that children should be seen and not heard. If you're photographing young children, you'll hear them: The din can get rather loud. You may also have a failure to communicate. You get your best kid photographs when you photograph a child who knows and trusts you. If you can create a rapport with the child, or for that matter, any subjects, perhaps you will get the shots you're after. Your best bet is to have the child's parents at the shoot. They can stand behind you and get the child to do what you want her to. Maybe.

You'll get some great shots if the child has something to occupy his attention. Props like a favorite stuffed toy, a blanket, or some candy gives the child something to interact with. (See Figure 1-2.) If you know the child, you can get some interesting photos by playing a game of hide and seek. When you find the child, snap a head-and-shoulders portrait that shows his gleeful expression and sense of innocence. If you want to create portraits of your kids, check out Chapter 6.

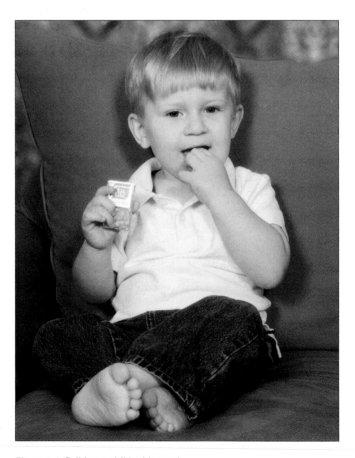

Figure 1-2: Bribing a child with candy.

Photographing pets

Unfortunately, pets have shorter lifespans then their human masters. When they are no longer with us, photos are all we have to help us remember our furry, feathered, or scaled friends. You can capture wonderful photos of your pet at play, or you can take more formal snapshots of your pet. Your pet's patience and trust in you and your equipment will determine the quality of shot you can get. If your pet is trained, you can capture a great portrait with your digital camera. However, you'll often get the best shots of your pet being his goofy self. If you're photographing a friend's pet, you'll get better shots if the pet knows you. However, it's always best to have the pet's master present. She can tell the pet what to do based on your instructions.

Dogs can be great hams. A dog may pose for you, allow you to place a hat on his head, and so on. On the other hand, a cat tends to be aloof, turning away from the camera when you point it at her. But if you're patient, you can get a great photo of your cat playing, or contemplating what's on the other side of the window. Sometimes all you need to do is grab your camera when your cat's snoozing, call her name, and click the shutter. (See Figure 1-3.) Another great shot you can get is a pet with her owner. The pet will be comfortable with her owner alongside. Kids and pets are also a recipe for wonderful photographs.

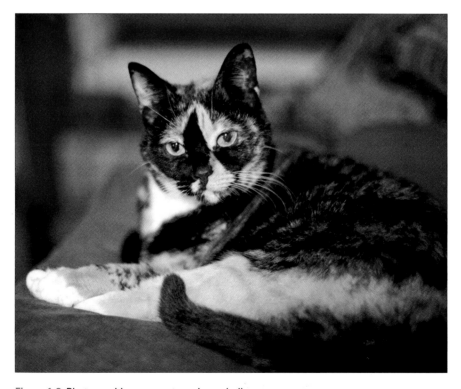

Figure 1-3: Photographing your cat can be a challenge.

Creating animal portraits

If you live near a zoo or a wildlife preserve, you can capture some wonderful photographs of animals. Armed with a digital SLR with a telephoto lens, or a point-and-shoot camera with a zoom lens that has a long focal length, you can get some great images. When you photograph at a zoo, you're a safe distance from the animals. However, when you photograph animals in the wild, you must exercise caution. Recently, while I was photographing some gorgeous white egrets at the Venice Rookery, a representative from the Audubon Society told me about the Rookery's resident alligator. When he saw I had a telephoto lens, he chuckled and told me he had to be on the lookout for tourists with point-and-shoot cameras that would try to walk within a few feet of the reptile to take a picture. Alligators may seem lethargic, but they can move quite quickly when provoked. Always keep a safe distance from any wild animal, including cats and dogs that may be roaming in your neighborhood. I show you some useful techniques for photographing wildlife and animals in Chapter 6.

Shooting Portraits on Location

When you decide to capture a digital portrait, the next decision is where to take the picture. Studio-type photographs with a colorful background are great for business photographs and formal portraits. But you can also get some great shots by photographing people on location. I find that people have a tendency to be more relaxed when they're outdoors. Recently I photographed a family at their home. I took most of the pictures outside of their home. The location was fantastic; their house was right on the water with lush foliage in the yard. I also took some photos inside their house, but the ones they liked best — the ones that were the most natural — were those that were taken outdoors. The family eventually ended up using one of the photos for their holiday greeting card.

Photographing people in parks and public places

Parks and scenic parts of town are wonderful places to create compelling portraits of anybody. The background is what makes photographs in a park or on a photogenic city street so special. When you photograph a person outdoors, your subject is the center of interest. A background that is in sharp focus gives the viewer too many details. Your job is to choose the proper lens and exposure settings to render the background as a pleasant out-of-focus blur. After all, you're taking a picture of your subject, not the scenery.

Of course, when you shoot outdoors, lighting is very important. If you shoot in adverse lighting conditions such as direct sunlight at high noon, your subject will have harsh shadows on his face, which will reveal wrinkles, or character lines, if you will. If your subject is female, showing skin texture is never a good thing. Shooting at the right time of day usually ensures that you'll get

a pleasing portrait. If the lighting is harsh, find some shade and use fill flash. (See Figure 1-4.) I show you how to enlighten your subjects with fill flash in Chapter 7.

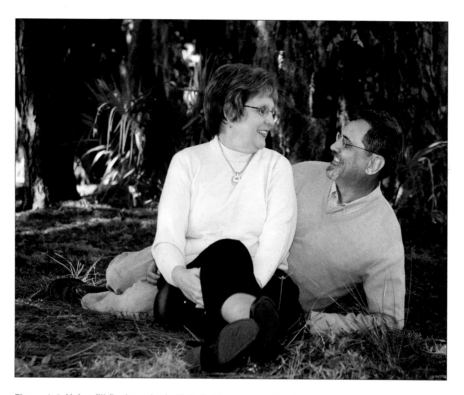

Figure 1-4: Using fill flash to shed a little light on your subjects.

Photographing subjects at work and play

Another location in which you can photograph people is where they work or play. If you have a friend or relative who's an attorney or architect, you can get some wonderful shots in his office, but this type of photo shoot can be quite challenging. You've got to work with the office lighting, which may be quite harsh, or use an external flash unit. In an office, distractions are abundant during business hours. If your subject gets an important phone call, she'll have to take it. This destroys the flow of the photo shoot. If the phone call is from an angry client, your subject will not be very photogenic when she returns. I remember photographing an attorney who had to answer an important phone call. The photo shoot was going great up to that point, but when he returned, I couldn't get him to relax. His mind was on what transpired over the phone, not on the photo shoot.

Another great way to tell a story about your subject is to photograph him doing his favorite hobby. If your subject paints watercolor, for instance, photograph him while he's painting. (See Figure 1-5.) The resulting photograph tells viewers a lot about your subject. Your subject will treasure the photograph for years to come.

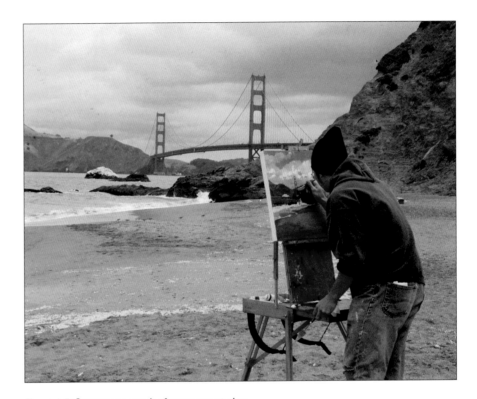

Figure 1-5: Capture a portrait of someone at play.

Capturing Portraits in Your Home

If you're like me, you have a camera nearby at all times. And even if you're not like me, you should consider having a camera nearby at all times. You never know when a digital-photo moment will present itself. All you need to do is be observant.

Capturing candid photos in your home

Your job as the card-carrying photo geek is to digitally record the family history. You can be your own candid camera director, and your family and friends can be your stooges . . . er, I mean *subjects*. A candid portrait can be

funny or serious. A candid portrait is not posed. As a photographer, you train yourself to look for interesting situations. When you're at home, these happen when you least expect them. For example, you can capture a candid portrait of your wife in deep concentration as she prepares a meal. The possibilities are endless if you keep your eyes open.

Using studio techniques in your home

If you've been bitten by the studio bug, you want serious portraits with formal backgrounds and studio lighting. Renting a studio is expensive. However, with a bit of work, you can convert a room in your house to a home studio within minutes. All you need is a blank wall, a background, and some means of lighting your subject. Using these techniques, you get a portrait that looks like it was photographed in a studio. (See Figure 1-6.) I cover home studio techniques in Chapter 9.

Figure 1-6: Creating a studio portrait at home.

Visualizing Your Photograph

Anybody can point a camera at something or somebody, press the shutter button, and create a photograph. The resulting photograph may or may not be good, but that's not really photography. True photography involves more than just random chance. True photography requires you to study your subject and then visualize the resulting photograph in your mind's eye. When you visualize the photograph, you know the focal length needed to capture your vision, the camera settings to use, and the vantage point from which to shoot your image. Only when all these decisions are made do you point the camera and press the shutter button.

Editing Your Work

After you get to know your camera like the back of your hand, and after you gain confidence in some of the techniques in this book, you'll start taking a lot of pictures of people. This is where many amateur photographers lose it. They download gobs of photos to their computer hard drive and just leave them there. Computer image-editing software enables you to sort through your images and organize them. After all, do you really want to search through a couple of hundred — or thousand — photos to locate the image of Aunt Molly that you photographed sometime last year? If you use Photoshop Elements to download and organize your photos, and follow the workflow I suggest in Chapter 10, you'll be able to find specific images in no time flat.

Back in the days of film, photographers edited their work in darkrooms. An image-editing application like Photoshop Elements is your digital darkroom. Within your digital darkroom you have the tools to retouch your photos and much more. This comes in handy if you capture some great pictures of your son that are perfect with the exception of a few pimples. You can easily remove the pimples and apply other enhancements to the photo using the techniques I show you in Chapter 11. After you've edited your images to pixel perfection, you can print them using Photoshop Elements and a printer attached to your computer as shown in Chapter 12. Or you can use an online printer like one of the ones I mention in Chapter 15.

2

Choosing Your Equipment

To create good portraits, you've got to have the right stuff. You can't take good pictures without a good camera, good optics, and the right lighting equipment. And of course, you've got to have more than just the basics if you're going to create good portraits. At some point in time, you've got to shed some light on your subjects. I strongly recommend that you don't use the on-camera flash. Can you say "red-eye?" I knew you could. And you'll need other accessories as well, if you're going to be a serious (or even semi-serious) portrait photographer. In this chapter, I show you what I think is essential for portrait photography. I cover digital SLRs and point-and-shoot cameras.

Finding the Ideal Camera for Your Needs

There are lots of digital cameras on the market. All of them will give you digital images, but there are a lot of other elements to consider. It pays to be prepared and know your stuff — if you let your local camera-store salesman make the choice, you may end up with too much or too little camera.

Digital cameras come in two flavors: point-and-shoot cameras, and digital SLR (Single Lens Reflex) cameras. A point-and-shoot camera is fully contained, complete with a telephoto zoom lens and built-in flash. As the name implies, all you need to do is point the camera at something or someone, compose the image, and then shoot. On the other hand, a digital SLR has only the camera body. You attach the desired lens, which can be

anything from an ultra-wide angle lens that captures a wide expanse of the scene before you or a telephoto lens with a long focal length that lets you get up close and personal with your subject. Some digital SLRs have built-in flash units and a hot shoe that enables you to connect a more powerful auxiliary flash to the camera. The following sections are designed to make you a better-educated consumer when you're shopping for the digital portrait photography camera that's best suited for your needs.

Portrait photography camera checklist

Do you make lists? I make need-to-buy lists for the various odds and ends I need at home. And then I forget to take them with me when I go shopping. But I'm fastidious when it comes to my photography. I have checklists for everything. The following is a list of things to consider when purchasing a camera for portrait photography:

- ✔ **If purchasing a camera with a built-in flash, does it come with a hot shoe?** An on-camera flash is very harsh. A *hot shoe* (which is a mount to which you can attach an external flash unit) gives you the option of using an auxiliary flash unit that slides into the hot shoe and communicates with the camera.

- ✔ **If you're purchasing a point-and-shoot camera, does it have a telephoto lens with a focal length that is the 35mm equivalent of 85mm?** This is considered the ideal focal length for a head-and-shoulders portrait shot. For more information on determining the 35mm equivalent of any focal length, refer to the "What's my focal length multiplier?" section of this chapter.

- ✔ **Does the camera you're considering have a mode dial with either Portrait or Aperture Priority mode?** Portrait mode attempts to give you an image where your subject is in sharp focus, but the background is blurred. The amount of the image that is apparently in focus is known as the *depth of field*. In portrait photography, you want a shallow depth of field. Your camera's ability to deliver a shallow depth of field in Portrait mode is dependent on the current lighting conditions. When you're taking pictures in bright conditions, Portrait mode won't always give you a shallow depth of field. You get much more control over depth of field using Aperture Priority mode. Aperture Priority mode lets you choose the desired aperture, and the camera calculates the shutter speed for a properly exposed picture based on lighting conditions. For more information on depth of field, refer to Chapter 3.

- ✔ **If you're purchasing a point-and-shoot camera, does it have threads at the front of the lens for attaching filters?** You can use accessory filters to control the amount of light entering the camera, change the color characteristics of the light, add special effects to your images, and so on.

✔ **Does the camera feature exposure compensation?** This feature gives you the option of manually increasing or decreasing the *exposure,* or the amount of light that reaches the camera sensor. This option is useful when you're taking pictures in tricky light conditions, such as when the sun is behind your subject — or *backlighting,* in photographer-speak.

✔ **Does the camera give you the option to display a histogram?** A *histogram* shows the distribution of pixels from shadows to highlights. When you read a histogram, you can tell whether a shot is overexposed (the highlights are blown out to pure white) or underexposed (there are not enough pixels in the highlight areas of the histogram, which creates an image darker than the actual scene). You can then adjust the exposure accordingly using exposure compensation.

✔ **Does the camera have a bright LCD monitor?** If you shoot portraits outdoors, a bright monitor makes it easier to see your shots and any other information displayed about the image.

Choosing a point-and-shoot camera

If you're a beginning photographer, the obvious place to start is with a point-and-shoot camera. There are many varieties of point-and-shoot cameras, but in order to capture compelling portraits, you need more than just a garden-variety point-and-shoot camera. You can see two of the better point-and-shoot cameras in Figure 2-1. The camera you choose needs good optics and the option to manually choose a shooting mode. A camera lens with good optics has multiple elements. The lens elements are coated for better light dispersion and protection against anomalies like lens flares.

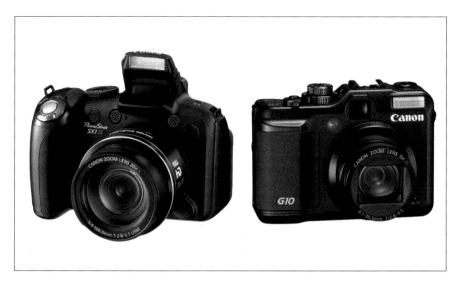

Figure 2-1: Point-and-shoot cameras for portrait photography.

Here are some things to consider when looking for a point-and-shoot digital camera:

- ✔ **Does the camera offer advanced shooting modes?** This feature gives you the option of choosing how the camera determines exposure, but you don't have to master all of the variables at once. You can set the aperture, and the camera determines the proper shutter speed for a perfect exposure. Or you can choose the shutter speed, and the camera chooses the proper aperture for a perfect exposure. (Chapter 3 tells you how aperture and shutter speed combine to make a perfectly exposed image.) Another handy option for portrait photographers is a camera with a Portrait mode, which chooses both aperture and shutter speed for you.

- ✔ **Does the camera have a hot shoe?** A *hot shoe* accepts an external flash unit. On-camera flash is very limited — the light is not good for portrait photography. When you need to augment natural light, or rely on a flash to provide all lighting, you have much better control with an external flash unit.

- ✔ **What is the focal length range of the camera lens?** A good range for general and portrait photography includes focal lengths that are the 35mm equivalents from 28mm to 140mm.

- ✔ **Does the camera feature image stabilization?** This option makes it possible for you to take pictures without a tripod at slow shutter speeds. Cameras with image stabilization give you the capability of shooting up to three exposure values lower than you can with an equivalent camera without image stabilization. Many cameras with image stabilization flash a warning icon if the shutter speed is too slow to produce a sharp image. Another benefit of image stabilization is that you can shoot pictures at a lower ISO setting (see Chapter 3), which means you'll get images with less digital noise. Digital noise comes in two flavors: color (random color specs in areas of solid color like blue skies) and luminance (random gray colored specks in areas with even tone such as shadows).

- ✔ **Does the camera have the option to capture images in the RAW format?** When you process a RAW image, you're working with the data the camera sensor captured. The RAW format, then, is like a digital negative: It gives you more control over the resulting image.

 If the camera doesn't allow you to capture images in RAW format, the camera processes the image as a JPEG file, which is more difficult to work with. This can result in problems when you're taking pictures in difficult lighting conditions because you have limited options for fixing a JPEG image. The RAW format, on the other hand, offers a lot of flexibility when you process images. For more information on processing RAW images, see Chapter 10.

- ✔ **What is the minimum and maximum ISO setting for the camera?** Lower ISO settings give great image quality, but the sensor needs more light. Higher ISO settings means the camera is more sensitive to light, and you

can capture images in low-light situations. However, high ISO settings also introduce digital noise to your images, which is very noticeable when you're capturing images with a point-and-shoot camera that has a small sensor.

- **What is the maximum resolution, in megapixels?** There are some point-and-shoot cameras with 15-megapixel resolution. However, when you cram 15 megapixels on a sensor that's the size of your pinky fingernail, you're dealing with small pixels indeed — much smaller than those on a digital SLR that has the same resolution on a bigger sensor. That means that the images shot at the same resolution on a smaller sensor won't be as crisp or sharp when you enlarge them.

- **Does the camera have a movie mode?** This option is useful when you want to create slide shows of images and have some live video. You can easily create slide shows in applications like Movie Maker (Windows) or iMovie (Mac). Some digital cameras even offer HD (high definition) video.

- **Will the camera accept accessory filters?** Accessory filters can change the look of the image, change the amount of light entering the camera, and so on.

- **Does the camera have a noticeable shutter lag?** This is the amount of time it takes the camera to capture the picture after you press the shutter button. If there's a noticeable lag, you may end up missing some great candid shots. After your subject realizes you have a camera pointed at her, she may change her expression and your shot is lost. When you try a camera out in a store, notice the amount of time it takes the camera to respond after you press the shutter button. You can also find information on shutter lag by reading camera reviews.

- **If the camera captures RAW images, how long does it take the camera to record the image to the memory card?** If it takes a long time, you'll end up filling the camera *buffer* (built-in memory) after a couple of shots, and you'll have to wait until the images are written to the memory card before you can take more shots.

- **What is the aperture range of the lens?** The aperture determines how much light enters the camera. The aperture also determines the depth of field. Small f-stop numbers let in large amounts of light, and large f-stop numbers let in small amounts of light. Smaller f-stop numbers give you a shallower depth of field (the area of the image that is in sharp focus), which is ideal for portrait photography. However, because a small sensor means shorter focal lengths, point-and-shoot cameras have an incredibly large depth of field. Your best bet is to get a camera that has an f-stop of 2.8 or smaller. The maximum aperture is listed with the focal length of the lens. For example, if you're considering purchasing an 85mm f/1.8 lens, 85 mm tells you it's a moderate telephoto, and f/1.8 tells you that the lens has a large maximum aperture.

Choosing a digital SLR

A digital SLR (single-lens reflex) is what I consider the ideal camera for portrait photography. A digital SLR is equipped with a larger sensor than those in point-and-shoot cameras, and you can take advantage of a plethora of lenses from both the camera manufacturer and third-party lens makers. If you previously recorded photos on film — you know, the stuff that came in plastic containers that you had to pay for? — and used a 35mm camera, a digital SLR (see Figure 2-2) is right up your alley.

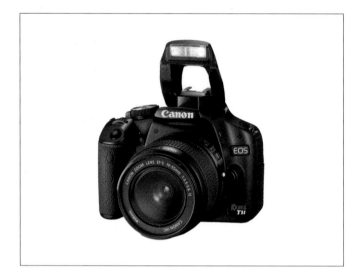

Figure 2-2: Digital SLRs are very versatile.

Here are a few things to consider when purchasing a digital SLR:

- **Is the camera equipped with a sensor cleaner?** When you change the lens on a digital SLR, you run the risk of getting some dust on the sensor and other objects behind the lens. Dust on your sensor shows up as black specks in large areas of the same color, such as a bright blue sky. Many of the newer digital SLRs vibrate the sensor when the camera is turned on and off, which shakes any dust particles off the sensor.

- **Does the camera come with a lens?** To competitively price a *camera kit* (the camera body plus a lens), some manufacturers include a lens that isn't fast and doesn't have great optical characteristics. If the camera comes with a lens, read reviews to see how the kit lens is rated. Better yet, buy just the camera body and then buy a higher quality lens made by the camera manufacturer. You'll get better pictures with better glass.

✏ **Will the camera work with lenses you already own?** If you're upgrading your camera, or finally making the transition from a film camera, make sure your old lenses will work on the new camera.

✏ **What is the camera resolution in megapixels?** When you buy a digital SLR, the larger sensor enables you to use lots of megapixels to their best effect. If you're going to create prints larger than 11 x 17 inches from your images, get a camera that can capture 12 megapixels or greater.

✏ **Does the camera have a full-frame sensor?** This factor determines the focal length of the lenses you buy to achieve a given angle of view. When a sensor is smaller than 24 x 36 millimeters (the size of a 35mm film frame), the light from the rear of the lens strikes a smaller area, which makes the picture look like it was taken with a longer focal length. To find the 35mm equivalent of a lens on your camera, you need to know the focal length multiplier. For more information on the focal length multiplier, see the "What's my focal length multiplier?" sidebar in this chapter.

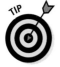

If you're buying your first digital SLR and you're a 35mm film camera convert, consider buying a camera with a full-frame sensor so you'll be able to use your existing lenses at their "true" focal lengths.

✏ **Does the camera have Live View?** This enables you to compose a picture through the camera's LCD monitor. This is a nice option, but not a necessity for portrait photography.

The megapixel myth

Digital cameras are technological miracles. Many of them are small enough to fit in your shirt pocket. Most point-and-shoot cameras come with built-in flash units and telephoto zoom lenses. But with this miniaturization come problems. The sensor on a point-and-shoot camera is much smaller than the sensor on a digital SLR, so the pixels are smaller as well. When you enlarge an image from a camera with a small sensor, it's not as sharp or crisp as one from a camera with the same megapixel resolution but a larger sensor. For example, a Canon G10 point-and-shoot camera with a 14.7 megapixel resolution has a sensor that measures 7.6 x 5.7 millimeters, which equates to a pixel density of 34 megapixels per square centimeter. A Canon EOS 50D digital SLR with a 15.1 megapixel resolution has a sensor with dimensions of 22.3 x 14.9 millimeters, which results in a pixel density of 4.5 megapixels per square centimeter. The original Canon EOS 5D has a resolution of 12.7 megapixels. This camera's sensor measures 36 x 24 millimeters, the same size as a frame of 35mm film, which means it has a pixel density of 1.5 megapixels per square centimeter. As you can see by this comparison, the G10 has the smallest pixel size of the lot. Even though it has more megapixels than the original EOS 5D, the latter will deliver sharper pictures.

Researching your camera purchase online

You can find some great information about cameras online. Many online camera retailers let readers post reviews based on their experience with a camera. There are also Web sites that specialize in digital photography and post authoritative reviews on cameras. If you've narrowed your choices down to a few cameras, go to your favorite search engine, enter the model of each camera on your list followed by the word "review." Or you can cut to the chase and go to my favorite resource for digital camera reviews: `www.dpreview.com`.

Choosing a second camera

If you own a digital SLR and a case full of lenses, you're probably reluctant to carry the camera with you at all times. Possibly, potential theft plays a role. After all, there are a lot of people out there who would break into a car to steal an expensive camera. One solution is to purchase a cheaper second camera. To address this problem, I bought a sophisticated point-and-shoot camera that had many of the same features as my digital SLR. My point-and-shoot, in fact, was made by the same company that made my digital SLR. When you're shopping for a second camera, here are some things to consider:

- **Does the camera enable you to capture images in a RAW format that is supported by your image-editing application?** It's not essential to capture your images in the RAW format, but this format gives you more flexibility when you process your images.

- **Is the camera menu similar to that of your digital SLR?** There's no sense in having to retrain yourself every time you pick up your second camera.

- **Does the camera take the same type of memory card as your primary camera?** This saves you the expense of purchasing different memory cards.

Trying before you buy

In today's economy, everyone wants to get the best deal possible. But you also need to purchase your equipment from a reputable source. The old-fashioned mom-and-pop camera shops have all but faded from history, which leads many people to believe they can get the best deal online only. The dilemma with buying online is that you don't know what you're getting until you open the box and start using the camera. If you're determined to buy from an online retailer, try the camera out at a local retailer first. The camera may get accolades from every review site out there, but if it's not comfortable to work with, or the controls are too big or too small, you won't use it that often. When you try the camera, do these things:

- Make sure the controls are easy to find and easy to use.

- Make sure you can understand the menu.

- **Make sure the camera is comfortable and easy to handle.** Imagine what the camera will feel like after using it for a few hours.

- **Shoot some pictures with the camera.** When you do your test shots, make sure you use different ISO settings.

- **If the camera salesperson isn't too busy, ask to see the images on a computer.** View the images at 100 percent magnification and pan to the shadow areas of the image. Look for any evidence of digital noise on the images you shot at high ISO settings. Digital noise shows up as random clumps of color or gray clumps. For those of you coming from a film background, digital noise should not be confused with film grain. Film grain has a definite pattern and could be used in an artistic manner. Digital noise is random and not at all artistic.

- **Look at the LCD monitor in bright light and make sure you can still read the menu options, see images clearly, and so on.**

- If the camera has **an electronic viewfinder,** point it at a bright light source and notice if you can still accurately compose the scene. On some cameras, you may notice the view is distorted and the bright light source looks like a bright star that obscures the rest of the objects in the scene.

- **Notice the shutter lag.** *Shutter lag* is the amount of time it takes the camera to take the picture after you press the shutter button. Does the camera have any noticeable shutter lag? If the lag time is long, you run the risk of missing spontaneous shots.

Lighting Your Portraits

A picture is a combination of colors, light and dark shades, shadows, and light. The way you use the light determines whether you get a compelling photograph or something that is washed out with no detail. There are several ways you can light a scene, some of them great, and some of them very bad. In the following sections, I introduce you to the preferred ways to light your subjects. I give you the Full Monty about lighting in Chapter 7.

Using available light

Available light is just that: the light that's available in the area in which you're going to shoot your portrait. If you're shooting a portrait on location, you may have multiple lighting sources: fluorescent lights, tungsten lights, and natural light. When you end up with a hodge-podge like this, you trust your camera to sort it all out. Or not. The human eye perceives the color white correctly under any light. Your camera determines the lighting source, and makes changes to render white correctly. This is known as *white balance*.

When you're photographing a subject under mixed light sources, the camera may not get the white balance correct and the resulting pictures may have your subjects looking a little green under the gills. You can improve the situation by turning off room lights, moving your subject to a different location, and so on. Or you can manually set the white balance.

By far the best type of available light is natural light. On a cloudy day you get wonderful diffuse light, which is perfect for photographing people. On a bright sunny day, you can also get some wonderful portraits, but you need to modify the light in order to diffuse it. Or you can move your subject to an area with open shade on a bright sunny day. You can also direct the light toward your subject with store-bought or makeshift reflectors. But by far, the nicest available light is diffuse light coming through a window. (See Figure 2-3.)

Lighting with commercial strobes

Professional portrait photographers with studios have the right stuff. They have strobes, multiple backgrounds, backdrops that look like brick walls and so forth. One way to get studio-type portraits is to rent some studio space, but that gets expensive. Fortunately, there are alternatives.

You can get shots like the pros if you learn how to use light and set up a studio in your home. All you need is a large enough living room that you can convert into a studio. If you do your homework, you can get a two-strobe lighting system with stands and umbrellas for a reasonable price. (See Figure 2-4.) I show you some of the things you need to know about setting up a home studio in Chapter 9.

Using external flash

The flash that's attached to your camera is next to worthless. It throws out a short burst of light that fades away just a few feet from the camera. This harsh light doesn't model faces well. You end up with very flat lighting with no contrast. You also end up with the dreaded red-eye, which is caused when the light bounces off blood vessels in the interior of your subject's eyes. Many cameras have built-in red-eye reduction, but the cure is often worse than the disease. You can also remove red-eye in image-editing applications like Photoshop and Photoshop Elements, but the best way to cure red-eye is to avoid it.

You have much better control when you use one or more external flash units — also known as *speedlites* — to light your scene. Using an external flash unit isn't rocket science — that is, of course, unless you want it to be. When you mount an external flash unit designed to work with your camera in the hot shoe, the camera and flash unit do the math and decide how many photons of light are needed to properly expose the image. And this dynamic duo also works quite well if you swivel the flash head and bounce

the flash off the ceiling or the wall. Talk about components that work and play well together! When choosing a speedlite for your camera, make sure it's compatible. Another nice option for a speedlite is the ability to manually adjust the settings. I illuminate you regarding the subject of speedlites in Chapter 7. Figure 2-5 shows a couple of flash units for Canon cameras.

Figure 2-3: Diffuse window light is wonderful for portrait photography.

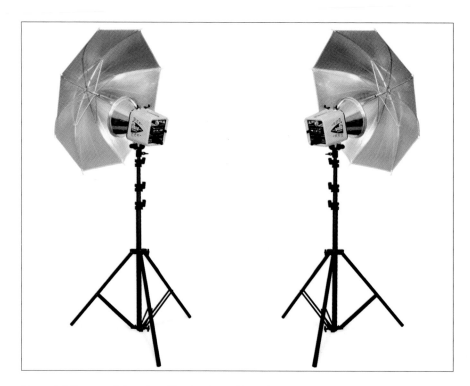

Figure 2-4: Commercial strobes. Illuminating subject, that.

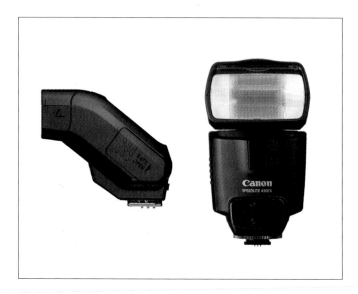

Figure 2-5: Speedlites: faster than a speeding bullet.

Choosing Accessories

Having a digital camera without accessories is like owning a Porsche and not having a Rolex on your wrist. The right accessories can make your photography experience more enjoyable. For example, although it has the manufacturer's name on it, the standard camera strap is very thin. After lugging the camera around for a couple of hours, that strap will begin to feel like a garrote, especially if the camera is a digital SLR with a telephoto lens. A wider-cushioned lens strap is one of the first accessories I always get when I buy a new camera. (See Figure 2-6.) And after you get a few accessories, you've got to have a place to store your stuff, and for that matter, your camera. In the upcoming sections, I share some of my thoughts on accessories for digital portrait photographers.

Figure 2-6: The right accessories make your life as a photographer easier.

Choosing additional lenses for your dSLR

If you bought a digital SLR kit, you ended up with a kit lens that is, well, a *kit lens*. In other words, the lens is a compromise. It's not the brightest glass in the chandelier. But the lens coupled with the camera body has an attractive price that entices people like you and me to buy the kit. Additionally, kit lenses aren't fast. A *fast lens* has a large opening (small f-stop number) that lets in a lot of light and creates a nice, blurry, out-of-focus background — exactly what the doctor ordered when it comes to portrait photography. If you have a digital SLR with a sensor size smaller than a full frame of 35mm film, another problem crops up: additional depth of field. That's right — smaller sensors have

a greater depth of field, something that's not desirable when you're shooting a portrait of someone. So the Rx for great portrait photography is fast, high-quality optics.

Lenses come in two flavors: prime and zoom. A *prime lens* has one — count 'em — focal length. That's right; you can't zoom in or out. Old-school photographers use something called *foot zoom* when working with a prime lens. Foot zoom won't burn many calories, but done properly, it will strengthen your calf muscles.

When you're shooting portraits, your best focal length range starts at the 35mm equivalent of 85mm. This is considered by many photographers, including your friendly author, to be the best focal length for head-and-shoulders portraits. You also want a fast lens (one with a small f-stop number). So your best bet is to get an 85mm f/1.8 lens. There are faster 85mm lenses, but the f/1.8 is affordable for mere mortals like you and me. I recently spoke with a Canon rep regarding their 85mm f/1.2 lens — a lens that costs more than some big-screen TVs. With it, you can shoot pictures in very dark conditions, but the rep told me it was too sharp for portrait photographers. So save your nickels and dimes and buy the best quality 85mm f/1.8 you can afford, or buy a fast zoom lens that has the 85mm focal length in its range. Figure 2-7 shows a zoom lens that fits Canon digital SLRs.

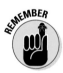

All focal lengths mentioned in this book are 35mm equivalents. If your camera has a sensor with dimensions smaller than a frame of 35mm film, you have to factor in the camera's focal length multiplier to get the 35mm equivalent for that lens on your camera.

If you're buying a zoom telephoto lens for portrait photography, make sure the 85mm focal length is included in the zoom range. A good all-around zoom lens includes a range from 28mm to 105mm. Just remember not to shoot any portraits using the wide-angle focal lengths, which put you very close to your subject. Being close to friends is a good thing when you're socializing, but it's a bad thing when you're taking pictures. Your subject will not appreciate the fact that her nose looks like it's bigger than an orange. If you do this kind of photography, your friends may never let you get close to them again.

Seeing in a different way

Film wedding and portrait photographers used a Holga camera to create an image that had vignetting, light streaks, and a sweet spot of focus. The Holga look was revered by photographers and clients that wanted dreamy looking romantic photos in addition to other photos of the wedding that were sharp and crystal clear. Then the digital age came along and photographers got very precise and crisp images. One wedding and portrait photographer named Craig

Strong wanted the Holga look when shooting digital. So he started experimenting with various optics connected to a camera mounted with vacuum cleaner hose and held together with duct tape — the universal quicker-fixer-upper for just about everything. When his experimentation yielded photos with the look he wanted, he then figured out a way to mass produce his brainchild, and the Lensbaby was born. The original Lensbaby, which debuted in 2004, had a single glass optic attached to the camera mount with a flexible hose. Aperture inserts were used to control the amount of light entering the camera. The aperture insert also controlled how large the sweet spot of focus was in the resulting image. (The smaller the f-stop, the smaller the sweet spot of focus.) The latest iteration of Lensbaby lenses ship with a coated doublet lens, which gives you a sharp image at the sweet spot of focus. You can purchase an optic kit that contains a plastic optic, a single glass optic, and a pinhole/zoneplate optic. You change the aperture disc with a magnetic tool that is included. You can also tilt the lens to move the sweet spot of focus to the desired area of your image. I've been using the Lensbaby Composer for several weeks. It has a ball-and-socket arrangement with a focus ring that enables you to precisely compose the sweet spot of focus. I use the lens for every type of photography, including wedding and portrait photography. Visit the Lensbaby Web site www.lensbaby.com for tutorials, stunning photo galleries of images photographed with Lensbaby lenses, and more information on Lensbaby products.

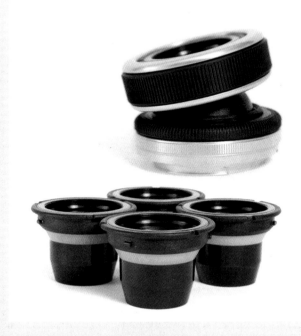

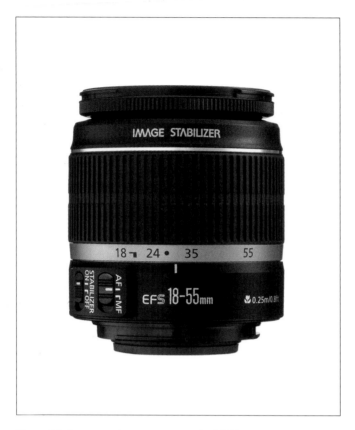

Figure 2-7: Accessory lenses are a wonderful thing.

In addition to buying digital SLR lenses made by your camera manufacturer, you can also purchase lenses made by other manufacturers that will mount on your camera. The age-old wisdom of trying before you buy or at least reading a couple of impartial reviews applies here. You can find reviews by typing the manufacturer and model of the lens followed by the word *review* in your favorite search engine. Figure 2-8 shows a variety of lenses manufactured by Tamron.

Using filters

If you were really into 35mm film photography, you had a grab bag full of goodies, including filters. Filters are used to create special effects and manipulate the light coming into your camera. When you want to use a filter, you screw it into the accessory threads on the end of your lens. Digital SLR lenses have accessory threads, and some point-and-shoot cameras have them as well. Here's a list of filters that are useful for portrait photography:

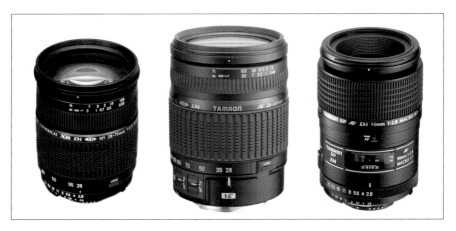

Figure 2-8: You can find third-party lenses to fit your camera.

✔ **Skylight filter:** A skylight filter slightly warms the colors in your image. Many photographers permanently affix a skylight filter to every lens they own for protection.

✔ **Polarizing filter:** This filter is great if you do portrait photography outdoors. It deepens the blue hues in the sky and makes clouds look more prominent. It also reduces or eliminates glare, a useful option if light is reflecting off your subject's glasses. You rotate the outer ring of the polarizing filter until you get the effect you're after.

✔ **Neutral-density filter:** Neutral-density filters come in different strengths and reduce the amount of light entering the camera, which enables you to shoot at lower f-stops in bright lighting conditions. A lower f-stop gives you a smaller depth of field, which is ideal for portrait photography. Some digital point-and-shoot cameras have a neutral-density option on the camera menu, which lessens the amount of light reaching the sensor. Check with your camera salesman to see if this feature is available on the camera you are considering purchasing.

✔ **Soft-focus filter:** A soft-focus filter is a great accessory when you're creating head-and-shoulders portraits. A soft-focus filter maintains image sharpness but lowers contrast. The filter also diffuses details like skin texture and wrinkles to give your portrait a more pleasing appearance. Soft-focus filters come in varying strengths. Use a filter with low diffusion for younger subjects and a filter with high diffusion for older subjects. Don't use a soft-focus filter when shooting someone with character lines like Clint Eastwood. As a rule, I use a soft-focus filter only when photographing a woman.

What's my focal length multiplier?

If you own a camera with a sensor smaller than a frame of 35mm film (36 x 24 millimeters), the sensor records only part of what the lens captures. The net result is that the lens acts like a longer focal length would on a full-frame sensor. The focal length multiplier depends on the size of your camera's sensor in relation to a full-frame sensor. The focal length multiplier generally falls in a range from 1.3 to 2.0. If you slap a lens with a 50mm focal length on a camera with a focal length multiplier of 1.3, the resulting 35mm equivalent is 65mm (35×1.3). Put the same lens on a camera with a focal length multiplier of 1.6 and you end up with a 35mm equivalent of 80mm (35×1.6). It's important to know your camera's focal length multiplier when choosing accessory lenses for your camera.

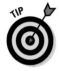

Lenses come with different accessory thread sizes. Purchase filters for the lens with the largest accessory thread size, and then purchase step-up rings that enable you to use the large filters on all of your lenses. A step-up ring has a small inner ring with male threads to attach to the lens and a larger outer ring with female threads into which you insert the filter.

Steadying the camera with a tripod

Holding the camera steady and not shooting below a shutter speed that is the reciprocal of the focal length you're using results in a sharp image. If you shoot with a digital SLR lens or camera that has image stabilization, you can shoot a couple of f-stops lower. But when you're shooting in very low light conditions, or shooting portraits with diffuse window light, your only solution is to crank up the ISO, or put the camera on a tripod. A tripod is always a better solution, especially when you're shooting portraits with a camera that has a small sensor. Figure 2-9 shows a tripod for a small point-and-shoot camera beside a tripod for a digital SLR.

Creating a homemade soft-focus filter

If you're a do-it-yourself kind of photographer, you can easily create a soft-focus filter using stuff you can find in your house. One way to create a soft-focus filter is to cut a piece of white pantyhose slightly larger than your lens. Stretch the fabric over your lens, and hold it in place with a rubber band. Another way you can make a soft-focus filter is to stretch a piece of plastic wrap over your camera lens. Make sure the plastic is taut and has no wrinkles. Use a rubber band to hold the plastic in place. Dip your finger in olive oil, and coat the plastic with it. You'll get different diffusion effects depending on the direction you smear the oil on the plastic. Try distributing it diagonally and in a circle. Yet another method is to smear petroleum jelly over a cheap skylight filter. The amount of jelly determines the amount of diffusion you get.

Figure 2-9: Steady your camera with a tripod.

Here are some things to consider when purchasing a tripod:

- ✓ **How much weight will the tripod support?** The tripod needs to support the weight of your camera. If you use a digital SLR, the tripod needs to support the weight of your camera body and your heaviest lens. To be on the safe side, include a fudge factor of 20 percent. You never know

when a manufacturer is being optimistic with data. The fudge factor will also accommodate a heavier camera if you upgrade, or if you add a heavier lens to your digital photography arsenal.

- ✔ **How heavy is the tripod?** If you use the tripod at home only, weight isn't a factor. However, if you're going to be lugging it around on vacation, or shooting portraits on location, consider one of the low-weight tripods.

- ✔ **Are you using the tripod outdoors?** If so, look for a tripod that has retractable rubber feet that reveal a sharp stainless steel spike. Retract the feet and push the tripod into the ground. The spikes anchor the tripod.

- ✔ **Does the tripod have a spirit level?** This device makes it possible for you to level the tripod, which means you'll get level horizon lines in your photos.

- ✔ **Does the tripod have a quick-release platform on top of the head?** This option is handy when you're attaching a camera to a tripod. Instead of attaching the camera to the head and the tripod, you're attaching the tripod to the platform, which is much easier to do.

- ✔ **What is the maximum extended height of the tripod?** Make sure it's tall enough for any scenario you're likely to encounter.

- ✔ **What is the folded length of the tripod?** This factor is important if you intend to travel with your tripod. If this is the case, make sure it will fit in your luggage.

- ✔ **Is it easy to lock and unlock the legs?** The better tripods have a twist lock or a lever.

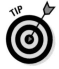

Purchase a carrying case for your tripod. Sling the carrying case with the tripod over your shoulder when you're shooting on location and will be moving around. It's much easier than lugging the tripod around without a case.

There are lots of tripod manufacturers. It's a good idea to look at a tripod and try the controls before you buy it. Many superstores have camera departments with tripods at reasonable prices.

Using a monopod

Another option for steadying your camera is a *monopod*, which has a single telescoping leg. You unlock a section to extend the monopod, and then lock the section when the device is at the desired height. Repeat with the other sections until the monopod is at the desired height. A monopod features a wrist strap. Some monopods also feature a retractable set of legs (a mini-tripod, if you will), or a retractable rubber foot and spike. When the monopod is extended, compose your picture and then pull down on the wrist strap to

steady the camera. If you decide to buy a mono-pod, make sure it will support the weight of your camera and that it's lightweight and easy to use. Figure 2-10 shows a monopod manufac-tured by Sunpak.

Choosing a camera case

You may have a point-and-shoot camera small enough to put in your hip pocket, but (if you're like me) you have more camera gear then the law allows. If you own a digital SLR, a couple of lenses, and accessories, a camera bag is a necessity. But even if all you have is a miniscule point-and-shoot camera and a lens cleaning kit, a camera bag is still a good idea. A camera bag protects your camera when it isn't in use, and it's the ideal place for your digital photography stuff. Here are some tips for finding the perfect bag for your digital gear:

- **Get a bag that's big enough for the gear you now own, and any additional equipment you anticipate buying in the near future.**

- **Purchase a bag that's comfortable.** Make sure you try the bag on for size in the camera store. Place your camera in the bag and put it over your shoulder. If it's not comfortable, ask the salesperson to show you a different bag. There's nothing worse than a chafed neck after a day-long photography adventure.

- **Make sure the bag has enough pockets for your stuff.** The bag should have a place where you can park extra memory cards, spare batteries, and other accessories.

- **Make sure the bag is sturdy enough to protect your gear.**

- **Make sure the bag is made so that you can get to your gear quickly.** There's nothing worse than fumbling for a piece of equipment as your digital Kodak Moment disappears.

Figure 2-10: One leg: monopod. Truth in advertising.

✔ **Divide your equipment into manageable portions.** If you've got a lot of gear, consider purchasing a hard-shell case that's big enough for all of your equipment, and a soft bag for day trips.

✔ **Consider purchasing a customizable camera bag.** These bags come with removable partitions that are held in place with Velcro.

✔ **Prepare for the elements.** If it rains a lot where you live and you shoot portraits on location, purchase a water-resistant camera bag, or one with a built-in rain cover.

Camera bags come in many different shapes and sizes. Figure 2-11 shows a camera that's suitable for a digital SLR and a couple of lenses. Figure 2-12 shows a camera bag that's suitable for a small point-and-shoot digital camera. This camera bag has an added bonus: It's green. The bag is constructed from recycled materials. Now that's a winning combination — a camera bag that's fashionable, holds your gear, and is good for the planet.

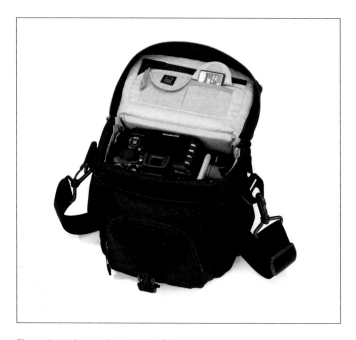

Figure 2-11: A case for a digital SLR and a few close friends.

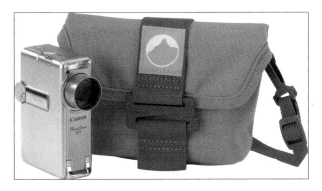

Figure 2-12: A case for a point-and-shoot camera.

Choosing other accessories

When you buy your camera, you get one battery, and maybe one memory card. That's enough to get you by when you're shooting close to home, but what happens when you take a day-long journey in search of cool places to photograph your subject? Or maybe you're combining portrait photography and landscape photography on your vacation. Well, the battery charge dwindles as you photograph, and you fill up the memory card pretty quickly. You've also got to maintain your equipment. Here are some additional accessories you should consider:

- **An extra battery:** I always keep one fully charged spare in my camera bag. If you decide to buy a third-party battery, make sure you're not voiding your camera warranty by using it.

- **Extra memory cards:** Memory cards come in different capacities and different data transfer rates. High-speed memory cards decrease the amount of time it takes the memory card to accept the data from your camera, which means your camera's memory buffer won't fill up as quickly when you hold the shutter button to capture a sequence of images. Some manufacturers include data recovery software with their high-speed cards. Data recovery software is handy if a card should ever become corrupt, which means you won't be able to download the images to the computer. The data recovery software may make it possible for you to recover the corrupt data.

- **A lens-cleaning brush:** A lens-cleaning brush has soft hairs that you use to whisk dust off the leans.

✔ **A lens-cleaning cloth:** A good microfiber lens-cleaning cloth is used to clean any smudges off the camera lens. Use the cloth after you use the brush.

✔ **A lens-cleaning pen:** A lens-cleaning pen has a lens-cleaning brush on one end and a pad for removing smudges on the other end. It has a clip on it, just like some pens have, for clipping to your pocket. A lens-cleaning pen is handy when you want to travel light. But in my opinion, you should still have a good lens-cleaning brush and cloth for cleaning your equipment after a photo shoot.

✔ **A memory card holder:** When you've got lots of memory cards, a memory card holder is a great way to keep everything organized. The holder I use has two sides. I put my empty cards on one side, which has a gray background. When I fill a card, I place it in the other side of the memory card holder, which has an orange background.

3

Getting to Know Digital Photography

*A*fter you buy your camera, you're ready to start creating portraits. Almost. Before you can create decent photographs, you've got to know what all those funny little buttons and dials do. You've also got to master the camera menu. That's not as easy as choosing one from Column A and one from Column B. If you don't know how to use the features of your camera, you're not going to get the most out of your camera. If all you're doing is pushing a button and hoping for the best, that isn't really photography. Photography is a combination of creativity and knowing your equipment. In the beginning, you'll spend a lot of time getting to know your camera. But after a while, you'll know your equipment like the back of your hand; your creative juices will flow, and you'll take some fantastic pictures. This chapter is about understanding what digital photography is all about, mastering your digital camera, and getting the most from it.

Understanding Digital Photography

Digital photography is pure technology. Think about it. Your camera captures photons of light through a lens composed of multiple elements of highly polished glass. The light hits a sensor that has a photosite for each pixel. The photosites in the sensor records what the lens sees, and then the

results are sent to a processor in the camera. The processor converts the information into digital format (and compresses the image when you shoot in JPEG mode) and then sends the information to a *buffer,* which is the equivalent of RAM memory in your computer. The data is then sent to your *memory card,* which is the digital equivalent of film.

If you shoot in your camera's RAW format (in which the camera collects unprocessed, uncompressed photo data), the raw data is sent to the memory card. It's then your job to process the RAW image in your digital darkroom.

In the upcoming sections, I demystify some of the technical terms associated with digital photography.

What the heck are pixels and megapixels?

A *pixel* (picture element) is the smallest part of a digital image. When you put a whole mess of pixels together in a rectangular grid, you end up with something that looks like an image. If you still read an old-fashioned newspaper (I've gone green and read all my news online), open the comics section and hold a magnifying glass over your favorite comic character. You see the individual dots of ink that make up the image. This is the print equivalent of a pixel.

A *megapixel* is one million pixels. Megapixel is also the unit of measure for the amount of pixels a digital camera sensor can capture. For example, the sensor in a Canon PowerShot G10 camera captures 4416 pixels horizontally, and 3312 pixels vertically. Do the math: Multiply the number of pixels captured horizontally with the number of pixels captured vertically. ($4416 \times 3312 = 14625,792$.) Divide the result by one million, and you get 14.7 megapixels. Round that number up, and you've got 15 megapixels. This also determines the size of the images you get from the camera. But for that to make sense, you've got to add image resolution to the equation. Isn't digital photography fun?

Resolving to resolve resolution

Image resolution is the number of pixels per unit of measure. In North America, our unit of measure for resolution is pixels per inch (ppi). If you've ever downloaded an image from the Internet and then printed it, you know something about resolution. The native resolution for most computer monitors is 72 ppi. However, when you print an image optimized for screen display, you can see all the pixels, which isn't a good thing. When it comes to printed image quality, a higher resolution yields better image quality.

Every camera has a native resolution. Many of the early digital cameras had a native resolution of 180 ppi. When you open the image in an application like Photoshop Elements, you'll see the size in pixels and the resolution. The size of the image in inches is determined by the size in pixels and the resolution.

You can calculate the image size (which is the largest size you can print a photo without distortion) by dividing the image width and height in pixels by the image resolution to get the size in inches.

For example, if you have an image with pixel dimensions of 3000 x 2400 with a resolution of 300 ppi, the printed image will be 10 x 8 inches. (3000 ÷ 300 = 10 and 2400 ÷ 300 = 8.) If you change the image resolution to 200 ppi, you end up with an image that measures 15 x 10 inches. You can get decent image quality with a resolution of 180 ppi, but with most printers you'll get the best quality when you resample your images to 300 ppi. I show you how to resample images in Chapter 10.

The Recipe for a Perfect Exposure

Each pixel represents a single dot of color. When viewed at 100 percent magnification, the pixels blend to produce a recognizable image. Each individual pixel is a mixture of red, green, and blue. Most digital cameras capture images with 24-bit color depth, which means 16.8 million shades of color are available. That's equivalent to what the human eye can see. The camera's job is to accurately measure the scene and produce a distribution of colors from shadows to highlights. If the shadow areas are pure black, detail is lost. If the highlight areas are pure white, detail is lost. Imagine a picture of a bride in bright sunlight. If areas of her gown, such as lace, are blown out (overexposed) to pure white (showing none of the detail of the lace for example), the bride isn't going to be very happy with the resulting image. Our job as photographers is to analyze the scene, analyze what the camera gives us, and modify the exposure, if necessary.

Understanding how exposure works in the camera

Digital cameras expose images the same way as film cameras did. When the camera exposes an image, the duration of the exposure and the amount of light entering the camera determines whether the resulting image is too dark, too bright, or properly exposed.

The duration of the exposure is known as the *shutter speed*. Digital cameras have a shutter speed range from several seconds in duration to as fast as 1/8,000 of a second. A fast shutter speed stops action, and a slow shutter speed leaves the shutter open for a long time to record images in low-light situations.

The aperture (f-stop) determines how much light enters the camera during the exposure. Some people get confused with the terms *aperture* and *f-stop*. The *aperture* is the opening that determines the amount of light entering the camera, which corresponds to an f-stop, which is a number. You would think that a large aperture would equate to a high f-stop value, but it's just the opposite. A small

f-stop number (large aperture) lets a lot of light into the camera, and a high f-stop number (small aperture) lets a small amount of light into the camera. (See Figure 3-1.) Depending on the lens you're using, the f-stop range can be from f/1.8, which sends huge gobs of light into the camera, to f/32, which lets a miniscule splash of light into the camera. The f-stop is also one of the factors that determines the depth of field, a concept I explain in the next section.

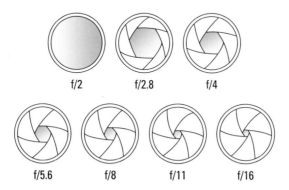

Figure 3-1: A lower f-stop number corresponds to a larger aperture, allowing more light into the camera.

As you can see, the camera has a number of different ways to create a perfectly exposed image. The camera's metering device examines the scene and determines which shutter speed and f-stop combination will yield a properly exposed image. The camera can choose a fast shutter speed and large aperture, or a slow shutter speed and small aperture.

If you shoot in automatic mode, the camera makes both decisions for you. But you're much smarter than the processor inside your camera. If you take control of the reins and supply one piece of the puzzle, the camera will supply the rest. When you're taking certain types of pictures, it makes sense to determine which f-stop will be best for what you're photographing. In other scenarios, it makes more sense to choose the shutter speed and let the camera determine the f-stop. I show you which settings make the most sense for portrait photography in the upcoming "Understanding shooting modes" section of this chapter.

Controlling depth of field

Depth of field determines how much of your image looks sharp and is in focus. When you're taking pictures of landscapes on a bright sunny day, you want a depth of field that produces an image where you can see the details for miles and miles and miles and miles and miles — thank you, Pete

Townshend. Then there are other times when you want to have a very limited depth of field, such as when you're shooting a portrait, with the person in focus and whatever's in front of or behind her out of focus.

You control the depth of field in an image by selecting the f-stop and letting the camera do the math to determine what shutter speed will yield a properly exposed image. You get a limited depth of field when using a small f-stop (large aperture), which lets a lot of light into the camera. A fast lens has an f-stop of 2.8 or smaller, and it gives you the capability to shoot in low-light conditions and have a wonderfully shallow depth of field. When shooting at a lens's smallest f-stop, you're letting the most amount of light into the camera. This is known as shooting "wide open." Figure 3-2 shows two pictures of the same subject. The image on the left was shot at f/1.8, and the image on the right was shot at f/10. In both cases, I focused on the subject. Notice how much more of the image shot at f/10 is in focus. The detail of the flowers in the second shot distracts the viewer's attention from the subject.

The focal length you use is also a factor when determining depth of field. A wide-angle focal length of 28 mm or less will yield a larger depth of field than an 85 mm lens at the same f-stop.

f/1.8 f/10

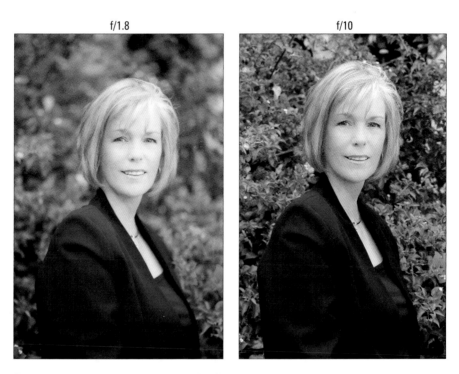

Figure 3-2: Use the f-stop to control depth of field.

Deciphering a histogram

You've got a digital camera with a microprocessor that does everything but tell you the time of day. (Come to think of it, the microprocessor records the time of day, and other bits of information about the photo, as *metadata* with the image file. But that's a topic for a different chapter.) Foremost of everything it does, though, your camera processor does its best to provide you with a properly exposed image for the available lighting conditions. But even the smartest and most up-to-date, all-singing, all-dancing digital camera can get it wrong when you're shooting under difficult lighting conditions. That's why most camera manufacturers give you the option to display a histogram (see Figure 3-3) alongside the image on your camera LCD monitor. A *histogram* is a wonderful thing. It's a graph — well, actually it looks more like a mountain — that shows the distribution of pixels from shadows to highlights. You see a peak in the histogram where there are a lot of pixels for a brightness level. Where you see a valley, there are fewer pixels at that brightness range. Where the graph hits the floor of the histogram, you have no data.

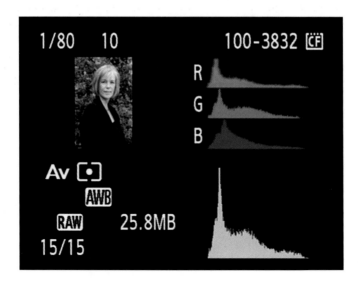

Figure 3-3: Displaying a histogram on your camera's LCD monitor.

When analyzing a histogram, you look for sharp peaks at either end of the scale. If you have a sharp peak that climbs the extreme left side of the histogram (the shadows), the image is underexposed. An image can also be underexposed if the graph is on the floor of the histogram in the highlight (right) side of histogram. If there's a large spike that's right up against the highlight side of the histogram, the image is overexposed and a lot of the detail in the image highlights are blown out to pure white. You can correct for

overexposure and underexposure to a degree in your image-editing program, but it's always best to get it right in the camera. If you analyze a histogram and notice that the image is overexposed or underexposed, you can use your camera's exposure compensation feature to rectify the problem. For more information on exposure compensation, see the upcoming section, "Correcting exposure."

The histogram is a tool. Use it wisely. When you're analyzing a scene that doesn't have bright highlights, you may end up with a histogram that is relatively flat on the right side. That's when you'll have to judge whether the image on the LCD monitor looks like the actual scene.

Mastering Your Equipment

Shooting portraits isn't rocket science, but you do need to know a few things. When your goal is to create a pleasing likeness of a friend or relative, you need to know what all the gizmos and gadgets on your digital camera do. When you shoot portraits, you graduate from rank amateur point-and-shooter to a serious hobbyist. After you start creating portraits of your friends and relatives, you may even consider becoming a professional photographer, but that's another kettle of fish. The key to shooting great photos is getting to know what features your camera has, and which ones are applicable to the type of photography you do. This is a book about portrait photography, so I won't go into a long discussion about stuff you won't use when shooting portraits.

If you're interested in other types of photography, consider getting a copy of *Digital Photography Workbook For Dummies,* written by Yours Truly (and published by Wiley), and available online and at most major bookstores. If your favorite bookseller doesn't have a couple of copies in stock, I'd appreciate it if you'd ask them to stock a few. My roommate Niki the Cat, and I would deeply appreciate it. Come to think of it, so would my publisher.

And now it's time to master your equipment.

Mastering your camera menu

All camera menus are not created equal. Therefore, it's impossible to cover each and every nuance that might appear on your camera menu, especially if your camera was hatched last week. Yup, they do update them that frequently. What I do in this section is cover what I think are some of the things you should know. Your camera may also use one or more dials to access certain functions. To find out where these gems are hidden in your multi-faceted, mega-page menu, or on the dial on which they appear on

your Swiss-Army-Knife camera, you'll have to consult that manual that came with your camera. Sorry if the manual is boring. And if the manual is really boring, tell them you know where they can find a *Dummies* author who can add a bit of spice to their boring drivel. Figure 3-4 shows two camera menus side by side. The camera menu on the left side of the figure is the shooting menu from a Nikon D5000, and the menu on the right is the shooting menu from a Canon PowerShot G10.

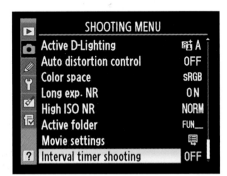
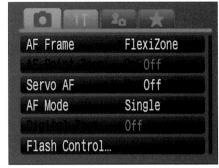

Figure 3-4: A tale of two menus. Vive le difference.

Setting image quality

The combination of image size and quality determines the file size. *Image size* is simply the largest image you can print given the number of megapixels your camera is capable of capturing. *Image quality,* in this context, is the amount of compression that is applied to the image when the camera processes it. When you let the camera process the image, in almost all cases you get a JPEG image. The camera compresses the image and data is lost. Letting the camera process the image is like having a digital Polaroid; you can't do much with the image after you download it to your computer. If you shoot RAW, the image isn't compressed and takes up the most amount of room on your memory card. However, when you shoot RAW, you can process the image in your computer. In essence when you capture pictures using your camera's RAW format, you end up with a digital negative.

So the size you select also determines the overall size of the image in pixels. Combined with the camera's native resolution, this determines the maximum size at which you can print the image. Most camera manufacturers feature the following image settings: S (small), M (medium image size), L (largest image size), W (widescreen with a letterbox), RAW (the camera manufacturer's proprietary RAW format).

The Quality setting determines how much the image is compressed, which also determines the resulting file size, and how many images you can fit on a card. If you choose a format other than RAW, you can specify a quality setting. My Canon G10 offers the following quality settings: Superfine, Fine, and Normal. When I choose Superfine, the camera applies the least amount of compression, which gives me the best image quality, Fine applies more compression, and Normal applies the most amount of compression. To give you an idea of how compression equates to file size, consider the following. With a 4GB memory card choosing the largest image size, I can fit 2080 images on the card with Normal image quality, 1013 with Fine image quality, and 602 images using Superfine image quality. I strongly recommend shooting RAW, but if you are going to let the camera do the processing, choose the largest image size, and the best image quality. Then you can use the images for prints, the Web, or e-mail.

To find out how to adjust these settings, you can explore your camera's manual and menus. If your camera has the option to capture RAW images, you'll find that option on the image quality section of your camera menu as well. On some cameras, such as the Canon G10, you'll find that image quality settings and many other features appear when you press a Function button on the back of your camera to display a menu similar to that shown on the left in Figure 3-5. Other cameras require you to press the Menu button and scroll to the image quality section as shown on the right in Figure 3-5.

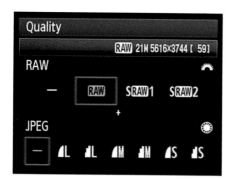
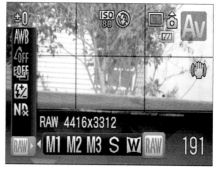

Figure 3-5: Setting image quality.

Some digital cameras that capture lots of megapixels may offer more than one RAW setting. For example, the Canon EOS 5D Mark II has three RAW settings, which capture different numbers of megapixels. The photographer can choose a smaller megapixel capture to conserve space on the memory card. If you know you're only going to print your images on 4x6-inch paper, you can get by with a RAW setting that captures fewer megapixels.

Changing to a different metering mode

Your digital camera has a built-in metering device that measures the light and sends the information to Mr. Camera Brain, who determines the proper exposure for the scene. But you have control over how Mr. Meter reads the light in the scene. The choice you make depends on the lighting conditions for the scene. To find out how to change the metering mode on your camera, you'll have to resort to the camera manual. The list that follows shows the metering modes you can choose from and the conditions in which you should use them.

 ✔ **Evaluative or Matrix:** This is the default mode for most cameras. You can use this mode for most of your work, including backlit scenes. The camera divides the scene into several zones and evaluates the brightness of the scene, direct light, and backlighting, factoring these variables to create the correct exposure for your subject.

 ✔ **Center Weighted (Average):** This metering mode meters the entire scene, but it gives more importance to the subject in the center of your scene. Use this mode when one part of your scene is significantly brighter than the rest — for example, when the sun is in the picture. If your bright light source is near the center of the scene, this mode prevents it from being overexposed.

 ✔ **Spot:** This mode meters a small area in the center of the scene. Use this mode when your subject is in the center of the scene and is significantly brighter than the rest of your scene.

The icons shown are for Canon cameras. The icons for your camera may be slightly different. Please refer to your camera manual to see which icon equates to which metering mode.

Your camera may have the option to spot meter where the auto-focus frame is. If your camera has the option to move the auto-focus frame to your subject, you can accurately spot meter a subject that isn't in the center of the frame.

Adjusting white balance

The human eye can accurately register white no matter how it is lit. Digital cameras automatically adjust white balance so that whites under different light sources look white. But under some lighting situations, digital cameras need help. If your subject looks a little green under the gills, automatic white balance (AWB) isn't doing its job. When this happens, you can change the way your camera responds to light by choosing a different white balance setting. The location of the white balance options depend on the camera you're using. Refer to your camera manual for further instructions. Table 3-1 shows the different white balance options available on most digital cameras.

Table 3-1	Adjusting White Balance	
Icon	*White Balance Option*	*Description*
AWB	Auto	The camera automatically sets the white balance based on lighting conditions.
	Daylight	Use this option for photographing bright sunlit scenes.
	Cloudy	Use this option when you're taking pictures on a cloudy day.
	Tungsten	Use this option when photographing a subject lit with tungsten and bulb-type 3 fluorescent lighting.
	Fluorescent	Use this option when photographing a subject under fluorescent lighting.
	Flash	Use this option when lighting your subject with a flash.

Your digital camera may have other white balance options, such as Fluorescent H (daylight fluorescent) or Underwater (for taking pictures under water with the camera in a water-tight enclosure). But what happens when you're photographing your subject under every kind of lighting known to man? Your camera's brain goes apoplectic and chooses a white balance setting that doesn't result in great pictures. When you review an image in the monitor and the color isn't right, your only choice is manual white balance. The process differs from camera to camera. In a nutshell, what you do is photograph something that is pure white in the same position where your subject will be. Then you use a camera menu option to set white balance based on this photograph. When all else fails, this will save your bacon and give you photographs with the proper white balance. Refer to your camera manual for the exact instructions for your camera model.

Remember to reset your white balance setting to Auto (AWB) when you've finished taking pictures with a different setting. If you don't, the rest of your photos will have the wrong white balance and look just plain weird.

Formatting your cards

Make sure you know where to find the command to format your memory cards. When you format a card, it's the same thing as formatting a hard drive, you wipe all the images off the card. You can erase images, but it's always best to format your cards after you download them to your computer.

Many image-editing programs offer the option to format cards after images have downloaded. Don't accept this option. Only your camera is best equipped to optimally format your memory cards. Besides, if something goes wrong with the download to your computer and you let the computer format your card, your precious images are lost forever.

Manufacturers are creating memory cards with huge capacities, in some cases up to 32GB. A memory card is a mechanical device that will eventually fail. When it fails, you'll lose all your data. If a card with a large capacity fails, you lose a lot of your prized images. Pack several small cards in your camera bag. That way, when one does fail, you don't lose as many photos.

Back up your images to an external hard drive after you download them to your computer and before you format the card. You never know when disaster will strike and corrupt the data on your hard drive. If you don't own an external hard drive, back up your images to CDs or DVDs. If you back up to CD or DVD, consider buying the archival discs (they're usually gold in color) that have life spans of 20–30 years or longer.

Setting other useful options

There are lots of other useful options on your camera menu. Of course, they vary from model to model. That's why there are many manufacturers and a plethora of models. Competition is a wonderful thing for the digital photographer. The cameras keep getting cheaper, with more bells and whistles. . . . But I digress. Here are a couple of other useful features that may be lurking on your camera menus, or on one of the dials:

- **Custom auto-focus point:** This gives you the option to move the *auto-focus point* (the object in the frame that the camera uses to focus on) when you're photographing a subject that isn't in the center of the frame. If your camera has this option, you may also have the option of moving the *metering point* (the place in the scene from which the camera measures the lighting to determine the best shutter speed and f-stop) to the auto-focus point when using Spot metering mode.

- **Single auto-focus point:** This gives you the option to change from multiple auto-focus points to a single auto-focus point. This option is handy when you're photographing people. Center the single auto-focus point over your subject and then press the shutter button halfway to achieve focus. You can then recompose your picture as desired. When you take pictures with a single auto-focus point, the camera won't be fooled into locking focus on something else in the scene, such as the slats in the venetian blinds behind your subject.

✔ **Face tracking:** This option is useful if you're photographing a couple of people and you want the camera to focus on them and not other stuff in the scene. Don't ask me how the camera does it, but when you select this mode, the camera draws a square around each face (but it doesn't show up in the final print, of course), or uses some other method to track a face. My Canon G10 detects a maximum of three faces, so if you're shooting a group of four, one will be low man on the totem pole. Your camera may also have the option to move focus to a specific face.

If there's something in your scene that looks like a face, say a bust of Mozart, the camera may mistakenly think it's a human face, in which case your picture may be a bust.

✔ **Servo or Continuous AF (Auto Focus) mode:** This option keeps focusing on a subject as it moves closer to or farther from you. This option is handy if you're doing candid portraits of someone at work or play. After you achieve focus, the camera keeps your subject in focus as it moves through the frame. This option does use more battery power, though. Your camera may use another name to refer to continuous auto focus. Refer to your camera manual for specific instructions.

✔ **Image stabilization:** This option is handy when you zoom in tight on your subject in low lighting conditions. Image stabilization compensates for any operator movement — that would be you — when you press the shutter button. With image stabilization, you'll be able to shoot one or two shutter speed stops slower than you normally would. Some camera manufacturers claim you can shoot even slower shutter speeds than these. Of course, if you hold your camera very still, with image stabilization, you'll be able to shoot at even lower shutter speeds than claimed by your camera manufacturer.

To find out how slow you can go with image stabilization, zoom to your longest focal length, and photograph something with a lot of detail like a leaf on a tree. Shoot several pictures and choose a slower shutter speed each time. Download the images to your computer and examine them at 100 percent magnification. Examine the edges of the leaves and the veins. When the lines start getting a little blurry, you know that the next fastest shutter speed is as slow as you can go.

✔ **Neutral-density filter:** This option lowers the amount of light entering the camera, which enables you to shoot at a larger aperture (smaller f-stop number) in bright light to reduce the depth of field.

✔ **Second-shutter synch:** This option fires the flash at the end of the exposure instead of the beginning. Use this option when you're using flash with slow shutter speeds. Any motion will appear to be coming toward the subject, instead of away from it, giving your image a more natural appearance.

Demystifying your camera dial

On the top or your camera, neatly organized with the utmost ergonomic efficiency, you'll find a dial. On this dial, you'll see some icons; some of them familiar, others strange. These dials determine what shooting mode the camera operates in. The number of icons you have on your camera depends on the model camera you use. Figure 3-6 shows the camera dial from a Nikon D5000.

On some cameras you use a combination of a button and a dial to change to a different shooting mode. Other cameras resort to a menu to change shooting modes.

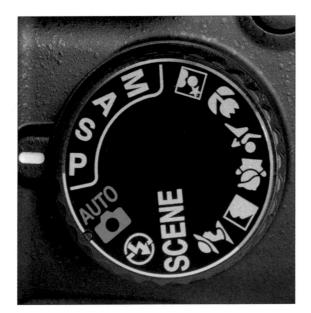

Figure 3-6: Rotate the dial to choose a shooting mode.

Understanding shooting modes

Almost all digital cameras come with a dial that you use to switch from one shooting mode to the next. Your camera is equipped with an automatic mode, which gives complete control to the camera. This isn't a good thing when you're photographing portraits of people. Your camera might also have a multitude of scene modes. The common scene modes handle sports, macros (close-ups), landscape, and portrait photography. In fact, some cameras have a scene mode called Scene, which hooks you up to the camera menu

and enables you to choose one of the special scene modes that are tailor-made for shooting stuff like fireworks, beach scenes, snow scenes, and so on. Your camera may also have a set of advanced settings where you can manually set the exposure, or provide one part of the exposure equation, and the camera supplies the other. Fortunately, portrait photographers need only be concerned with the following modes:

- **Portrait:** The icon you see in the margin is used by almost all camera manufacturers to indicate Portrait mode. When you take pictures in Portrait mode, the camera chooses a large aperture, which keeps your subject in sharp focus and gives you a soft, blurry background. Note that if you're shooting in very bright conditions, the camera may not be able to choose a large enough aperture to yield a blurry background.

- **Aperture Priority:** The icon you see in the margin indicates Aperture Priority mode. On some cameras, this is shown as Av (Aperture Value). When you take a picture in Aperture Priority mode, you specify the aperture and the camera dials in the shutter speed to yield a properly exposed image. When you shoot portraits, choose the largest aperture (smallest f-stop number) for the current lighting conditions. If you choose an aperture that will cause the image to be overexposed, your camera will flash some kind of warning in the viewfinder or LCD monitor.

If the light is too bright to use a large aperture, use a neutral density filter to decrease the amount of light reaching the sensor. Your local camera store probably carries a neutral density filter to fit your lens. If you own a point-and-shoot camera, it may have a built-in neutral density filter that you can access from the camera menu.

If you like to shoot other types of pictures, I urge you to explore the other shooting modes your camera offers.

Correcting exposure

A properly exposed image is a wonderful thing. Overexposure is never a good thing, even if you're a public figure. And underexposure never quite cuts it. When you're taking pictures in challenging lighting conditions, the camera does its best to deliver an exposure where everything in the scene is properly exposed. But what happens when the camera gets it wrong and your subject is too bright (overexposure) or too dim (underexposure)? You get a gnarly looking picture that even the subject's mother wouldn't love. You may be able to correct these problems to some extent in your favorite image-editing program. But it's always best to get it right in the camera. If your camera has an exposure compensation feature, you can correct a bad call on your camera's part by doing the following:

1. **Review the image on your camera monitor.**

 When you're reviewing the image, make sure your subject doesn't have harsh white spots on her face. This is a sign that the image may be over-exposed. If there's no detail at all in the brightest areas of the image, the image is overexposed. If your subject appears to be dim — I'm not refer-ring to her intelligence — the image may be underexposed. The only way to know for sure is to review the histogram. (See the "Deciphering a Histogram" section earlier in this chapter.)

2. **Display the histogram.**

 If your camera has this option, you either use a menu command or button to display the histogram. Many cameras have an Info button; pressing it displays different information screens.

3. **Examine the histogram.**

 If you see a sharp peak at the right edge of your histogram, your image is overexposed. If you see a flat line at the right edge of your histogram, your image is underexposed. But the histogram is not always the defin-ing factor. If you're shooting in low light conditions without any bright highlights, it is perfectly normal to have a flat line on a small portion of the right side of the histogram. When you're taking photographs in tricky lighting conditions, let your eyes be the judge. If what you see on the LCD monitor doesn't match the scene, dial in some exposure compensation as shown in the next step. If the LCD monitor accurately depicts the scene, you've nailed it, regardless of what the histogram indicates.

4. **Dial in the needed amount of exposure compensation.**

 The amount of compensation you dial in depends on how much the image is over- or underexposed. When the image is underexposed, you increase exposure. When the image is overexposed, you decrease the exposure. In the old days, that meant fiddling with the shutter speed or aperture. The exposure compensation feature lets you increase or decrease exposure 1/3 stop at a time. Most cameras have an exposure compensation range of 2 stops over and 2 stops under.

 On most cameras, there is an actual dial for exposure compensation. It may do double duty with other camera functions. For example, on my Canon EOS 5D, I have to press the shutter button and turn another dial while watching the viewfinder to determine how much compensation I'm dialing into the exposure. On my Canon G10, there is a dial on the left side of the camera that you rotate to specify the desired amount of compensation. Your camera manual shows you how to adjust exposure compensation.

Your camera may have a menu option that lets you change the increment by which exposure compensation is applied. Refer to your camera manual for details.

5. Take the picture after adjusting the exposure.

After taking the picture, review the histogram again. If the exposure still isn't right, you'll have to increase or decrease the exposure as outlined in Step 4.

Using autoexposure bracketing

To hedge their bets, many photographers bracket their exposures. When you *bracket* an exposure, you take three pictures: one at the exposure the camera thinks is optimal, one shot that has less exposure than what the camera deems correct, and one shot that has additional exposure. This is a good option when you're taking pictures in tricky lighting conditions when the action is hot and heavy and don't have the time to review each shot and dial in exposure compensation. Fortunately, most cameras have a menu command you can use to bracket your exposures. When you choose this option, you determine how much the bracketed images are over- and underexposed. Most cameras enable you to bracket your exposures in 1/3 stop increments. After enabling this option, the camera takes three pictures at different exposures. You can speed up the process by enabling continuous-release mode. After enabling this mode with autoexposure bracketing, the camera takes three pictures when you press the shutter button.

Understanding focal lengths

The *focal length* of the lens you use determines how much of the scene in front of you the camera records. A short focal length includes a wide view of the scene, which is why a lens with a short focal length is referred to as a *wide-angle lens*. Wide-angle lenses cover focal lengths from 12mm (very wide field of view) to 35mm. A long focal length magnifies the scene, essentially capturing a small part of the scene (also known as *field of view*) and magnifying it to fill the frame. Lenses with long focal lengths are called *telephoto lenses*. Telephoto lenses begin with a focal length of 80mm and exceed 500mm. A lens with a focal length that is the 35mm equivalent of 50mm encompasses the same field of view as the human eye.

When you have a lens that encompasses a range of focal lengths, you have a *zoom lens*. You can zoom in on your subject to focus on an small area, or zoom out for the big picture. You may see zoom lenses referred to as wide-angle to telephoto zoom, or normal to telephoto zoom.

For portrait photography, a focal length of 85mm is considered ideal for a head-and-shoulders portrait. You can also use longer focal lengths of up to 200mm. A longer focal length compresses details in a scene. Objects behind your subject appear to be closer. If the background is colorful foliage or architectural shapes, for instance, this is a good thing. If the lens has a large aperture (small f-stop number), the background will be an out-of-focus blur.

The following image, Figure 3-7, shows a subject photographed with a 28mm focal length, a 70mm focal length, and a 200mm focal length. These are shots of a garden gnome on the deck in my backyard. I have too much respect for the people who have graciously consented to have their images included in this book, which is why you don't see a picture of a person taken with a wide-angle focal length. These pictures were all taken from the same distance and with the same aperture. Notice the wider field of view in the first and second image. Also notice that the background details are easier to identify in the first image. The background details in the second image are a soft, out-of focus blur, and in the third image, they're barely visible. The second image is similar to the effect you're after when you create portraits.

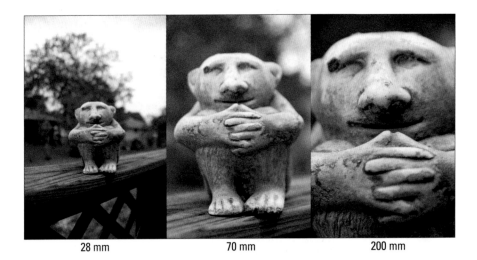

28 mm 70 mm 200 mm

Figure 3-7: Using focal length to control field of view.

Setting image quality and image format

The image quality and size determine how many images you can fit on a memory card. Image quality also determines how crisp the resulting image is and the maximum size you can print the image. When you determine image

quality, you determine how much the image is compressed. When an image is compressed, the file size is smaller and the quality is lower. Depending on the camera you use, you set the image quality and size using either the camera menu or access choices using a function button.

What the heck is a bokeh?

When you take pictures with a lens that has a larger aperture, the background is out of focus. When the background has specular highlights such as bright lights, reflections of shiny metal, leaves, and so on, the specular highlights in the background form a pattern which is known as a *bokeh*. (It can be pronounced *boke-aay* or *boke-uh*.) The way the lens is constructed determines the look of the bokeh. Many lenses are prized by photographers because of the bokeh they produce when a picture is taken with the lens wide open (maximum aperture, or smallest f-stop number).

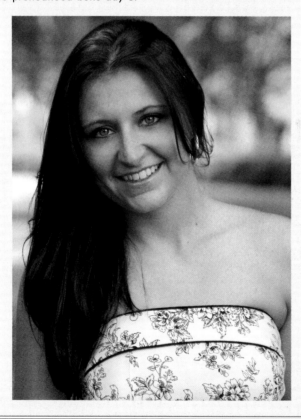

You also use the camera menu or function dial to specify the image format. When you set the size and quality, you're working with images in the JPEG format. Your camera may also have the option to shoot images in your camera's RAW format. This option is also found on the camera menu or function dial. If you happen to have one of the newer cameras that captures a humongous amount of megapixels, you may have the option to specify a lower number of megapixels when capturing RAW images to conserve room on your memory card. Choose a lower setting if the image is going to be printed as a 4-x-6-inch image.

Understanding ISO

Your digital camera probably has the option to determine how sensitive the camera sensor is to light. If you've used film cameras, you may remember that film's sensitivity to light was determined by its ISO rating, which is a number. Cameras are the same. With a film camera, you need to change film when shooting in different lighting conditions. With a digital camera, you can change ISO ratings on the fly. The ISO range depends on your camera. My Canon G10 has an ISO range from 100 to 1600.

When you increase the ISO rating, you increase the camera's sensitivity to light, which means you can shoot with faster shutter speeds in low-light situations. When you increase the ISO rating, you also increase digital noise, which is prevalent in shadow areas of your image, of large areas of similar color such as the sky in a landscape picture. Many people think *digital noise* is like film grain. It's not. It's digital mish-mosh that doesn't look good. If you own a digital point-and-shoot camera, digital noise is exacerbated due to the amount of circuitry that's crammed onto the miniscule sensor and the smaller pixel size.

When you increase ISO, you run the risk of creating an unusable image. How far can you crank up the ISO and get an acceptable image? That depends on the camera you own, and the age of your camera. The sensors on the newer cameras have less noise than older ones. The only way to be sure is to take test shots of the same subject in the same lighting at every ISO setting on your camera. Make sure you've got some shadow areas in the scene you're photographing. Download your test shots to your computer, open them in your image-editing application, and zoom in to 100 percent. Digital color noise shows up as tiny specks of color in the shadow areas and areas of solid color. (See Figure 3-8.) And luminance noise shows up as gray clumps in the shadow areas.

Figure 3-8: High ISO settings induce digital noise.

Creating a perfect portrait

If you've read this chapter from the start, you can see that there are many variables involving camera settings to focus on when your goal is a perfect portrait. There are additional variables concerning lighting, location, and so on that I address in upcoming chapters. In this section, I summarize what camera settings you need to fiddle with to create the perfect portrait:

✔ **ISO:** Choose the lowest ISO possible. Remember that when you choose a lower ISO setting, you'll have to use a slower shutter speed or a larger aperture (small f-stop number). Make sure the shutter speed is fast enough to ensure a blur-free picture.

✔ **Shooting mode:** When you're shooting portraits, I suggest that you always use Aperture Priority mode and then choose the largest aperture (lowest f-stop number) for the given lighting conditions, which creates an image with your subject in sharp focus and a blurry, out-of-focus background. If you aren't comfortable manually adjusting the aperture, choose your camera's Portrait mode, which achieves similar results.

✔ **Aperture:** If you're using your camera's Aperture Priority mode, choose the largest aperture (smallest f-stop number) possible for the given lighting conditions. As you change the aperture, the shutter speed the camera chooses is displayed in your viewfinder (on a digital SLR camera with no monitor), LCD monitor, or both. If you're taking photographs in bright light, you probably won't be able to use your largest aperture setting. When this is the case, put a neutral density filter over the lens to decrease the amount of light reaching the camera sensor. Some point-and-shoot cameras have a menu command that enables you to activate a digital neutral density filter.

✔ **Focal length:** Never use a wide-angle focal length when taking a portrait. The resulting portrait will not be pleasing. If you're using a point-and-shoot camera to capture your portraits, back away from your subject and zoom in. If you're using a digital SLR to capture your portraits, use a lens that gives you a focal length that is the 35mm equivalent of 85mm. If your camera doesn't have a full-frame sensor, you'll have to do the math. (See Chapter 2.) If you fall into this category, use a lens that has a focal length of about 55mm and you'll be in the right ball park. As a matter of fact, many digital SLR kit lenses have a focal length range from 18mm to 55mm.

✔ **Auto-focusing points:** Your camera probably has multiple auto-focus points. Switch to one auto-focus point in the middle of the viewfinder. This enables you to establish focus on your subject; the camera won't be fooled into focusing on something else that is closer to the camera, or moves into the frame. If your subject is off-center, use your camera's focus lock and exposure lock.

Establishing a post-shoot ritual

You've had a great photo shoot with your subject. Now it's time to get your images into the computer and think about what or who you're going to shoot next. If that's all you do, you're heading down the highway to disaster. After a photo shoot, there are several things you should do before the next time you use your camera. Here's what I suggest you do after every shoot:

1. **Download the images to your computer.**

After you download the images to your computer, you should give them meaningful names and add keywords. This does take a bit of time, but it makes it much easier to find your images after you download a few hundred — or a few thousand — to your computer. I cover downloading images and adding keywords in Chapter 10.

2. **Back up your images to an external hard drive.**

 This is extra work, but it prevents the loss of your valuable images if the hard drive on your computer ever decides to go belly-up on you. Hard drives are cheap these days. If your hard drive crashes in the future, your images are safe and sound on your external hard drive. If you don't have an external hard drive, back up your images to CD or DVD discs. Most CDs and DVDs last only about 5 years. To safeguard your backed-up images, purchase archival CDs or DVDs. These cost more, but most have life expectancies of about 35 years.

3. **Clean your camera.**

 Follow the manufacturer's instructions for cleaning the camera body. Clean your lenses with a soft brush and a lens-cleaning cloth. You can find these accessories at your local camera store.

4. **Return your camera settings to their default states.**

 Check all settings. For example, if you changed your white balance setting to cope with tungsten light and forget to set it back, you end up with blue pictures the next time you shoot in bright sunlight. Make sure to change your ISO setting back to its lowest value as well.

5. **Format your memory cards.**

 If you start shooting with a partially full card, you'll end up mixing images from two photo shoots. If you're dealing with a minimal number of memory cards, you run out of room before you expect to. And this always happens at the worst possible time. Always format your cards in the camera.

6. **If necessary, recharge your camera battery.**

 Look at the battery life in your LCD monitor. If it's close to being exhausted, recharge it. Some people recharge their battery after every shoot. It's great to start a shoot with a full battery, but your camera battery has a limited number of charges. I advise purchasing at least one extra battery and keep the spare fully charged.

7. **Remove the battery from the camera.**

 Batteries discharge when left in the camera. When you remove the battery from the camera, it holds its current charge until the next time you use it.

Editing Your Images

Many people let the camera do all the work, download the images to the computer, and then burn them to a disc and take them to a local camera shop or printing kiosk to get prints. But the camera doesn't always get it right. Have you ever seen images that look very blue? These images have a color cast that will show up when printed. That is, of course, unless you correct it. That's what an image-editing application is for. With an image-editing application, you can fix and enhance your images. You can also crop them to size, add special effects, and much more. In the following sections, I introduce you to image-editing applications and show you a few of the things you can do with them.

Choosing an image editor

Many digital cameras come with an image-editing program. Image-editing applications are like cars — some come full featured and others are stripped down to the bare bones. The image-editing chapters in this book are based on Photoshop Elements 8. If this application came with your camera, you're in luck. If it didn't, consider purchasing this feature- rich application. It retails for less than $100 and gives you the capability of organizing your photos and then editing them.

Sorting, ranking, and other delights

After downloading images to your computer, you may be tempted to just leave them as is and move on to your next photo shoot. If you use your camera only a couple of times a year, this may be okay. But the fact that you're reading this book leads me to believe that you take a lot of pictures, or soon will be. When you take a lot of pictures, you end up with some duds. So how do you separate the wheat from the chaff? You rate your images. After you rate them, you delete the duds.

Okay, so you've rated your images and deleted the duds. After a couple of months, you end up with a huge folder full of images that were named by the camera. And your Aunt Edith asks you for a print of that wonderful portrait you took of her last July. That's when you realize that searching for a single image among thousands is like looking for the proverbial needle in the haystack. Fear not, intrepid portrait photographer. In Chapter 10, I show you how to organize your images using Photoshop Elements 7.

Working with RAW files

When the RAW format was first introduced, photographers didn't embrace it because the images needed to be processed before you could do anything else with them. The first applications to process RAW images were hard to work with, and you had to process one image at a time. Is it any wonder that photographers would rather endure a root canal instead of processing a couple of hundred RAW images?

The current batch of RAW processors are much better than their predecessors. They're easier to work with, and they enable you to process lots of images quickly. Photoshop Elements 7 uses a watered-down version of the Camera Raw editor that ships with the full version of Photoshop. But you can still do a lot with it. I show you how to process images with the Photoshop Elements 7 version of the Camera Raw editor in Chapter 10.

Tweaking your images

Many people think the images photographed with digital cameras aren't as crisp as those shot with film cameras. I agree with this assessment. There are a number of reasons for this, but I won't bore you with a lot of technical info. You can, however, make your images look their best when you edit them. You can make them look just like the scene or person you photographed, or you take a few extra steps and make them look better. Some people think this is cheating. However, what photographers do with image-editing applications installed on their computers is the same thing that film photographers did in their darkrooms. If you think Ansel Adams didn't tweak his images in the darkroom, you are mistaken. In fact, a good image-editing application functions as a digital darkroom. I show you how to tweak your portraits in Parts III and IV.

4

Becoming a Portrait Photographer

You've got your brand-spanking new, 14-megapixel camera, and now you just want to go out and shoot something. But you're not sure what to shoot, or how to go about it. It's kind of like being all dressed up with no place to go. Many new photographers, and a lot of old-timers, are tempted to take the camera, point it at the first thing that moves, and shoot. But photography is so much more than that. Good photographers don't happen overnight. Photography is a discipline, just like basket weaving, albeit a lot more fun. In this chapter, I discuss some of the things that go into the makeup of a good photographer.

Seeing, Thinking, and Acting

In order to take a good picture, you've got to have the right equipment. But the right equipment doesn't guarantee you'll get a good, or even mediocre, picture. Getting a good or great picture is all about you. Your unique personality, vision, and creativity is what separates your photographs from those taken by the guy down the street who owns the same digital camera. Have you ever looked at two photographs of the same person, place, or thing, yet they look completely different? That's where the skill and unique vision of each photographer comes into play. Compare Ansel Adams' fine art photographs of Yosemite to tourist snapshots, and you'll see what I mean.

Being in the moment

Some people think of photography like a religion. They approach their equipment and their subject with reverence, awe, and wonder. I'm sure you've seen photographs that have brought out those feelings in you. There's no reason you can't work to create your own jaw-dropping images. One of the best skills you can develop as a photographer is being in the moment. What I mean by that is experiencing the present moment and not thinking about anything else but the subject you're about to photograph. If you're distracted by things you have to do later in the day, you can't focus on your photography. When you're not thinking about anything in particular, but observing what's around you, you notice things that would normally pass you by. This is important in portrait photography as well. When you're giving your full attention to your subject, she knows it and will work with you. You'll also notice things about your subject that you wouldn't if you just glance superficially and snap the shutter. You get better pictures when you're focused on what you're doing and not fretting about what you're going to cook for dinner.

Practicing 'til your images are pixel-perfect

If you use your camera only once in a blue moon, your pictures will show it. Letting your gear gather dust in the closet isn't the way to become a better photographer. Use your camera every chance you get. Consider joining a local camera club. Networking with other photographers is a wonderful way to get new information. You can also find a mentor in a photography club. Strike up a friendship with an experienced photographer and tell her you'd like to tag along the next time she does a photo shoot.

The best way to practice portrait photography is to take pictures of people every chance you get. Tell your friends and relatives about your love of photography, and ask them if they'd be willing to let you photograph them every now and again. Practice your photography when you see something that inspires you, such as a compelling portrait from a magazine, or a picture you see on the Web. With the picture fresh in your mind, try your best to create a reasonable facsimile with a friend or relative.

Becoming a student of photography

When you decide to seriously pursue portrait photography, you can find a lot of resources. Great portrait photography is all around you. You'll find portraits of the rich and famous in magazines like *People* and *Us*. You'll also find portraits of people like you and me in those magazines. Advertisers use portraits all the time when promoting their client's wares. Your local newspapers and magazines are also a great resource for portrait photography. Advertisements for lawyers can be great examples of formal portrait photography, and advertisements for products such as swimming pools and barbecue grills can be the inspiration for great candid photographs.

When you see a portrait in a magazine, study the picture carefully. Look at the subject's pose and try to figure out the light source for the portrait. Look at the subject's eyes. You'll see bright spots that are a dead giveaway to how the photographer illuminated his subject. These are known as *catch lights.* The size and shape of the catch lights give you clues. If the catch lights are large and rectangular, the photograph was probably taken using soft boxes in a studio. If the catch lights are fairly large and round, the photographer probably bounced studio strobes into an umbrella (see Figure 4-1). You may also see catch lights that look like windows. If this is the case, the photographer used natural light to illuminate his subject.

Figure 4-1: Study a portrait to learn more about portrait photography.

Another great way to understand portrait photography is to study the masters. Annie Leibovitz, for example, is a wonderful portrait photographer. She's photographed musicians, actors, and other celebrities since the 1970s. You can find examples of her work online and in books that you can find in your local bookstore. Her portraits epitomize the concept of capturing a true likeness of the person. Another excellent portrait photographer is Greg Gorman. If you like to study the work of the old masters, Google Arnold Newman. He created some wonderful environmental portraits. If you like the gritty style of street photography, Google Henri Cartier-Bresson.

You can also find wonderful examples of portrait photography in online galleries. If you see a photograph that inspires you, type the photographer's name into your favorite search engine to find online galleries of his work. LIFE magazine has a wonderful online gallery with lots of portrait photography. Visit www.life.com (see Figure 4-2), and navigate to the celebrity section. The site also has a search feature. Type a celebrity's or politician's name in the search field to view photos of that person.

Figure 4-2: Examine the work of other photographers to hone your skills.

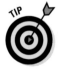

You can also find lots of great portrait photography, as well as other genres of photography at www.photo.net.

Never leave home without a camera

You can't ask a photo opportunity to wait while you go home to get your camera. Photo opportunities happen when you least expect them. Therefore, you should never leave home without a camera. And no, the camera in your cellphone doesn't count. If you're nervous about taking an expensive camera with you wherever you go, I don't blame you. I feel the same way. That's why I bought a relatively inexpensive point-and-shoot camera that I do carry with me everywhere I go. When I see something I want to photograph, I reach in the glove box of my car, grab my trusty point-and-shoot, and snap the picture. For more information on choosing a second camera, see Chapter 2.

Waiting for the light

Landscape photographers arrive at a scene they want to photograph and often patiently wait for the right light, or wait until a cloud moves into the frame to get the perfect picture. Sometimes they'll backtrack to a spot later when they know conditions will be better. Good landscape photographers are very patient. Patience is a virtue that all photographers need to cultivate. When you're working with a subject, you need to give her time to relax in front of the lens when you're shooting formal portraits. When you're shooting candid pictures of your friends and family, minutes may pass when nothing exciting happens. Don't put the camera away yet. If you wait patiently, something will happen that piques your interest and compels you to compose a picture and press the shutter button.

Working with Your Subjects

When you take someone's picture, you're interacting with that person. The success of the photos you take depends on how well the two of you hit it off. You also have to take the lead and tell your subjects what to do. If you just point the camera and expect great poses to appear like magic, you're in for a big surprise. Being observant is a necessity no matter what type of photography you do. When you're a portrait photographer, you have to observe your subjects. When they appear relaxed, you're ready to take control and start clicking the shutter button.

In portrait photography, there are no signposts that say Scenic Overlook. Your job as a photographer is to collaborate creatively with your subject. Use your skills and creativity to bring out your subject's most endearing characteristic, but remember not to overlook the flaws. These combinations of her most endearing qualities and her flaws are what make her truly unique. Combine these to create a truly flattering portrait. This means you really

have to see your subject and look past the familiar. Your subject has an inner and outer beauty. A good portrait captures both. Experienced photographers do this automatically when they look through the viewfinder. Don't be in a rush to take a photograph. Slow down and really see your subject. In the following sections, I tell you how to take command of the situation and gain rapport with your subject.

Photographing people you know

Photographing friends or loved ones can be a challenge. They're not used to having a camera in front of them. And the fact that you're behind the lens can make matters even more difficult. I mean, after all, they know you as a family member, not a portrait photographer. But if you show your friends and family that you take your photography seriously, they'll relax. Here are a few tips for photographing people you know:

- **Tell your subject your goals for the photo shoot.** (See the upcoming "Defining Your Goals" section for tips on how to set those goals.)

- **Compliment your subject about how great she looks.** If your subject resembles a well known person, say something like "Jennifer Aniston looks a lot like you." That compliment carries a lot more weight than "You look like Jennifer Aniston." Sincere flattery will relax your subject.

- **If your subject is female and you're a man, always ask permission when you have to touch her to adjust a pose.** In fact, if you don't know your subject well, it's a good idea to ask before touching no matter what gender you are and what gender your subject is.

- **Take photographs of people doing things they love.** You'll get your best shots of people you know when they're relaxed or doing something they love. It's rare to get good formal portraits of people who don't often have their pictures taken. (See Figure 4-3.)

- **When you're photographing friends and family, consider doing environmental portraits where they work and play.**

When you photograph someone you know well or love, you're photographing familiar landscape. You can see this person in your mind's eye. When you photograph someone you know well, dig deep and look past the familiar. Remember the endearing characteristics of the person, her inner beauty, to create a stunning photograph that represents the person's true character and isn't a cliché. Study your subject carefully until you find your photograph. Try several different compositions until the photograph comes to you. Sometimes, you'll have to take a lot of pictures to get the ideal photograph of a person you know well.

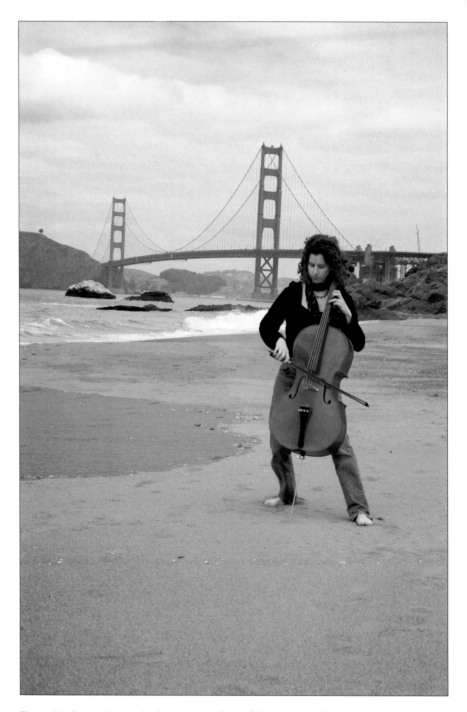

Figure 4-3: A staged portrait of a concert cellist at China Beach in San Francisco.

When you photograph your subject, don't label her. Your subject's name may be Jane, but you're not photographing Jane. You're photographing a vibrant human being, a special person. Your job is to show your subject in her best light. Not doing so is like reading the wine label and never tasting the wine. To see your subject, and create a good photograph, look past the labels that identify your subject and capture her true essence digitally.

Taking pictures of strangers

When you're on vacation, or traveling, you'll meet interesting people that you may want to photograph. It takes a bit of nerve to walk up to a perfect stranger and ask to take his picture. Here are a few tips for photographing strangers:

- ✓ **When you want to take someone's picture, walk up to her, smile, and tell her you're a photographer.**

- ✓ **Tell your subject she has an interesting face that you'd love to capture.**

- ✓ **Never travel alone when you want to photograph people. Safety in numbers.**

- ✓ **Make sure you're in a safe part of town before you start photographing.** Ask the hotel concierge if there are any areas of town that are unsafe. Taxi drivers are another good source for local information.

- ✓ **If you're traveling to a foreign country, find out something about the culture.** Photography may be taboo. You'll insult the locals if you dress or act inappropriately. Always show respect for people when you're in a foreign country, or for that matter, anywhere you travel. This is especially important if you're toting a camera.

- ✓ **If you don't speak the language of the country you're visiting, hold the camera up in front of the person you want to photograph and smile.** If you get a nod of the head and a smile in return, you're good to go. If the subject moves his head from side to side, move on.

- ✓ **Smile and maintain eye contact while you're photographing your subject.** After you take the picture, smile. If you know how to say "thank you" in your subject's language, do so. If not, consider learning how to say the phrase. Common courtesy goes a long way.

- ✓ **If you're photographing a child, make sure you get permission from his parents first.**

- ✓ **Don't travel in a large group.** You'll get better results when you travel in a small group, or with a buddy who can watch your back. Anyone would be overwhelmed at the sight of 15 or 20 photographers approaching. Travel alone only if it's safe to do so. The image in Figure 4-4 was photographed in San Francisco's Chinatown. The shopkeeper's red apron caught my eye and made an interesting composition with the red apples.

Figure 4-4: Photographing people while on vacation.

When you move to a new town, or go on vacation, wander around interesting areas of the city and photograph scenes that appeal to you. You'll find interesting people to photograph as well.

Candid photography

Candid photographs tell more about a person then a formal portrait. As photographers, we must be alert and perceptive enough to realize when our subject is being herself. This means letting go of preconceived notions about your subject and waiting for the spontaneous moment when the true nature of your subject is revealed. When you see your subject doing something that captures your interest or piques your curiosity, quickly compose the picture and click the shutter before the moment is gone (see Figure 4-5).

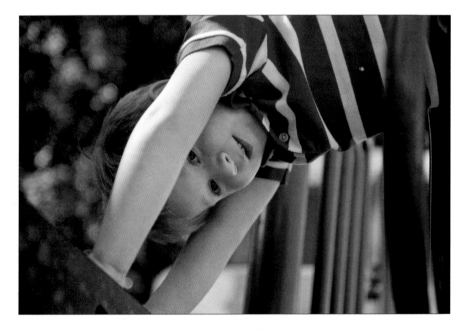

Figure 4-5: Candid photos of children can be fascinating.

Gaining rapport

If you and your subject don't hit it off, you're never going to get a good portrait. So before you start taking pictures, your goal is to relax your subject and get him talking about something. Begin by talking about topics that interest you.When you find a subject to which your subject responds enthusiastically, ask your subject for his opinions about the topic. This will

be easier to do if you know your subject well. I recently did a portrait session for a local attorney, and I knew he was a big fan of Jerry Seinfeld, so I started talking about memorable episodes of the *Seinfeld* show. When he started laughing, I started taking pictures.

If you're photographing someone you don't know very well, you can quickly gain rapport by using a technique called *mirroring.* Observe how the person communicates with you. Does she use her hands? Does she speak fast? Does she use a lot of hip phrases? Find out how she communicates and then mirror what she does. Just don't go over the top so that what you're doing is blatantly obvious. When you mirror someone, the person thinks you're a kindred spirit and will relax in front of the camera.

Lights, camera, action

No matter what type of portrait you're taking, a little bit of planning goes a long way toward getting the results you're after. If you're going to take formal portraits of a friend or family member at his place of work, make sure you know the location. Figure out which area will be the best to capture the photographs you're after. You'll get the best shots when you're in control of the situation. Before the shoot, rearrange the furniture and get rid of any obstacles. Set up your equipment ahead of time. If your subject's desk is cluttered, ask him to clear away everything but the essentials. After that's done, look around the office for something that belongs to your subject, something that says something about him, and place it on the desk. For example, if your subject loves automobiles and has a collection of small die-cast automobiles, place his favorite on the desk. You can use items on the desk as integral parts of the image. The objects tell viewers something about your subject and become points of interest. When placing objects, remember the rules of composition that I show you in Chapter 5.

If you're taking pictures of your subject on location, choose a location that you know well. If your subject tells you the location where she wants the pictures taken, check the place out ahead of time. First and foremost, make sure the location is workable. You'll need some items of interest to spice up the images. If you've got interesting architectural details such as a staircase, you've got an interesting backdrop for your subject. (See Figure 4-6.) You can also use foliage to frame your subject and direct the viewer's eye.

Whether you're doing a location shoot, or formal portraits in your makeshift studio, take control of the shoot from the start. Tell your subject where to stand or sit, and then tell her your goals for the photo shoot and ask her if they coincide with what she has in mind. When you've gained rapport with your subject and she relaxes, start taking pictures. While you're taking the pictures, pay attention to what you see in the viewfinder. If you notice wrinkled clothing, or a piece of jewelry such as a locket that isn't centered,

tell her what you've noticed and ask her to make a few adjustments. You'll also be responsible for telling her how to pose. I cover posing your subject in Chapter 6.

Figure 4-6: Use architectural and natural elements in your composition.

Defining Your Goals

Before you photograph someone, you should have a clear idea what the final image will look like. If you don't have a goal for the picture or the photo shoot, you're wasting your time and your subject's time. Of course, the goal

doesn't have to be a perfect portrait. You can set up a photo session to experiment with new ideas, master a new technique, or perfect a technique such as lighting your portraits. After all, practice does make perfect.

When you know why you're taking the picture, you'll know what settings to use, how to light the photo, which lens to use, and so on. If you're creating a portrait for someone, you adhere to the standard rules of portrait photography as outlined in this book. However, if you're creating a portrait for yourself, you can get as creative as you want. You can shoot from different and unique vantage points, tilt the camera, and so on.

What is your center of interest?

When you create a portrait of a person, or a group of people, decide on the main point of interest in the photo. For some photos, it may be the person's face. Or if you're creating a portrait of a family member who's a pianist, a picture of him playing the piano would be appropriate, and your center of interest would be his hands on the keys. Sometimes, you have more than one vantage point. When this is the case, you can compose the photo in such a manner that one center of interest leads the viewer's eye to the other center of interest. In Figure 4-7, I used barbells and the exercise ball as visual props to draw the viewers into the image. The athletes' heads form an oval that leads the viewer through the photo. Each person is a center of interest, but the man on the exercise ball is the lead trainer. I composed the image according to the rule of thirds and moved until his head was in the proper position. For more information on composing your images and the rule of thirds, see Chapter 5.

What is your best vantage point?

The decision you make on your best vantage point depends on what you're photographing. In most instances, you want to be eye-to-eye with your subject. With adults, this is fairly easy to do. However, when you photograph children, you'll have to squat down, or drop to one knee. Pets and wildlife should also be photographed at eye level. When you photograph small subjects from above, the results aren't flattering. Of course, any rule can be broken. Refer to Figure 4-7, where I intentionally shot the image from a low vantage point to accentuate the lean physiques of the standing athletes.

If you're capturing a full body shot of a short person, you can make her look taller by shooting from below. Drop to one knee, rotate the camera 90 degrees (Portrait format), and take the picture.

Figure 4-7: Define your center of interest.

What else is in the picture?

The only time you're not bothered by other objects is when you shoot a portrait against a solid color background such as a wall or cloth backdrop. But even then, you have to notice everything in the viewfinder or LCD monitor. If your subject is too close to the background, you may notice wrinkles from a cloth backdrop, or texture from a wall. If this is the case, ask your subject to move forward. Then shoot the picture in Portrait mode, or in Aperture Priority mode with a large aperture to blur the background.

Muslin backgrounds get wrinkled when you store them. A product called Downy Wrinkle Releaser gets rid of wrinkles in short order. Set up the background, and follow the manufacturer's directions to get rid of the wrinkles. Wait for the backdrop to dry, and you're ready to start your portrait session.

When you're taking pictures of subjects on location, you often have unwanted objects, such as telephone poles, in the background. Sometimes you have to make a decision to include the distracting elements in the image and clone them out in an image-editing application. But that takes time. If you have the alternative to move your subject slightly and make the distracting elements disappear, that's always your best option. You can also move to a different place in the same general area with a pleasing background and no distracting elements.

Thinking like a Photojournalist

A photojournalist records the history of everyday life and the world around him, capturing compelling photographs of man and his environment. Anyone with an avid interest in photography can create a photographic journal of his life, and also document his family's life. All you need to do is carry a camera with you wherever you go and take photographs of the things and people that interest you. This isn't exactly portrait photography, although you will be able to practice your portrait photography skills while taking pictures of the people in your life. The other trait so common to a photojournalist is his power of observation. A good photojournalist seems to have a sixth sense and knows when something interesting is about to happen. Yes, this is a gift. But it also comes from years of photography experience. If capturing a slice of your life and your family's life digitally sounds like something you might be interested in, study the work of Henri Cartier-Bresson, who is considered by many to be the father of modern photojournalism.

Telling a story

When you photograph a family event with a journalist mindset, you're telling a story. No story is complete without a beginning, middle, and ending. So if you're going to photograph an event like your grandmother's birthday, get there early and take pictures of the host preparing the party. Take close-up pictures of the birthday cake, candid portraits of the host setting the table, and so on. If it's a surprise party, take pictures of the guests arriving. The picture of your grandmother entering the room and being surprised by the guests will be a portrait in and of itself. If you have a zoom lens with a focal length that's the 35mm equivalent of 85mm, zoom to that focal length, and have one of the guests enter through the door. You'll know right where you need to stand to get a great shot of the birthday girl with a surprised look on her face.

When the party starts, you can photograph the guests interacting with your grandmother. This part of the party can also be great for getting candid shots of your relatives. Just make sure you don't photograph them while they're eating. A photo of a person stuffing a taco in his mouth is not a good thing unless you're taking pictures as part of an advertising campaign for a national taco chain. Other great photo opportunities are when she opens her gifts and when she blows out the candles.

When the party's over, you can create some slice-of-life photos. Take a picture of your grandmother's gifts, a partially eaten piece of cake, crumpled up gift wrap, and so on. After the event, you can post the photos online in a Web gallery. If it's a really special event, like your parent's 50th wedding anniversary, create a photo book using pictures from the event.

Being the fly on the wall

If you decide you like being a photojournalist, the next step is to develop some techniques for capturing great photos of your family at work and play. After you make it known that you're the family photographer, they'll get used to seeing you with a camera around your neck. But the camera still sticks out like a sore thumb, and your friends and family will be on guard if they see you quickly raise the camera.

Some people get very self-conscious when you point a camera at them. So you have to be kind of sneaky and be the proverbial fly on the wall. You can't magic the camera away, but you can be a bit clandestine in your approach. If you live in a two-story house with a balcony, you can be a fly on the balcony. Another trick is to do all your composing through the camera's LCD monitor. This is a breeze if you've got a point-and-shoot. Put the camera on the table, compose your picture, and press the shutter button. If you have a digital SLR with Live View, enable Live View, compose your image, and press the shutter button when one of your family members does something interesting. Another technique you can use is to focus the camera on an object that is the same distance from you as your subject is. Then when your subject does something interesting, quickly compose the picture and press the shutter button.

Another way you can be a fly on the wall is to set up your camera in a room where you want to take a picture. For example, if you want some photos of your wife preparing a meal, camp out in the kitchen. When she sees you with the camera, she'll look at you when she starts to prepare the meal. Smile and fiddle with your camera. After a few minutes, she'll become engrossed in what she's doing. Then you can calmly raise the camera and squeeze off a couple of shots. If she gives you the hairy eyeball, smile and fiddle with the camera some more.

Becoming the family historian

After you delve into the world of portrait photography and become familiar with your camera, you'll want to use it more and more. What better way to be of service to your family than to become the family historian? You can shoot portraits of your children at each birthday and portraits of your parents' special occasions, such as wedding anniversaries. If your children are involved in sports, take music lessons, or participate in any special events, take photos of these occasions. Portraits of your children dressed up in their uniforms, or with their instruments, will spark wonderful memories in later years. Make sure you archive everything so you'll be able to get the photos 10, 15, or 20 years in the future. At that point in time, you may want to consider creating a photo book of the family history. Photo books make wonderful holiday gifts.

The genius of digital photography

The genius of digital photography is immediacy. The old days of waiting for your film to be developed and returned from the lab are gone. You know if you got the shot as soon as it appears on your camera's LCD monitor. You also never have to pay for film again. Ever. But for the most part, people have made the switch to digital because they can capture their images on cards the size of a postage stamp, they don't want to worry about film expiration dates, and so on.

But with these advantages is also a curse. If you're not careful, the very genius of digital photography can turn you into a bad photographer. You don't pay for film so you tend to shoot more images. This is a good thing if you take good photographs. But if you just shoot everything that pops up in front of your camera, you're going to get a lot of bad photos that end up in the trash bin. To take advantage of the genius of digital photography, be in the moment and do your best to make every image a keeper. If you apply the techniques in this chapter, you'll be more focused on your subject. Practice also enters into the equation. When you know your camera like the back of your hand, and you apply all of your attention to your photographing the subject before you, you're well on the way to utilizing the genius of digital photography and capturing compelling photographs.

Part II
Portrait Photography Techniques

In this part . . .

*P*ortrait photography is much more than pointing a camera at someone and pressing the shutter button. You've got to consider quite a few things if you're going to capture someone's true essence digitally. You have to figure out where to place your subject in the frame, what camera settings to use, how to light your subject, and so on.

In this part, I devote a chapter to composing your photographs. I also show you how to work with your subjects, gain rapport, and so on. And I cover photographing your subjects (including wildlife) on location. Last but not least, I cover photographing people in your home or at their office.

Composing Your Portraits

T he glorious moment has arrived. Your victim — I mean *subject* — has arrived for his portrait session. Now it's time to put your finely honed portrait photography skills to work and take some really fine portraits. But you'll never get a really fine portrait if you don't use the right camera settings or choose the right focal length. Then there's the matter of composing the picture. Yes, you have to put some thought into this process. Just randomly pointing the camera at your subject and pressing the shutter button won't get you a good portrait. There are rules of composition you can follow. But if you're a rebellious kind of photographer and you know the rules, you can break them. In this chapter, I show you some suggested camera settings and rules you can follow to take your portrait photography to the next level.

Using the Right Camera Settings

Most digital cameras come with an Auto mode, which you find on a dial that is usually on top of the camera on the right side. Your camera's Auto mode does all the thinking for you, but it has no idea of what your subject is. It makes its decisions based on the available light and other factors. For portrait photography, the Auto setting is not a good thing. It makes decisions based on normal point-and-shoot photography. You have different goals when you create a portrait. For some reason, camera manufacturers assume that a good number of their patrons are idiots who haven't read a *Dummies* book on digital photography and use Auto as the default mode.

Fortunately, there are other shooting modes you can use for specific situations. In the following sections, I show you the ideal camera settings for portrait photography.

Choosing a camera mode

You're not getting the most out of your camera if you let it make all the decisions for you. Portrait photography is a different breed of cat. Your goal is to accentuate your subject, not the background. Your best options for portrait photography are to use Portrait mode or Aperture Priority mode. Aperture Priority mode gives you the best control. However, if you still want the camera to do most of the work, Portrait mode is the best option for you. These modes are described in the next two sections.

Shooting portraits using Portrait mode

When you rotate the dial to the funny icon that looks like a woman with an oversized floppy hat (see Figure 5-1), you've selected Portrait mode. When you shoot in Portrait mode, the camera chooses a shutter speed and aperture that creates a soft, out-of-focus background. This gives the photo a dreamy look and draws the viewer's attention to your subject.

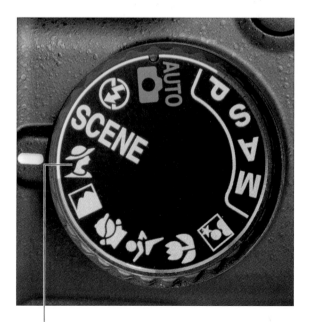

Portrait mode

Figure 5-1: Portrait mode is your first choice for portrait photography.

The camera chooses the largest aperture based on the available light. This can pose a problem if you're taking pictures in bright light. The aperture the camera chooses may not be enough to render the background as an out-of-focus blur. When this occurs, move your subject to a shaded area. Shade or diffused light is a better option when creating a portrait of your subject. Your results using Portrait mode will be better with digital SLR cameras because they have bigger sensors. Small point-and-shoot cameras will always give you a sharper background, even when you photograph using Portrait mode.

Shooting portraits in Aperture Priority mode

When you take pictures in Aperture Priority mode, you choose the aperture, and the camera determines the shutter speed needed for a properly exposed image. When you shoot in this mode, you have complete control over depth of field. When you shoot portraits, you want a shallow depth of field to blur the background. When you shoot in Aperture Priority mode, you have better control over depth of field. Then it's a matter of marrying the right focal length with a large aperture as a prelude to capturing wonderful portraits. Most digital cameras have an option for Aperture Priority mode on a dial (see Figure 5-2), which is generally found on the top-right side of the camera.

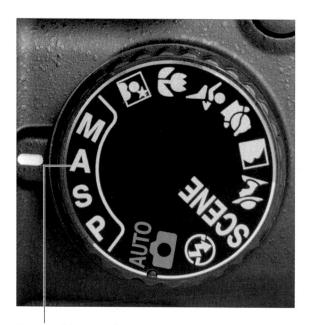

Aperture Priority mode

Figure 5-2: Choose Aperture Priority mode to control depth of field.

Choosing a focal length and aperture

When you create a portrait, if you've dialed in Aperture Priority mode, you get your best results when you choose the proper focal length and aperture. A wide-angle focal length gives you a greater depth of field, even when you're shooting in Portrait mode, or when you're choosing a large aperture (low f-stop number) when shooting in Aperture Priority mode. Wide-angle focal lengths are ideally suited for taking pictures of landscapes, not for portrait photography. Many beginning portrait photographers who don't know better get close to their subjects and use a wide-angle focal length. This tends to make the object closest to the camera — usually the subject's nose — look much bigger than it actually is.

Most portrait photographers agree that 85mm is the ideal focal length for portraits. The best way to get a good portrait is to move away from your subject and zoom in. If you're capturing portraits with a point-and-shoot camera with a zoom lens, zoom in to a focal length that is the 35mm equivalent of 85mm. Many digital point-and-shoot cameras have the 35mm equivalent marked on the lens barrel. Your camera may display a bar that shows the amount of magnification you've zoomed to on the LCD monitor. If this is the case, you can come close to the ideal focal length by doing a bit of math. For example, my Canon PowerShot G10 has a zoom lens with a 35mm equivalent range, from 28mm to 140mm. When the bar is approximately three-quarters of the way to the end, I know I'm somewhere near the 35mm equivalent of 85mm.

If you have a digital SLR, you can precisely zoom to 85mm. However, if your camera has a sensor that's smaller than a frame of 35mm film, you have something known as a *focal length multiplier* to contend with. (See Chapter 2.) Multiply this by the selected focal length to ascertain the 35mm equivalent for this focal length on your camera. For most digital SLRs with a sensor smaller than a 35mm frame, 50mm will get you in the right ballpark.

The next piece of the puzzle is the aperture. You want to choose the largest aperture you can for the existing lighting conditions. If you're taking pictures in diffuse light, or on an overcast day, you can easily achieve this goal. However, in bright lighting conditions, you may not be able to get a properly exposed picture shooting with the largest aperture. If this is the case, you can screw a neutral density filter to the end of your digital SLR lens (see Chapter 2) to reduce the amount of light reaching the sensor. If you own a digital point-and-shoot camera, you may have a menu option to enable a neutral density filter. Check your camera manual to see if you have this option on your camera.

When you shoot a portrait with a lens that is the 35mm equivalent of 85mm or longer, and use your largest aperture (lowest f-stop number), you have a very shallow depth of field, especially when you're using a fast lens with a

minimum f-stop value of 2.8 or less. In fact, the depth of field is so shallow that parts of your subject's face may be slightly out of focus. When you're shooting at your lowest f-stop value, switch to a single auto-focus point (good advice any time you take pictures of people), and focus on your subject's eyes. Your viewer's attention is first drawn to the eyes, so when the eyes are in sharp focus, it gives the illusion that the entire face is in sharp focus.

Specifying an ISO setting

As noted in Chapter 3, the ISO setting determines how sensitive the camera is to light. When you increase the ISO, you run the risk of adding digital noise to your image. Whenever possible, always use the lowest ISO setting available. However, if you're creating portraits in very low light, you may end up with a shutter speed that is too slow to hand-hold the camera and still get a blur-free picture. For more information on ISO settings, see Chapter 3.

If you want to see how far you can increase the ISO and still get acceptable pictures, take some photos of a landscape with a clear blue sky. With each shot, increase the ISO to the next highest rating. After taking the pictures, download them to your computer and open them in your image-editing program. Zoom in to about 200 percent and examine the sky for evidence of noise. Note the ISO where the noise starts looking ugly and then you know you can use the next lowest ISO rating and still get acceptable pictures.

The ideal digital SLR portrait lens

Because most portrait photographers agree that 85mm is the ideal focal length for portraits, many portrait photographers purchase an 85mm prime lens with a large aperture and use it exclusively for head-and-shoulders portraits. An 85mm f/1.8 lens gives you the best of both worlds. The focal length is ideal for portraits, and the large aperture gives you a shallow depth of field, which ensures that your viewers' attention will be focused on your subject.

There are faster 85mm lenses. Canon makes an 85mm f/1.2 lens in their L series. Recently, I was talking with a Canon rep at a trade show. He says the L series lens is too sharp for portrait photography and recommends their 85mm f/1.8 for portrait photography.

Composing Your Images

Digital cameras are great for creating portraits of friends, family, and interesting people. With a digital camera, you have the ability to take a lot of pictures and store them on a memory card. And you don't have to pay for film or developing. But the point-and-shoot mentality can also be a curse. If you just point a camera at someone without thinking, and snap the shutter, you're creating a snapshot. In the following sections, I show you some time-honored methods professional photographers use to compose their images.

Composing your picture in the viewfinder

When you compose an image, your viewfinder or LCD monitor is your window to the world. When you compose a picture, you have to make a decision about what to leave in the image and what to leave out of the image. Include only enough to tell your story. Anything else is excess information and will detract from the image. Sometimes, zooming in is all you need to do to exclude unwanted elements; other times, you'll have to move or ask your subject to move.

Check the edges of the frame: Some photographers make sure their subject is composed perfectly, but they forget to look all around the viewfinder. If you're taking a picture indoors and forget to clear the breakfast table behind your subject, your photo won't be very pleasing. The same thing applies for outdoor photos. Garbage cans in the background will ruin an otherwise well-composed shot.

You can also diminish the appearance of elements within an image through use of focal length and aperture. For example, if you're shooting a portrait of a college president on location, you may want to include a recognizable element in the background. Of course, you don't want it in sharp focus. That would distract the viewer's attention from your subject. You can achieve this goal by choosing a focal length that will include both your subject and part of a building, but choose a large aperture (low f-stop number) that will blur the building so as not to detract attention from your subject.

Zoom in to fine-tune what's in the viewfinder, removing elements from your composition until you've removed one too many and your story is no longer being told. Then recompose your picture to add the element back and take your picture. The practice of what to leave in and what to leave out of the picture becomes second nature with practice. Take lots of pictures.

Some photographers attempt to say too much about a person when they take her picture. For example, when you create a portrait of a person where she works, you'll make some decisions on what items to include in your picture.

You may want to include way too much stuff on the desk in your picture in an attempt to tell your viewers everything about your subject. The visual clutter will confuse your viewers. Once you decide the most important thing about your subject, you'll know what to include in your picture. Anything else in the picture is too much information. Determine what it is you want to say about your subject and zero in on that. For example, if your subject is a photographer, you can create an effective portrait by taking a picture of him with the camera raised to his face. (See Figure 5-3.)

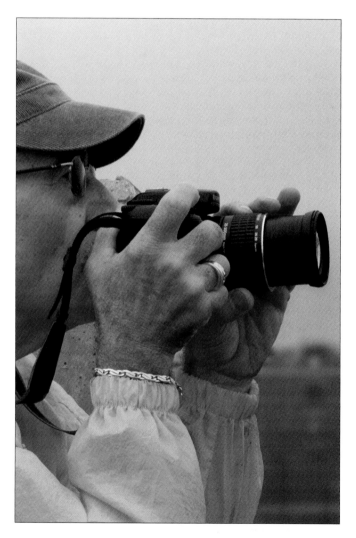

Figure 5-3: The elements in the image tell a story about your subject.

Defining the center of interest

The center of interest in a photo is the predominant feature in the image, the feature to which the viewer is first attracted. When you create an artistic portrait of a person, you determine what is important about that person, and you use your knowledge of photography and rules of composition to draw your viewer's attention to the center of interest.

It's up to you as the photographer to determine what will be the center of interest in the photo. Your knowledge of the person will help to ascertain the true essence of the person. For example, if you were photographing cellist Yo-Yo Ma, it would be appropriate to include part of a cello in the picture, even if you're shooting a head-and-shoulders portrait. Picture one of his hands around the neck of the cello, which is resting on his shoulder. Perhaps you'd want to include the bow in the picture. I envisioned this picture in my mind, but if you go to his Web site, there's almost a carbon copy of the picture I just described.

Positioning the camera

Many photographers take pictures in *landscape format,* which is an image that's wider than it is tall. However, when you're photographing a scene like a waterfall, photographing a person, or anything that's taller than it is wide, rotate the camera 90 degrees. This is known as *portrait format.* If you're photographing a group of people, take the picture in landscape format. If you're photographing one person, especially if you're creating a head-and-shoulders portrait, rotate the camera 90 degrees. (See Figure 5-4 for an example of a photo in the portrait format.)

Using the rule of thirds

You've probably seen a lot of pictures where the subject was smack-dab in the middle of the frame. Everything in that type of photo might be symmetrical — well, at least as far as the human form can be. But there's no intrigue, no mystery to the image. It's nothing more than a snapshot. Photographers commonly use the rule of thirds to define a point of interest in the image. Instead of placing the subject in the center of the frame, the photographer positions the subject so that a key feature appears at a power point within the frame. To apply the rule of thirds, imagine that your camera viewfinder is divided into three sections vertically and horizontally, as shown in Figure 5-5. A power point is where two of those sections intersect. Some digital cameras provide a grid that you can use to compose your images according to the rule of thirds.

Check your camera manual to find out how to display it. Figure 5-5 shows an image that has been composed using the rule of thirds. I've also included a grid overlay for reference. Notice how her left eye is aligned to a power point according to the rule of thirds. Your gaze is first drawn to that point of the photo.

Figure 5-4: Rotate the camera when shooting head-and-shoulders portraits.

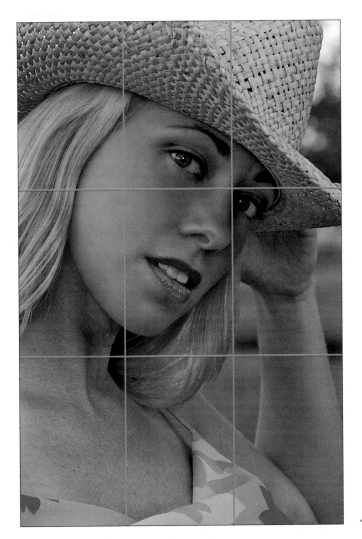

Figure 5-5: Composing an image according to the rule of thirds.

Determining point of view

The *point of view* is the vantage point from which you photograph your subject. If you're photographing an adult, you can do so from a standing position. If you photograph a child or pet, kneel to their level. It's always best if you're eye to eye with your subject. The exception to this rule is when you're photographing a short person. To make the person look taller, kneel and then take

your picture. Be careful not to tilt the camera when you're kneeling. If you do, the person may look like she's falling toward or away from you. Instead of tilting the camera, move back until your subject fills the frame without tilting the camera.

The golden ratio

The golden ratio, also known as the divine proportion, has fascinated artists and scientists since the Renaissance. The aspect ratio of the golden ratio is 1:.618. A chambered nautilus (a sea creature) is an example of the golden ratio in nature. If you imagine a nautilus shell in a rectangle whose dimensions match the golden ratio, you get an idea of how you can use this concept when composing your images. Where the shell spirals down to its smallest point, you place your center of interest. The aspect ratio of most digital cameras is 1:0.6666, or 3:2. However, you can crop an image to the golden ratio in an image-editing program. If you compose your image with the golden ratio in mind and place it in a new document with dimensions that conform to the golden ratio, you can end up with an interesting image. A program called Corel Painter has a feature, called Divine Proportion, which you can use to compose an image using the golden ratio after the fact.

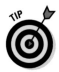

Take pictures of your subject from several different points of view. Make sure that one of them is a point of view most people would never see him from. For example, photograph a bald friend from overhead with him staring you in the eyes with a sardonic look on his face and one arched eyebrow. Yes, sometimes whimsy does have a place in photography.

Framing your subject

If you're taking a photograph outdoors, look for natural frames. You can frame your subject in a window, frame your subject with foliage, trees, and so on. Naturally, frames are everywhere you look. When you frame your subject, you draw your viewer's attention to your subject. You can even create whimsical frames by having your subject hold a picture frame around her head. Archways also make great frames. Or you might consider using an interesting door jamb to frame your subject. (See Figure 5-6.)

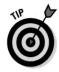

Your goal as a photographer is to capture the decisive moment that tells your story. When photographing a person on location, or when taking candid photographs, be alert and ready to act decisively, clicking the shutter when your subject does something interesting. If you miss the shot, don't be afraid to ask your subject to repeat the pose or gesture.

Placing the horizon

When you photograph people in natural surroundings, it's important not to bisect them with the horizon line. In other words, don't place the horizon smack-dab in the center of the image or your subject. If you read the "Using the rule of thirds" section, you know that in this rule of composition, the scene is divided into thirds vertically and horizontally. Look at the background in your image. If there are interesting objects such as clouds or mountains in the background, place the horizon line in the lower third of the image. If you've got an interesting seascape in the background, or a beach, place the horizon line in the upper third of the image.

Using lines and natural curves in your composition

Another element you can use for composing your photo is the simple straight line. Sometimes, the line will be an element in a location portrait. It can also be the subject's arm, her shirt collar, or a pleat in her blouse. When you notice a line that you want to use in your composition, compose the photo so that the line actually leads to a center of interest in the photo.

You can also use diagonal lines to draw your viewer into the image. If you're photographing a musician with an instrument such as a flute, ask your subject to start playing. Ask your subject to move the flute a bit until it's diagonal, and then compose the image so that your subject is aligned according to

the rule of thirds, with her left hand almost intersecting a power point. The viewer's eye will be drawn to the tip of the flute and follow the diagonal line formed by the flute to your subject (See Figure 5-7).

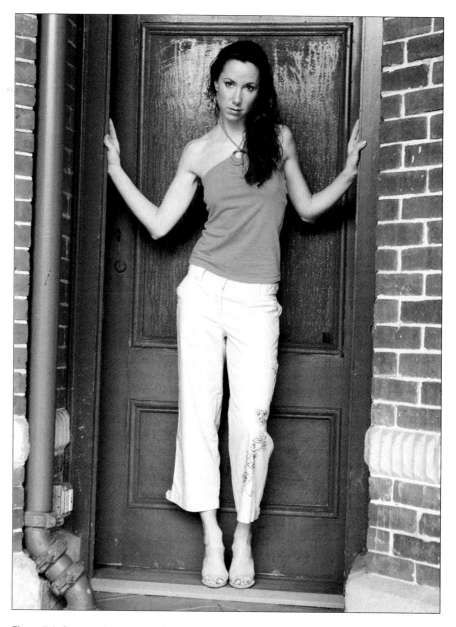

Figure 5-6: Create a frame around your subject.

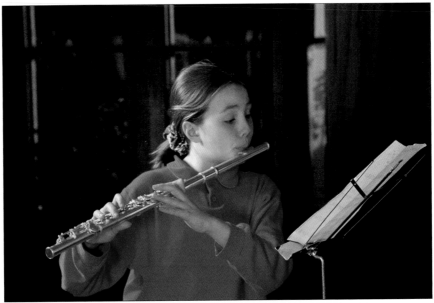

PhotoDisc, Inc.

Figure 5-7: Using a diagonal line as part of your composition.

If you're doing a location portrait, you can use lines from architectural elements to draw your viewer into the picture. A banister is an excellent way to draw your viewer up to a subject when you photograph him from a lower vantage point. You can use straight lines or diagonal lines. Your job as a photographer is to notice these elements and figure out how to use them to your advantage.

Curves are other elements you can use to create a compelling portrait. If your subject has long curly hair, you can use the curls to draw your viewer into the picture. You can also use natural curves such as the slope of a woman's shoulder, the curve from the nape of her neck, and so on. Look for naturally occurring curves and then figure a way to use them to move your viewer through the image.

If lines and curves are an integral part of your image, make sure the horizon is level. Otherwise you'll confuse your viewers.

Using color, shapes, and texture

The beauty of digital photography is the ability to capture all visible colors and minute details, such as small shapes and texture. You can use these elements when you're composing an image.

When you use color as a compositional element, you can use it to draw your viewer's eye through the photograph. If there is one predominant color in the scene, or in your subject's wardrobe, move the camera around until the elements fall into a pleasing pattern. If there's a lot of red in the scene, consider placing a red object according to the rule of thirds. Or you may try using one of the other composition rules, such as using a curve to draw your viewer into the image. If your subject has a red rose in her hair, scatter some rose petals on the table in front of her and use them to draw your viewer's eye to your subject and then the rose.

Make sure the colors in the image work well together. The colors should harmonize with your subject's wardrobe. If they don't, you can change them in some image-editing applications. Another option is to convert the image to black and white in your image-editing application.

If there are similar shapes in a scene, you can use these to compose your picture. Sometimes, you have to look hard to see shapes in the viewfinder, but with a bit of concentration, you'll find them. Your subject's eyes are round. Perhaps she's wearing large hoop earrings. Then you have two more circles. Is she wearing a ring with a round stone in it? There's another circle. Once you notice the shapes in the viewfinder, you can use them to compose the image. Change your vantage point until you see the elements are aligned in a pleasing manner. You may also have to ask your subject to move in order for the image to come together as you envision it.

Shapes are geometric forms. If you look closely in the viewfinder, you may find geometry. Perhaps you can compose the image to arrange the shapes in a geometric form. Consider Figure 5-8. The earrings, rose, and her lips form a triangle. The color red is also repeated three times in the image. The triangle and the color lead your eyes through the image.

When adding objects to a scene, it's always better to go with an odd number. Three objects look better than four, five better than six, and so on. But remember not to add too many objects to a scene to avoid visual clutter.

Using selective focus

If you use a lens with a large aperture, you can selectively focus on one part of the image, and the rest of the image will be soft. You can use selective focus when you want to draw the viewer's attention to a specific part of the image. For example, if you're creating a portrait of a person playing a violin, you can use selective focus to draw attention to her face. If you use a focal length that's the 35mm equivalent of 85mm, her hand closest to the camera will be softly focused, but still recognizable. (See Figure 5-9.) Notice that the hand closest to the camera intersects a power point according to the rule of thirds. The bow adds an interesting diagonal element as well.

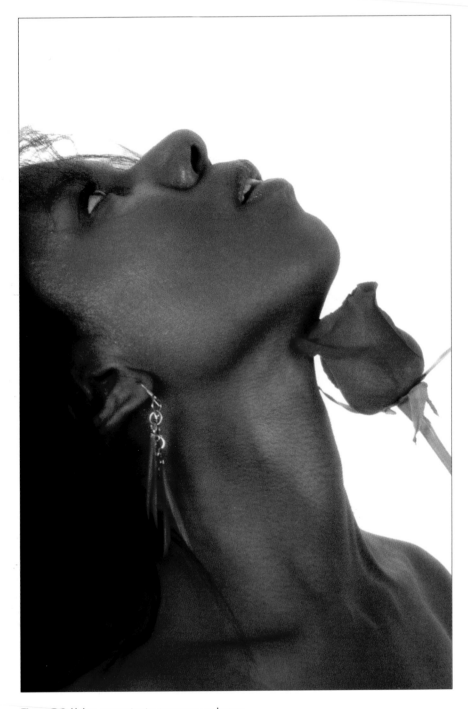

Figure 5-8: Using geometry to compose an image.

PhotoDisc, Inc.

Figure 5-9: Using selective focus to draw attention to a specific part of the image.

If you're not focusing on something your subject is holding, focus on your subject's eyes. The rest of the image can go soft, but if the eyes aren't in sharp focus, the entire image appears to be out of focus. Even out-of-focus details add to an image. The colors, textures, and shapes of out-of-focus objects marry your subject to the place.

Breaking the rules

There are many rules of composition in photography, which I cover in previous sections. However, sometimes you can break the rules and create a more compelling photograph. When should you break the rules? When you examine a scene through the viewfinder or LCD monitor and decide that you'll get a better photograph if you don't stick to the rules. For example, sometimes it makes sense to center your subject in an image, as shown in Figure 5-10. But notice that even though the part in her hair and her nose are centered vertically in the image, the reverse S-curve her hair forms on the right side of the image gives you a road map to the center of attention: her eyes.

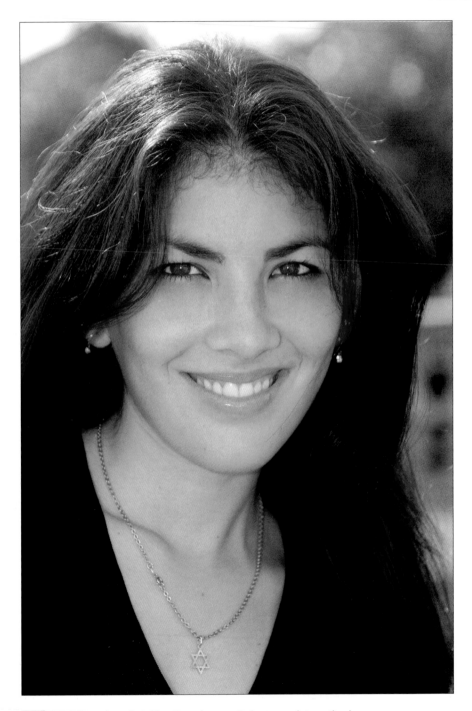

Figure 5-10: Sometimes breaking the rules results in a more interesting image.

Here are some other rules you can break:

- **Maintain a level horizon line.** Sometimes, you can tilt the camera diagonally and get an interesting picture. For example, if you take a picture of a cheerleader lying on the grass with her pom-poms, tilt the camera diagonally and compose the picture so that her feet are in the lower-left corner of the image, and her head is in the upper-right corner of the image. Figure 5-11 shows a wildlife portrait of a young alligator. I photographed him once with the log running parallel to the bottom of the image. After reviewing the image on my LCD monitor, I decided to take another picture with the log and alligator diagonally, which resulted in a more natural and interesting photograph.

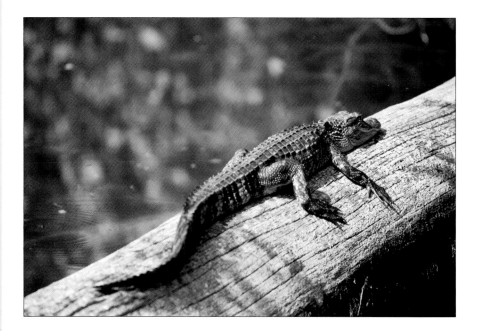

Figure 5-11: Break the rules to get a better picture.

- **Use a telephoto lens.** Try using a wide-angle lens for an environmental portrait. For example, you can use a wide-angle lens instead of a telephoto lens when creating a portrait of a child in a playground to emphasize his size in relationship to the environment.

- **Shoot from the optimal vantage point.** Instead of sticking to the tried-and-true dogma of photographing your subjects at eye level, experiment with shooting from an unusual vantage point. For example, you can photograph your child or pet from high above and have them look at you. Or try the opposite and photograph a very tall person from a low vantage point.

The latter technique really makes body builders look quite intimidating. Another alternative is to stand on a ladder and have your subject look up at you.

- ✔ **Take a head-and-shoulders portrait in portrait format.** If your subject has long, flowing hair and you've got a stiff breeze, don't rotate the camera 90 degrees as you normally would. Using the landscape format, compose the image with your subject's face on the side of the image facing the wind. Her hair will stream away from the wind, giving you a unique portrait.

- ✔ **Leave room for your subject to look into.** When you photograph someone looking pensively into the distance, you generally leave some space for him to look into. For a different effect, zoom in tight filling the frame with your subject's face. This is also known as an *extreme close-up*.

- ✔ **Have one central point of interest.** When you photograph a person, you've typically got one center of interest. In most cases, it's your subject, or something your subject is holding. However, you can have more than one center of interest in a portrait. For example, if you're photographing an attorney at his desk, you can strategically place a picture of his family according to the rule of thirds. Each center of interest lies on one of those power points on the rule-of-thirds grid. Having more than one center of interest gives your viewers more information about your subject. In the case of the attorney, the picture on the desk shows viewers and potential clients he's a family man.

Feeding your creative muse

Great photographs are made by creative photographers who stretch the envelope. You can enhance your creativity by trying new things. Schedule a time each week when you experiment with new techniques or new equipment. Julia Cameron, author of *The Artist's Way* (Tarcher), calls this an "artist's date." When I do this, I limit myself to one or two lenses and I often visit familiar territory with someone I've photographed before. When you photograph a person you know well at a familiar place, and the goal is to enhance your creativity, you do things differently. Shoot from a different vantage point and use a different lens than you'd normally use for the subject. Photograph your subject against a backdrop you've never photographed him against before.

Great photos always inspire me to get out the camera and take some pictures. Great photos can also help you become more creative. When you see a really great photo, dissect the image and try to figure out what the photographer did to make it so compelling. Was it an in-camera technique, or did the photographer do some editing after the fact to make the image pop? There are lots of places on the Internet where you can find great photos. One of my favorite places is www.photo.net. At this Web site, you'll find many types of inspirational photographs, from portraits to drop-dead gorgeous landscapes.

You can even join www.photo.net and upload your own images. Next time you need something to spark your creativity, look at some great photographs.

You can enhance your creativity while you're taking pictures. Stretching the envelope is a wonderful way to create interesting photographs. When you're photographing a friend, cut to the chase and simplify the scene to its lowest common denominator. A great way to do this is to use a large aperture (low f-stop number) and focus your camera on the most important part of the scene. Or you can compose your picture so the viewer's eye is drawn to a single element in the image.

Do you have favorite places or things you like to photograph? Explore your favorite subject and create a theme of photographs. For example, if you're a cat lover, photograph your cat and then photograph the neighborhood cats. When you photograph the same subjects or places frequently, you think of new ways to create interesting pictures. Your creative juices start flowing, and before you know it, you learn to see your favorite subject in a different way. I love landscapes and photographing friends and relatives in beautiful scenery. My main goal is to create a compelling portrait, but I use the scenery to frame my subjects, or to provide a colorful out-of-focus backdrop that enhances the portrait.

Practice makes perfect

If you're not an experienced photographer or haven't dabbled in the graphic arts, composition may be a bit daunting at first. Here's where the old adage of practice makes perfect comes into play. The first step is to master your camera. After you master your camera, you no longer have to think about which settings to use. When you take someone's picture, you react instinctively, dial in the right settings, and take the picture before the moment is gone. The next step is mastering the art of portrait photography.

Bug your friends, neighbors, and loved ones for photo sessions. Make composition a priority during your first photo shoots. Consciously look for elements you can use in your composition. Approach each photo shoot as a new opportunity to master the art of composing photographs. When you consciously think about composition, you may miss some other important factors. But you will slowly but surely master the rules of composition.

Consciously work on mastering one rule of composition for three or four photo shoots, then move on to the next rule you want to master. After a while, you'll recognize the elements in your viewfinder that you can use to create compelling portraits. You'll know how to compose the image instinctively because of your practice. You'll know which rule of composition is ideally suited for the picture. You'll also know when to break the rules to achieve the image you have in your mind's eye. But before you can break the rules, you've got to master them.

6

Working with Your Subjects

If you really get into portrait photography, you end up photographing a broad spectrum of humans, from bawling babies to crotchety spinsters. Each subject has his own quirks, and each age group has its own special quirks. In addition to working with a wide and diverse group of subjects, you also have to concern yourself with wardrobe suggestions and, perhaps, makeup. You can also use props in your photos. So much to think about. And then there's the subject of photographing people with their pets or pets without their people. If you live close to wildlife, you've got yet another great subject for pictures. In this chapter, I share some techniques for photographing the wide spectrum from children to wildlife.

Photographing Children

Kids do the darnedest things. It's your job as a photographer to capture the antics, quirks and foibles of children digitally. But kids come in all shapes and sizes, from diapered babies to adolescents. Some kids have the attention span of a flea. Young children have a tendency to be very active, running, jumping, and playing games. And you, the fleet-footed photographer, are responsible for capturing digital portraits of them.

Photographing babies

Photographing babies can be tricky, especially newborns. They're immobile and sleep for long periods of time. When they do wake, they're not the happiest campers on the block, either. They tend to cry, which, combined with laughter, is the only communication they know. If you're photographing a friend or relative's baby, you're invited into the home for an hour or so, and you capture cute pictures of the baby. Here are some tips for creating portraits of a baby:

- **Get to their level.** Most newborns are swaddled or in diapers. You'll have to get to their level to get pictures of the baby's beautiful eyes looking at you. Instead of crawling on the floor, create a pile of neatly folded large white towels on a table. Place the baby on top of the towels. You can use the top towel to move the baby to a different position if your camera is mounted on a tripod and you're using fixed lighting.

- **Use a backdrop.** Hang a clean white sheet on the wall behind the table on which you'll photograph the child. Make sure the table on which you're photographing the infant is a few feet away from the backdrop.

- **Use props.** Swaddle the newborn so you can see only her face, eyes, and perhaps a hand. If you're not comfortable posing the baby, ask her parent for assistance. You can then place a prop, such as a freshly cut red rose, or perhaps a pacifier, next to the infant. You'll get a more interesting picture if you use a colorful prop that adds contrast to the image.

- **Take close-up shots.** Back away from the child and then zoom in. This will give you a pleasing close-up of the child's cherubic face.

- **Go macro.** If your camera has a macro mode or you use a digital SLR and have a macro lens, take pictures of the newborn's tiny hands, feet, and ears. Another interesting close-up is the child's tiny hand grabbing his father's finger. For a contrast of new and old, take a picture of the baby's hand grabbing one of his grandparent's fingers.

- **Take a sequence of images.** Newborns make subtle movements when they change position. (See Figure 6-1.) If you take a single shot, you may miss something interesting. Switch your camera to continuous shooting (burst) mode, and press the shutter button when the baby starts moving. You'll have a wonderful sequence of images from which to choose. You can also combine these images to make a slide show, or use your image-editing application to create a document that is a collage of the best shots.

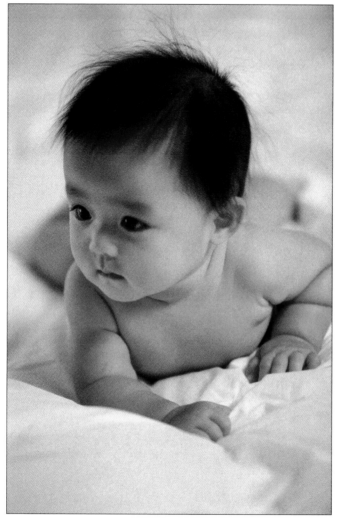

Purestock

Figure 6-1:Take a sequence of shots of a baby in motion.

If you're a parent who's had a recent addition to the family, photography of your newborn takes on a whole different meaning. In addition to creating portraits for friends and family, you're also the family historian, capturing

images of your child for posterity. Documenting the first few weeks of your newborn's life provides wonderful memories for the rest of your life, and your child's life. When you document your child's life, think like a photojournalist and always have a camera close at hand. Here are a few things to consider when creating a photo journal of your child's earliest days:

- ✒ **Capture the special moments.** Document your child's arrival at your home, and take other pictures, such as the child's first bath, your child being nursed, and so on.

- ✒ **Photograph the happy moments.** Infants spend a lot of their time crying, soiling their diapers, throwing tantrums, and so on. Make sure you've got your camera ready to capture the moments when he's a happy camper, such as when your spouse plays with your baby, the moment after he's been fed, when one of the other children in the family or the family pet interact with the baby, and so on.

- ✒ **Take pictures of the special moments.** Your baby will be fairly predictable. After you know your baby's routine, keep the camera handy to capture the special moments when she does something cute, funny, obnoxious, and anything else you think should be documented.

- ✒ **Document the changes.** Your baby changes from week to week as he starts to learn how to interact with his world. The changes can be fascinating to watch. If you take pictures of your baby's first days and neglect to take pictures for several weeks, you'll miss an important part of your child's development. You may not see the changes from day to day, but when you compare pictures of your child when he's a few days old to pictures of him when he's six weeks old, you'll be amazed at the changes that have taken place.

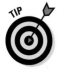

Never use direct flash when photographing babies. The sudden burst of light will scare them. Always use indirect lighting for your baby portraits or bounce the flash off a wall or ceiling. For more information on lighting, check out Chapter 7.

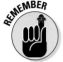

When you shoot portraits of babies, choose a focal length that is the 35mm equivalent of 85mm and choose a large aperture (low f-stop number), which will create a soft blurry background. Make sure you focus on the child's eyes.

Photographing young children

Young children are very active. It's difficult to get one to slow down long enough to get a formal portrait. However, you can get wonderful candid shots of kids playing with other children, or interacting with pets. In fact, the best time to photograph children is when they're doing something they enjoy. Here are some things to consider when photographing children:

- **Photograph at eye level.** Unless you're trying for a special effect, you should always crouch down and photograph children at eye level.

- **Get some help.** If you're photographing a child you don't know, ask the parents for assistance. In fact, when you ask for assistance, ask the child's mother to be in the frame and you'll get a wonderful mother and child portrait. If the child doesn't know you, having her picture taken with her mother may put her at ease.

- **Shoot in continuous mode.** When you're photographing children at play, switch your camera to continuous or burst mode. When something interesting starts happening, press the shutter button and hold it down to take a series of pictures.

- **Switch to continuous focus mode.** When you photograph children at play using this mode, the camera locks focus when you press the shutter button halfway. As the child moves in the frame, the camera changes focus.

- **Shoot with a wide-angle focal length.** Normally, you shoot portraits with a telephoto lens. However, you can create a compelling environmental portrait of your child in the playground using a wide-angle focal length. When you use this technique, don't fill the frame with your child. Include the environment in which the child is playing.

- **Get the child to laugh.** Sometimes you've got to act like a kid to bring out the best in a kid. Laugh or make a funny face. If that doesn't work, get the child's parent to laugh or make a funny face.

- **Anticipate emotion.** Children go at their own paces. Sometimes children are bored; other times they get excited really quickly. Be ready to take one or more pictures when you see the child's mood start to change.

- **Include friends in the picture.** Take a picture of your subject with his best friend, who may be another kid, or his favorite toy.

- **Remember the details.** You can get interesting pictures of children by photographing details such as the child's hand as she tries to lace her shoe, or the child hugging her teddy bear. You can use a macro lens for small details like the child's tiny fingers fumbling with shoe laces.

- **Use a zoom lens.** Some children are camera shy. If you run into an elusive child, step back and then zoom in on the child. Have someone who isn't in the frame interact with the child. The child may not be looking at the camera, but you'll get better pictures than if you try to coax the camera-shy child into looking at the camera and smiling.

- **Switch to Shutter Priority mode.** If the child is moving quickly, switch to Shutter Priority mode and use a shutter speed of 1/125 of a second or faster. This freezes the child's motion. If you're not comfortable manually setting the shutter speed, switch to Sports shooting mode. (See Figure 6-2.)

✔ **Play Simon Says.** If you know the child well, play a game of Simon Says with him. When you see a pose you like, say, "Simon says, 'stop'." When the child stops, press the shutter button.

There are a million ways to create interesting photographs of children. Whether your goal is to capture a formal portrait of the child, or an environmental portrait of the child at play, the key is to stay focused and be ready for anything once the child is in front of your camera.

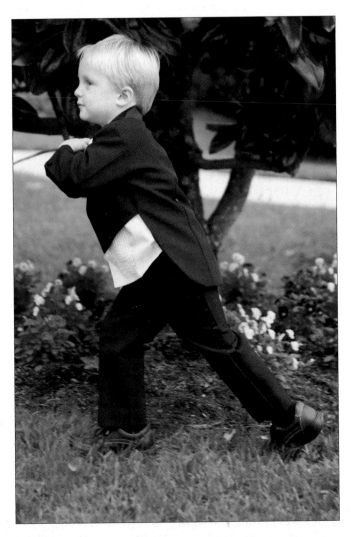

Figure 6-2: Switch to Shutter Priority mode when photographing a child at play.

 Remember your rules of composition. You almost always get a better picture if you follow one of the rules of composition instead of centering your subject in the viewfinder.

Creating Portraits of Couples

When you photograph a couple, your goal is to capture the bond between the couple, their love and intimacy. When you create a photo of a couple who know each other well and are romantically involved, it's similar to the engagement shoot that many wedding photographers do. Here are some tips for photographing couples:

- Make sure they're close to each other. If the couple has a romantic relationship, ask them to hug or ask the man to put his arm around the woman.

- Make sure there is little or no space between their heads. (See Figure 6-3.)

- Get your couple to start talking and keep your eye on the viewfinder or LCD monitor. When they start relaxing and laughing, start taking pictures.

- Put on some music and ask the couple to start dancing.

- Ask them to look at each other.

- Photograph the couple doing something, such as looking at a laptop computer or preparing a meal.

- If you know the couple well, you know what they like to do together. Photograph them doing their favorite pastime. Even a game like tennis holds possibilities for interesting photos of a couple. You can photograph them walking to the court with their rackets over the shoulders while talking.

- Take a close-up of the couple holding hands.

- If you're photographing the couple outdoors in a setting like a park, ask them to sit back to back. Use a wide-angle focal length to create an environmental portrait of the couple and their surroundings.

- Photograph the couple holding a glass of wine and toasting each other; then zoom in for a close-up of their hands and the wine glasses.

- Photograph them from behind, in silhouette, holding hands walking away from the camera.

These are just a few ideas to get your creative juices flowing. The opportunities for creating wonderful photos of a couple are limited only by your imagination. Your goal is to create a photo that tells the viewer something about the couple. This is not just a snapshot. Put your own creative spin on one or more of the items in the previous list and create beautiful portraits your friends will cherish forever.

After you take a picture, review it to make sure you've captured the moment. Zoom in and review the image carefully to make sure they're both smiling, and that nobody's blinking.

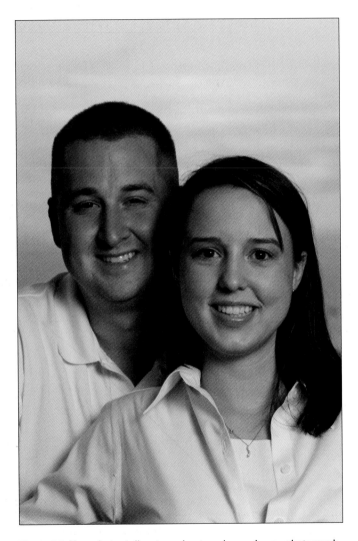

Figure 6-3: Your photos tell a story about each couple you photograph.

When you begin a photo shoot, get your subjects to relax and laugh. Tell them that the area in front of your camera is a no-blink zone.

Photographing Groups

Photographing a group presents a different challenge. Even if it's a family, you still have a diverse range of subjects ranging from young tykes to grandparents. Add the different heights to the equation and you've got an interesting challenge on your hands. Here are some things to consider when you're photographing a group of people:

- Avoid the police-lineup look, where you've got the shortest in the front, tallest in the back, and they're all shoulder to shoulder.

- If you're in a natural setting such as a park, get the youngest members of the group to sit on the ground, or in the lap of an adult sitting on the ground. Another possibility is to have the youngsters lie on their stomachs with their hands holding up their heads. You might even consider having the tallest member of the group lie horizontally propped up on one elbow, with other members of the group standing or kneeling behind him.

- Ask everyone to move in close and touch faces. Take a picture of the group from above. Compose your picture and ask the group to look at you and smile.

- Photograph the group doing something together. But if you photograph them enjoying a meal together, make sure you don't take pictures that show a group member with a mouth full of food. If you accidentally take one, delete it immediately.

- If one member of the group is heavier than the others, sandwich him between and behind two thin people. Make sure you can see his face clearly and he's not in shadow.

- Ask the group to lie on the floor like they're spokes on a wheel. Take the picture from overhead and zoom in on their faces.

- Group shots are more interesting if you have an odd number of people in the group.

- Photograph the group from above and have them look up at you. (See Figure 6-4.)

When you photograph a group of people that are two or more rows deep, you want everybody to be in focus. The best way to achieve this goal is to shoot in Aperture Priority mode and choose an f-stop of f/5.6 or greater. However, every rule is meant to be broken. If you want to draw your viewer's attention to one member of a group, choose an f-stop of f/4.0 or lower. For example, in a family portrait, you may want to focus the viewer's attention on the grandparents. Place them in front of the rest of the group, choose a large aperture, focus on them, and take the picture. After you take the picture, review it on your LCD monitor before taking the next shot. If the other family members are too out of focus, increase the f-stop to the next highest number and take the picture again.

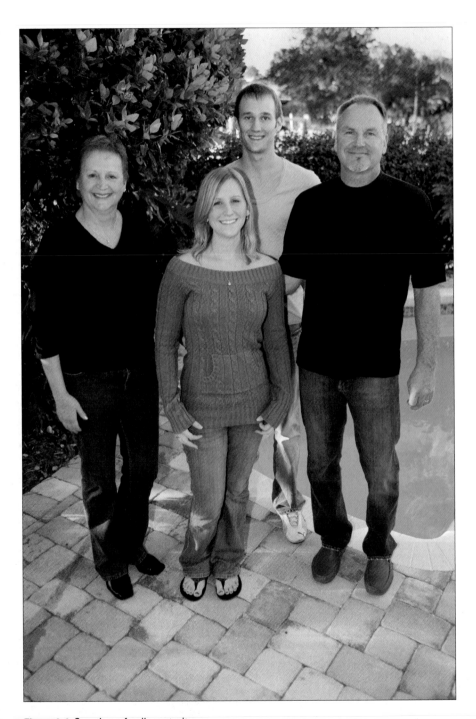

Figure 6-4: Creating a family portrait.

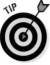 Review each photo immediately to make sure everyone is looking at the camera and everyone is smiling. Also check to make sure no one is blinking. If you're photographing a group at a once-in-a-lifetime event, such as your parent's 50th wedding anniversary, you won't get a second chance.

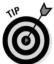 If you have a hard time capturing a picture where everybody has their eyes open, tell your subjects to close their eyes and open them and smile at the count of three. Count to three and press the shutter button.

Choosing Wardrobe

When you're creating a portrait, the emphasis is on your subject, not the clothes she's wearing. Tell your subject to avoid bringing clothes with bright colors or patterns that will detract from her face. She should bring a wardrobe with complimentary colors. Black and white colors are always good choices because they blend with most backgrounds. You can also try burgundy, dark browns, greens, or blues. Blondes look good in navy blue or black clothing. Avoid colors like beige or pink, as these colors can alter skin tones. Your goal is draw attention to your subject's face.

When you're photographing people with dark colored skin, ask them not to wear bright colors. Dark blue and black clothes work well when photographing people with dark skin. Get the lighting right to draw attention to your subject's face.

Long sleeves are generally the best choice unless you're capturing candid shots or photographing people at the beach. V-neck collars accentuate a woman's figure better than round or turtleneck collars.

 Avoid baggy clothes because they make your subjects look bigger. Ask your subjects to wear clothing that fits them well and isn't too tight or skimpy.

Ask your subject to iron her outfit before the shoot. It's also a good idea to have her change into the outfit you'll be photographing her in when she gets to the shoot location. If you're taking the pictures in a public place, make sure there's a clean restroom nearby where she can change her clothes. This is also useful if you're photographing her in more than one outfit.

If you're photographing a group, make sure group members have similar styles so that they look like they belong together. If you're taking a full-length portrait, make sure they have socks and shoes, although children can go barefoot. Of course, if you are photographing a group on the beach, everyone can be barefoot or wear flip-flops.

Women should keep jewelry to a minimum. A simple necklace, earrings, and the rings she usually wears is more than enough. If you notice that any of the jewelry draws attention away from your subject's face, ask her to remove it. If she does wear a necklace with a pendant, make sure it's properly aligned before taking the picture.

Ask your subjects not to wear trendy clothing, as it dates the photo when the clothing goes out of style. Casual, timeless outfits are always the best bet.

Keep a lint roller with your portrait photography equipment. You can use this to perform spot maintenance on your subject's clothing.

Using Makeup

Unless you can afford a professional makeup artist, your best bet is to go with little or no makeup. Or course, this depends on your subject. If you're photographing a man with oily skin, use a little powder to diminish the sheen and even out his skin tone. If you're photographing a woman, ask her to apply some powder and light eye makeup. Ask her to use a bit more lipstick and blush than normal so that it shows up better in the resulting portrait.

If your subject is getting her hair styled for the portrait, ask her to do it two weeks prior to the session. If you're photographing a man, ask him to shave before the session and trim his sideburns. Men's facial hair grows quickly. It's not uncommon for a man with dark hair to sprout a five o' clock shadow before noon. If he has a moustache or beard, ask him to trim it before the session.

Visit your local beauty supply store and purchase a few neutral tones of powder and a makeup brush. Take your makeup kit along to a portrait shoot for when your subject needs a quick touch-up.

Posing Your Subject

After applying makeup and tidying the wardrobe, you're ready to begin your portrait session. If your subject isn't a professional model, or isn't used to being in front of the camera, you're going to have to tell him what to do. The first step is gaining rapport, as outlined in Chapter 4. When your subject starts to relax, you're ready to click the shutter. Now it's your job to show him how to pose so that you make him look mahvelous. Here are some things to consider to get a compelling portrait of your subject:

✔ **Shoulders:** In many cases, your subject's shoulders should not be level. A high shoulder and low shoulder add interest to the image. The alternative is to have your subject square his shoulders to the camera. This implies strength and works well with portraits of young men, especially if you shoot from below, looking up at your subject. If he has a slim waist, you'll see get a nice triangular shape from the pelvis to his shoulders.

✔ **Head:** If your subject tips his head back, you'll get a casual portrait with a "punk" look. This works well for young men. If your subject is standing sideways to the camera and gently turns her head toward the camera, this gives her an elegant look. If your subject is older and has sagging skin on her neck, have her tilt her head up to diminish the appearance of the wrinkles and then turn her head toward the camera. If your subject is a young woman, have her tilt her head to the high shoulder, which gives her a flirtatious look. Have a man tilt his head toward the low shoulder to impart a feeling of power. This works well when you shoot from a lower position, looking up at your subject.

✔ **Joints:** Have your subject bend her wrist and elbow to create a graceful pose. A rigid arm and wrist imply rigidity, something you should avoid at all costs. Make sure the bends are graceful and natural looking.

✔ **Arms:** Have your subject bend his arms slightly to impart a casual, at-ease feeling. If your subject straightens his arms, this implies rigidity and should be avoided at all costs. When you're composing the portrait through your viewfinder, make sure the angle of the arms doesn't look unnatural, and make sure the arms aren't bent the wrong way. You're creating a portrait, not a poster of a circus contortionist.

✔ **Hands:** A woman's fingers should be extended so they look long and elegant. A man's fists should be lightly clenched like he's holding a small rock. You can also give your subjects something to hold, something that they use in their work or hobby.

✔ **Hips:** If your subject is facing the camera sideways, have her tilt her hips forward for a slimming effect.

✔ **Legs:** If your subject is a man, have him face the camera with legs spread shoulder-width apart to show a feeling of strength. If your subject faces the camera sideways, one leg should support the body weight and the other leg should be bent gracefully.

✔ **Feet:** Feet that are shoulder-width apart impart a feeling of strength and solidity. You can also have your subject place one foot on an object such as a wall or a step to add interest to the composition.

Where is your subject looking?

When you take someone's picture, the area into which he's looking tells a story, even more so when you photograph two people. For example, if you're photographing a couple looking at each other, that implies a relationship. If they're looking away from each other, that implies a difference of opinion or disharmony. If your subject is holding something and looking at the camera, this implies an invitation, and your subject is the center of attention. If your subject is holding something, and looking at the object, the object then becomes the center of attention. If your subject is looking out of the frame, this implies a sense of mystery: What is he looking at? If the subject is looking toward the camera, she is definitely your center of interest. If the subject is looking at the camera with an intense look on his face, it's a very strong pose which implies tension.

Getting the body parts right is part of the puzzle. Putting it all together to get an artistic pose can be a bit more challenging. Here are some poses you can try:

- **Pose 1:** Have your subject stand with feet shoulder-width apart. Have him place his hands on his hips, or hook one thumb in his front pocket. Kneel when you take a picture using this pose and your subject will look powerful and confident. Smile is optional.

- **Pose 2:** Have your subject lean against a wall and rest one foot on the wall. Have her put one hand in her pocket, or rest it on her hip.

- **Pose 3:** Have your subject sit in a chair or on a step that's almost at a right angle to the camera with one leg slightly bent at the knee. Have her look toward the camera but not all the way, with her head slightly tilted up.

If your subject has a large nose, have him tilt his chin and make sure his nose is pointed straight at the camera.

Using Props

When you add a prop to a portrait, you add another layer to the story, telling viewers more about your subject. Props can run the gamut from your subject's favorite object or memento to the musical instrument he plays. A prop can be subtle or in-your-face. For example, if your subject is a pipe smoker, take a picture of him tamping the tobacco with an ornate tamper. If your subject is a cello player, place your subject behind the cello with the neck over one shoulder and the bow in his hand.

If you're creating an environmental portrait, you'll have natural props all over the place. You'll have to weed out the props that don't really belong in the picture and limit yourself to a few that help tell your story. For example, if you're creating an environment portrait of a woodworker in his study, a photograph of him holding a chisel over his latest work in progress while intently deciding where to use it will create a compelling photo to which everyone can relate.

Other props to consider are tools used by the person you're photographing. If you're photographing a business person, take a picture of her with her laptop while talking on her cell phone, as I did in Figure 6-5. If you're photographing a firefighter, take a picture of him holding an axe.

Props are also great when you're creating portraits of children. The prop keeps the child occupied while you take pictures. The prop should be something the child loves, something with which viewers of the photograph can identify.

Photographing People with Pets

People who have pets think of them as members of the family. So it's no wonder that every pet wants a portrait of himself with his human. When you photograph a pet and his owner, you want to show viewers the bond between the pet and its owner. This is easy to do when you're photographing a dog and his owner, as shown in Figure 6-6, but cats can be more elusive. No matter what type of pet you're photographing, you're going to have to rely on the owner for assistance.

If the pet is small, take a picture of the owner holding her pet. If the pet is large, ask the owner to have the pet come to her side. Dogs will generally give you something that looks like a smile. Use your rapport techniques to loosen up the owner and get her to smile, too. Take as many pictures as you can when the pet isn't fidgeting. It's also a good idea to switch your camera to continuous shooting (burst) mode to take several pictures quickly. Press the shutter button when the owner starts interacting with her pet. You may get a picture of the dog plastering a big wet kiss on his human.

Photographing Pets

Photographing pets without their owners is definitely a challenge, especially if they don't know you. Here's another case where you'll have to rely on the pet's owner for assistance. That is, of course, unless you're photographing a cat. When you photograph a cat, you're definitely on your own.

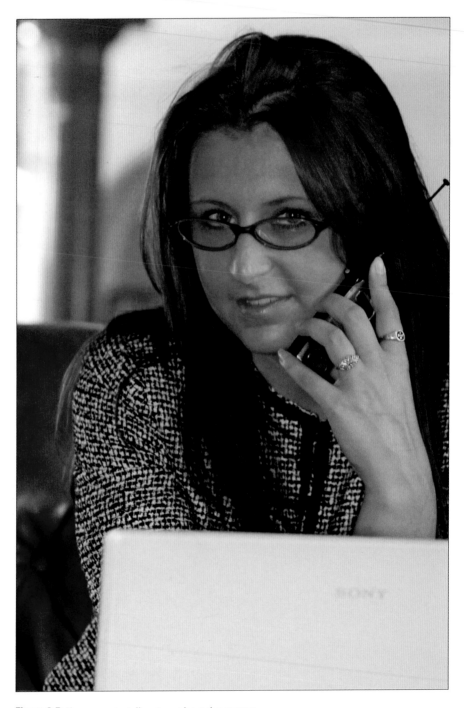

Figure 6-5: Use props to tell a story about the person.

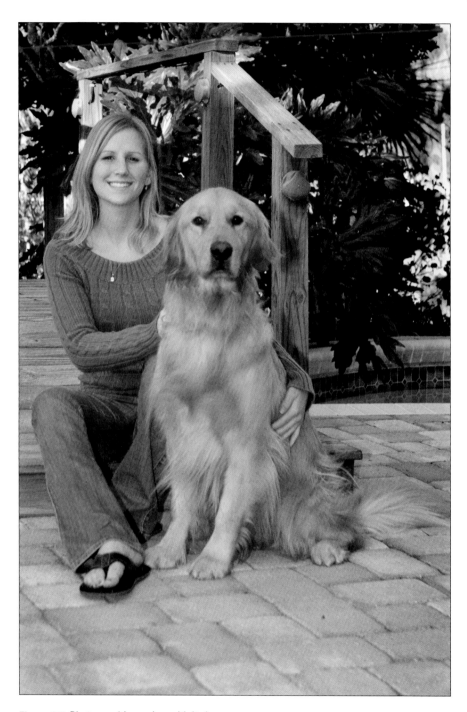

Figure 6-6: Photographing a dog with its human.

Creating formal pet portraits

You can create some wonderful portraits of your pet with your digital camera. Many of the same composition rules apply when you create a formal portrait of your pet. Your goal is to create an interesting composition that tells a story about your family friend. Formal portraits work best if your pet is trained. You can tell your pet to sit, shake hands, and whatever other stupid pet tricks you've taught him. It also helps if your pet is used to seeing you with a camera pointed at him. You may have to try several attempts before getting the photos you want. If you're photographing someone else's pet, have the owner stand beside you so she can tell the pet what to do. If you have the pet's favorite treat handy, you'll have a captive audience. That is, unless you're trying to photograph a cat. They live in their own world and definitely have their own agenda. Trying to get a cat to do anything on command may prove fruitless. If your subject is a cat, fast forward to the section on candid pet portraits. When creating a formal portrait of your pet, consider the following:

- **Consider the background.** If you're photographing a pet with dark hair against a dark background, your pet may be hard to distinguish. Choose a background that isn't busy and contrasts well with your pet's colors. If you're shooting indoors, you can use a bed sheet as an impromptu background.

- **Don't use on-camera flash.** When the flash fires, it may frighten your pet. You'll also get the pet equivalent of red-eye, which looks more look glowing demon eyes. Your best bet for illuminating a pet is to use soft, indirect window light. If you do need to use flash, bounce it off a ceiling or wall.

- **Shoot from the animal's level.** Your pet's eyes should be at camera level.

- **Zoom in.** Back away from your pet and zoom in. Choose a focal length that's the 35mm equivalent of 85mm or higher. You can include your entire pet in the image, or zoom in tight for a whimsical face shot of your smiling pooch.

- **Shoot close-ups first.** If you're taking a picture of your pet in his environment, take the close-up shots first and then back up to capture more of the surrounding environment. If you shoot the environment portraits first, the pet may lose interest and wander off. Get the good stuff first while you've got Fido's undivided attention. If necessary, a couple of treats will keep your subject interested.

- **Switch to Aperture Priority mode.** Whether you're photographing your pet indoors or outdoors, you don't want the background to be sharp and draw the viewer's attention away from your pet. Choose a small f-stop number to limit the depth of field.

✔ **Focus on the eyes.** When you choose a large aperture (small f-stop number) combined with a telephoto lens, your depth of field is extremely limited, and part of your pet may not be in sharp focus, especially if your pet is large. Therefore, it's important that the eyes be in sharp focus. After all, the eyes are the windows to the soul, even with a pet.

Creating candid pet photos

Dogs are very active critters. Cats can be active when it suits them. If your pet isn't trained, candid photos are your best bet. You can get some great pictures of your pet playing with her favorite toy. If you've got a really athletic dog who loves to fetch a Frisbee, you've got everything you need for a great series of candid photos. Here are a couple of suggestions for capturing great candid photos of your pet:

✔ **Be ready.** Have a camera nearby at all times. You never know when your pet will do something funny or interesting. I own a cat named Niki, who is also known as "Queen of the Universe." She stares out the window with Zen-like focus waiting for squirrels to run by. I've taken some great photos of her, just by being ready.

✔ **Choose the right shooting mode.** If you're photographing a pet looking out the window, switch to Aperture Priority mode and choose a large aperture (small f-stop number) to blur the background and draw attention to your pet. If you're photographing an active pet, switch to Shutter Priority mode and choose a shutter speed fast enough to stop the action.

To accentuate the motion of your pet, switch to a slow shutter speed of about 1/30 of a second. Have someone toss a ball so that it travels across the frame from left to right. Zoom in on your pet and pan the camera to keep your pet in the frame. Press the shutter button and continue to pan. You'll get a wonderful picture with your pet's head in sharp focus, but the legs will be a blur. When you pan the camera, make sure your hands are cradling the lens and your feet are spread shoulder-width apart to create a stable platform.

✔ **Switch to continuous shooting (burst) mode:** This mode enables you to take a sequence of pictures as long as the shutter button is depressed. This is a wonderful way to capture a series of images of your pet doing something like jumping up to catch a Frisbee in mid-air.

Photographing your pet can be a lot of fun. After you've had a pet for a while, you know her routine, and you can be ready when she does something cute or interesting. My cat sits by her food bowl and begs for a handout whenever she sees me pick up the camera bag or change my clothes, and sometimes she just finds a ray of sunshine and contemplates whatever cats contemplate when they stare out a window. I take opportunities like these to capture some new photos of my buddy. (See Figure 6-7.)

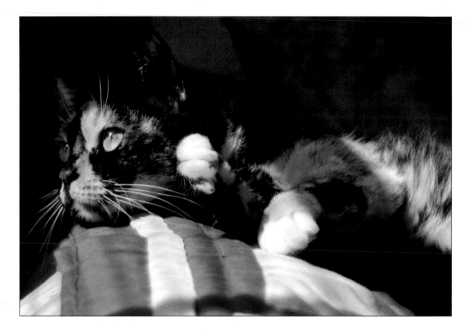

Figure 6-7: Cats are great subjects for candid photos.

If you have children, you can create some great images of the family pet playing and interacting with the kids. When you see your pet getting playful with your children, pick up your camera and get ready to shoot. This is another time when it makes sense to switch to continuous shooting (burst) mode.

7

Lighting Your Portraits

*W*hen you create a portrait, lighting is everything. With the right light, you reveal all of the character and warmth of your subject. Lighting isn't rocket science, but you do have to take advantage of what nature has dealt you and modify or augment the light source with flash or other devices. In this chapter, I show you how to work with camera flash and natural light sources, and how to modify both.

Understanding Light Sources

The source and size of the light you use for your portraits is very important. When you deal with a small light source, you have very harsh shadows. Picture the sun at noon. It's a relatively small light source because it's so far away from the planet. The small size of the sun relative to the earth creates very harsh shadows when it illuminates something. Now picture a cloudy day. The sun is still there, but it's hidden by the clouds. The sun hits the clouds, and it's diffused to create a very pleasing light source that is large with hardly any shadows. If you do have shadows, they're very soft with a diffuse edge. Compare this with the hard knife-edge shadow you get with a small light source. Therefore, it's important to use the largest light source possible when your goal is to create a flattering portrait. In upcoming sections, I share some techniques for using the most flattering light source possible.

Using Camera Flash

A camera's built-in flash units — you know, those deals that pop up and send a flash of light when you press the shutter button — are the harshest artificial light source available. They're small and aimed directly at your subject. The small light source creates a very harsh shadow. The light also bounces off your subject's retina and creates a condition known as *red-eye,* which causes your subject's pupils to look blood red. On-camera flash is never a good choice for portrait photography.

Using auxiliary flash

If your camera is equipped with a hot shoe, you can mount an auxiliary flash in the hot shoe and use it to create a more flattering light than you'd get with the on-camera flash. If you have a flash that is dedicated to your camera, you can take advantage of TTL (Through The Lens) metering, where the camera metering system determines how much illumination is needed from the flash to properly illuminate your subject. Figure 7-1 shows an auxiliary flash unit mounted on the Canon PowerShot G10. The on-camera flash for the G10 isn't very powerful, and it's totally unsuitable for portrait work.

Figure 7-1: Mounting an auxiliary flash unit in the camera hot shoe.

Some camera manufacturers feature auxiliary flash units that enable you to modify the amount of light coming out of the flash. This allows you to increase or decrease the power of the flash unit. This comes in handy when you need to add a kiss of light to a portrait or just fill in a few shadows. Some cameras let you communicate directly with the flash via a menu option to adjust the flash power. Other units have options for adjusting flash power from the unit itself.

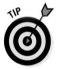

Many flash units feature flash compensation, which enables you to increase or decrease the amount of light coming from the flash unit. When you review a picture on your LCD monitor and decide you need more or less light on your subject, you use flash compensation to achieve this result. Refer to your flash manual for more details.

Bouncing flash

If you have a dedicated flash with a swivel head, you can turn the head toward a wall or ceiling and bounce the light toward your subject. The benefit of *bounce flash* is that you end up with a much larger light source, which produces soft light without harsh shadows. The disadvantage is that you need a longer exposure because the flash loses quite a bit of its punch because it travels a greater distance, and is diffused. When using bounce flash, increase your ISO to the largest value that will still give you an acceptable image without too much noise. If you don't know the highest ISO you can use without creating unacceptable digital noise, refer to Chapter 3.

When you use bounce flash, you must remember one of the laws of physics, which states that the angle of incidence equals the angle of reflection. In other words, if your flash hits the ceiling at a 45-degree angle, it bounces off the ceiling at a 45-degree angle. Most flash units with swivel heads have a detent that clicks in to hold the flash at a 45-degree angle from the head. You need to be far enough away from your subject so that the full illumination from the bounced flash reaches her. If you're too close, the flash will bounce over her head, too far away, and the light will fall short.

When you use bounce flash properly (see Figure 7-2), it produces a flattering light. Figure 7-3 shows a Canon flash with a swivel head as you would position it when bouncing the flash off a ceiling. The head rotates on two axes. You can bounce it up toward the ceiling, and sideways to bounce some of the flash off a nearby wall or reflector. The swivel gives you endless possibilities.

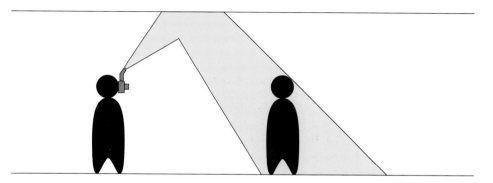

Figure 7-2: Bouncing flash off a ceiling.

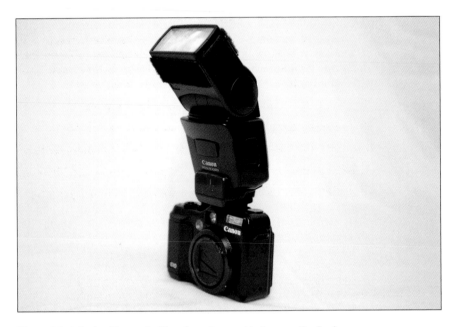

Figure 7-3: A flash with a swivel head can be used to bounce the flash.

Creating a bounce card

Bounce flash is great when you have a white ceiling or wall nearby. But what happens when you're creating candid portraits at a party or an event that's being held in a large room without white walls and with a ceiling that might as well be in the stratosphere? You use a *bounce card*. A bounce card spreads the flash out, giving you a larger light source, which produces a flattering light. You can create a bounce card for your camera using supplies from a craft store. Here's how:

1. **Purchase a sheet of white foam and some Velcro.**

 Michaels (an arts and crafts store with retail stores in the U.S. and Canada) sells foam sheets called Creative Hands Cool Foam. Each sheet is approximately 12 x 18 inches, thin, and white, and is the perfect product for creating a bounce card. You can purchase Velcro at Michaels or at your local office supply store. Velcro that is ¾ of an inch wide is perfect.

2. **Download the bounce card template from `www.dasdesigns.net/ downloads/bouncetemp.zip`.**

 Download this to a convenient spot on your hard drive. In most cases, I download files like these to my desktop, which unfortunately can lead to a bit of clutter. Hmm… maybe we need a *Computer Desktop Feng-Shui For Dummies* book. But I digress . . .The template is a Zip file. When you unzip the file, you'll have a PDF document.

3. **Unzip the file and open the PDF file.**

 Most versions of Windows will open a dialog box with options for extracting the zipped file. To open the PDF file, you'll need to have Adobe Reader installed. If you don't have Adobe Reader, you can download it for free at `http://get.adobe.com/reader`.

4. **Print the PDF file and then cut out the template.**

5. **Trace the template onto the foam and then cut it out.**

6. **Attach one side of the Velcro to the flash, as shown in Figure 7-4.**

7. **Attach the Velcro to the bounce card, as shown in Figure 7-5.**

8. **Attach the card to your flash unit, as shown in Figure 7-6.**

Figure 7-4: Attaching Velcro to the flash.

Figure 7-5: Attaching Velcro to the bounce card.

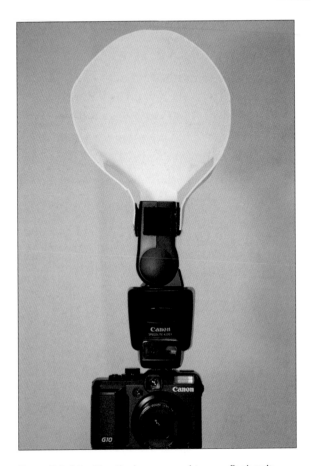

Figure 7-6: Attaching the bounce card to your flash unit.

Notice that the flash is pointing with the narrow side facing the subject and up toward the ceiling. This is so you can quickly swivel the unit when you want to rotate the camera 90 degrees and shoot in portrait format.

9. **When you shoot vertically (portrait format), rotate the flash unit as shown in Figure 7-7.**

In either configuration, the flash is bounced up to the ceiling, and toward your subject. This bathes your subject in diffuse light instead of the harsh light normally associated with a small flash unit.

Modifying pop-up flash

If your camera doesn't have a hot shoe but does have a pop-up flash, you can still produce flattering lights for your portraits. Most camera stores carry a device that you can attach to your camera that creates a small tent over the

flash to diffuse the light before it reaches your subject. LumiQuest (www. lumiquest.com) makes a device known as the Soft Screen (see Figure 7-8), which currently retails for $13.95.

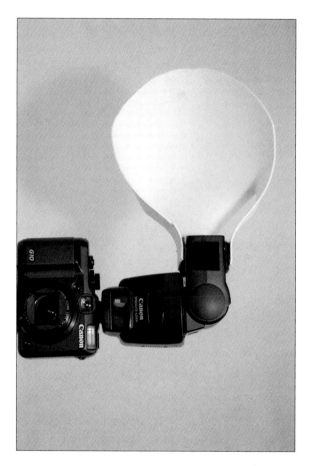

Figure 7-7: Swivel the unit and bounce card to shoot vertically.

Modifying the light from an auxiliary flash

If you're a geek like me, you like gadgets — I've got a camera bag full of them. If you've got an auxiliary flash and you want to modify the light coming from it, you can take the DIY approach and create a bounce card. But if you want something that looks more professional and is scientifically designed to modify the light, you can find a device at your local camera store to fit the bill. LumiQuest makes several devices for modifying the light from an auxiliary flash unit. These units mount directly on your flash unit. The Softbox is shown on the left of Figure 7-9, and the UltraSoft is shown on the right.

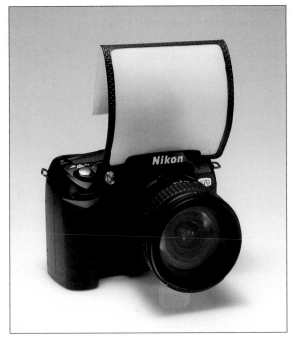

Image courtesy of LumiQuest

Figure 7-8: Modifying light from a pop-up flash.

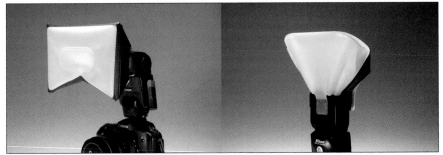

Image courtesy of LumiQuest

Figure 7-9: Light modifiers for auxiliary flash units.

Using Fill Flash

When the light source is coming from behind your subject, your camera should meter the scene, and the resulting image will be a compromise. The background will be exposed almost perfectly, but your subject will be in dark shadow, or perhaps a silhouette. You have two choices with a backlit subject: Use exposure compensation to increase the brightness of your subject or use fill flash to fill in the shadows. The problem with the first solution is that

the background will be overexposed. When you enable fill flash, your camera meters the overall scene and then figures how much flash is needed to fill in the shadows. When you use fill flash, shoot in one of the advanced shooting modes. When you're shooting a portrait, Aperture Priority mode is ideal. Enable your on-camera flash or auxiliary flash. Even though you're using ambient light for the background, it's still a good idea to put a light modifier on your flash, which fills the shadows with soft, diffuse light. The portrait on the left in Figure 7-10 was taken outdoors using ambient light only. Compare that with the portrait on the right side of Figure 7-10, which was shot using fill flash. Notice that the colors are much more vibrant. The flash caused catch lights to appear in each eye, drawing the viewer's attention to her eyes. I used a light modifier on the flash similar to the ones shown in Figure 7-9.

You can use fill flash indoors and outdoors. Actually, it's a good idea to use fill flash whenever you create portraits outdoors. The extra light fills in shadow areas of the face, such as the area under your subject's brow. It's also great if your subject is wearing a hat or cap that creates a harsh shadow as the flash will fill in the shadow area under the brim of the cap and reveal detail that would otherwise be lost. Fill flash also adds a bit of sparkle to the eyes in the form of catch lights.

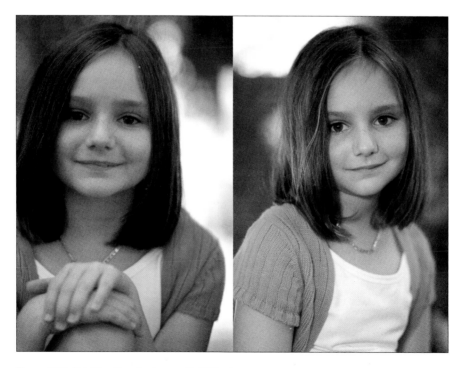

Figure 7-10: Brighten the shadows with fill flash.

Creating Portraits with Window Light

If you've got a window with a window treatment that filters the light, you have the ideal light source for a compelling portrait. When window light is filtered through curtains made of a white fabric that lets light through, you end up with a wonderful diffuse light that is very flattering.

The time of day also makes a difference when you're creating a portrait using window light. If you create the photograph when the sun is rising and filtering in through the window, you get a soft, warm light. The same is true when the sun is setting. If you create the photograph during the afternoon, the light will still be flattering, but you won't get the warm light of the rising or setting sun.

When you create a window-light portrait, your subject can look toward the window or look toward the camera. A profile shot of your subject facing the window and looking toward the light source can be an interesting character study. You can also create a nice portrait by positioning your subject perpendicular to the light source. One side of her face will be in shadow and the other will be illuminated by the light coming in through the window. When you create a window-light portrait, turn off any other lights in the room. If part your subject's face is in deep shadow, use a reflector to bounce some light into the shadow side of her face. Figure 7-11 was photographed with window light. To fill in the shadow side of her face, I used a reflector with a grip manufactured by Lastolite, shown in Figure 7-12. The catch lights show the window on the right side of each eye, and the reflector on the left side of each eye. For more information on reflectors, refer to the section, "Using a reflector," later in this chapter.

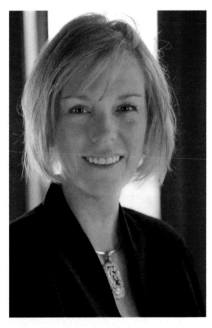

Figure 7-11: A reflector is used to bounce light back into shadow areas.

Image courtesy of Bogen Imaging

Figure 7-12: A Lastolite reflector with a grip.

Modifying Light

The great thing about light is it's not a WYSIWYG object. You can modify the available light with devices you can purchase from a camera store. You can modify light by diffusing the ambient light, or by bouncing light back into the shadows. In the following sections, I show you how to use photography equipment that's designed to modify light.

Using a reflector

You use a *reflector* when you need to bounce light back into the shadows. Basic reflectors have two sides. One commonly used reflector has a highly reflective gold colored fabric on one side and a highly reflective silver fabric on the other side. Use the silver side of the reflector when you want to add light to an image without changing the color temperature but also add contrast to the image. The silver reflector is a favorite for black-and-white photography. Use the gold side of the reflector when you want to bounce warm light onto your subject. The left side of Figure 7-13 shows a portrait illuminated by window light with no reflector. The right side of the figure shows the same portrait using the gold side of a reflector to bounce light onto the shadow side of the young girl's face.

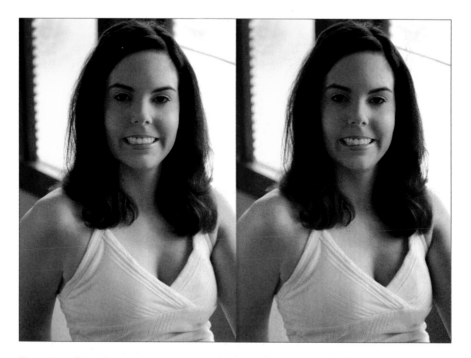

Figure 7-13: Bouncing warm light into shadow areas.

Some reflectors are multipurpose. They have silver, gold, white, or black discs and a translucent disc. The translucent disc is actually a diffuser, which I discuss in the next section. The black reflector is also known as a *gobo*. The black reflector decreases the amount of light reaching the subject and is also used for removing unwanted reflections and color casts. The white side of the reflector bounces neutral light back onto your subject.

Reflectors come in a wide variety of sizes. Small reflectors up to 22 inches in diameter are ideal for head-and-shoulders portraits. Reflectors 40 inches and larger are ideal for a portrait where you're photographing the person from head to toe. Larger reflectors are also handy when you're photographing a group. When you need to use a reflector, ask a friend to hold it, and tell her where to move it. You'll notice the changes in your viewfinder or LCD monitor.

Circular reflectors require the use of an assistant. There are, however, reflectors on the market that can be held by the photographer. A company called LastoLite makes a triangular reflector with a grip on one end. If you place your camera on a tripod, you can easily move the reflector to bounce the light where it is needed. Figure 7-14 shows an assistant handholding a reflector and a diffuser over a bride. Notice that the top part of her body is shaded by the diffuser, and the right side of her face is brighter than the left, thanks to the reflector.

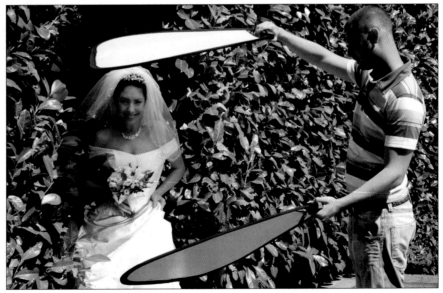

Image courtesy of Bogen Imaging

Figure 7-14: Using a reflector with a built-in grip.

You can also purchase an inexpensive light stand and use it to hold the reflector. If you're shooting in windy conditions, you'll have to secure the light stand with a sand bag or some other weight. You can also purchase a bag to counterweight the light stand. It looks like a hot water bottle. Fill the bag with water and attach it to the light stand.

Using a diffuser

A *diffuser* reduces the amount of light reaching the scene. A diffuser is the ideal solution when you have no choice but to photograph someone under harsh light. A diffuser acts just like a layer of clouds occluding the sun. It spreads the light out and minimizes harsh shadows. You can purchase a diffuser from your favorite camera store, or use a multipurpose reflector that has a translucent disc. Have a friend hold the diffuser over your subject. Figure 7-15 was photographed under a harsh glaring sun. Earlier, I had photographed the young lady in a shaded area, but I wanted one photo of her in the bikini with the lake as a background. I showed her mother (her chaperone and my assistant) how to hold the diffuser, and I took several pictures. Note that using a reflector or diffuser can be a challenge if it's a windy day.

Using Auxiliary Flash Off the Camera

When you illuminate your subject with on-camera flash, the light source hits your subject square in his face. You can modify the light for a more flattering portrait, but you still end up with hardly any shadows on his face. Shadows model the face and give it some dimension. You can achieve this by taking the flash out of the hot shoe and moving it to one side or another. Mount the flash on a tripod or light stand and angle the flash so that it strikes your subject directly. The light striking your subject from an angle will add some nice shadows on the other side of her face. You should also add some type of modifier to diffuse the flash as discussed in the "Modifying Light" section.

Of course, you'll have to have some way to connect the flash to the camera. If your flash and camera have PC sockets, you can use a PC cord to connect the flash to the camera. Another option is to purchase a cord that mounts in the hot shoe of your camera and has a hot shoe on the other end, into which you mount the flash. (See Figure 7-16.)

There are several ways you can trigger an off-camera flash without using cables. Many Nikon digital SLRs feature a Commander system, which is built into the camera and can be used to trigger Nikon flash units. The off-camera flash units are slaves controlled by the Commander. Canon has a wireless

transmitter that plugs into the camera hot shoe. (See Figure 7-17.) The ST-E2 transmitter acts as the master flash and sends out an infrared pulse to trigger the slave units. The ST-E2 can trigger an unlimited number of 420EX, 430EX, 550EX, and 580EX flash units in two separate groups.

Figure 7-15: Using a diffuser to modify the ambient light.

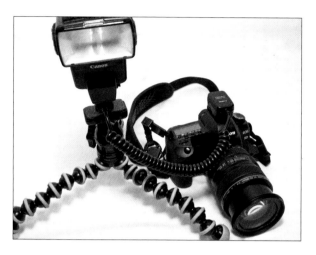

Figure 7-16: Using a hot shoe cord to connect the flash to the camera.

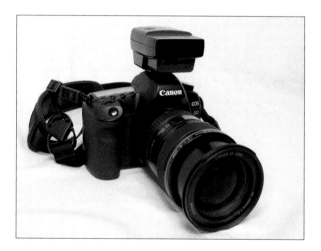

Figure 7-17: Using a wireless transmitter to trigger off-camera flash units.

Creating Portraits at Night

When you use flash at night, your subject is properly exposed, but the background is underexposed. You can solve this problem if your digital SLR or point-and-shoot camera has what is known as Night Portrait mode. When you enable this mode, the camera strikes a balance between a perfectly exposed background and a perfectly exposed subject. The camera uses a slow shutter

speed with this mode to properly expose the background, and the camera flash fires to create a perfect exposure of your subject. Because of the slow shutter speed, you'll have to mount your camera on a tripod and tell your subject to remain perfectly still. although some photographers do shoot portraits using Night Portrait mode with no tripod, which results in a blurry background because of camera movement. The latter can be aesthetically pleasing with the right background. If you shoot in Night Portrait mode with no tripod, there will also be a ghost image around your subject due to the camera movement.

If your camera doesn't have a Night Portrait mode, the only solution is to use one of the advanced shooting modes and let the camera meter the scene. For a portrait, the ideal mode is Aperture Priority. If you choose a large aperture (low f-stop number), the background will be soft. If you choose a small aperture (high f-stop number), the background will be in focus, but the shutter speed will be very slow. In either instance, use fill flash to illuminate your subject, and mount the camera on a tripod to compensate for the slow shutter speed.

Shooting in Sunlight

If you create portraits outdoors, you're going to have to deal with sunlight at some point in time. The quality of light from the sun differs depending on the time of day. In early morning and late afternoon, the sun is low on the horizon and the light travels slightly longer and through considerably more atmosphere. The resulting light is soft and diffuse, which results in a more pleasing portrait. Photographers refer to the hour after sunrise and the hour before sunset as the *golden hour* or *magic hour*. The light has an orange or reddish hue, which is well suited to portrait photography.

As with any lighting situation, there are challenges, to which I present solutions in the upcoming sections.

Photographing backlit subjects

When the sun is behind your subject, your subject is *backlit*. Digital cameras have a hard time dealing with backlit subjects. The camera meters the entire scene and creates an image that is a compromise: Your subject is either a silhouette or very dark and the background is perfectly exposed. You can deal with a backlit subject in one of two ways:

 ✓ **Use exposure compensation to increase the exposure.** You can increase the exposure until your subject is perfectly exposed. The solution is acceptable if you're doing a head-and-shoulders portrait, or an extreme close-up. However, if you've got a lot of the background in your image — or worse yet, the sun — these parts of the image will be overexposed.

 or

✔ **Use fill flash**. When you use fill flash, the camera meters the entire scene and adds enough flash to fill the shadows. With fill flash, you get the best of both worlds: a properly exposed background and a properly exposed subject. If your subject is still darker than you'd like, you can use flash compensation to add more light to the shadows.

Photographing subjects facing the sun

When you photograph people with the sun in their eyes, you face a couple of problems. First is the time of day. If you photograph just after high noon, the sun will still be rather strong and cast strong shadows on your subject. If you must photograph someone facing the sun, your best bet is to wait until late afternoon when the sun is closer to the horizon, casting a warmer light. Another option is to photograph in the early morning, just after sunrise. The second problem you face is that your subjects squint when they look directly into the sun. The way to overcome this is to ask them to close their eyes, open them, and smile at the count of three.

8

Photographing
Portraits on Location

reating portraits on location can be a lot of fun. You can incorporate interesting elements from the location in your images. The possibilities for creating portraits on location are limited only by your imagination. You can find interesting locations in your hometown, while on vacation, or anywhere else you happen to travel. The trick is to be observant and not overlook possible locations for portrait photo shoots. In this chapter, I share some information about shooting portraits on location.

Shooting Portraits on the Beach

If you live or vacation near a beach, you've got the ingredients for creating wonderful portraits on location. Miles of bleached white sand, lush vegetation, and sun-dappled water provide wonderful backdrops for casual on-location portraits. Whether you're photographing children at play or an entire family, the beach is a wonderful place to create a keepsake photo your subject will cherish forever. (See Figure 8-1.)

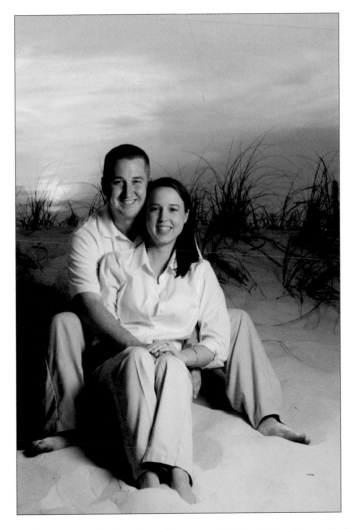

Figure 8-1: A pristine beach provides a wonderful backdrop for a portrait.

Here are some things to consider when creating portraits on the beach:

✔ **Location:** When you opt for a portrait shoot at the beach, scout the location before your subject arrives. Look for an interesting background and notice the orientation of the sun as compared to the shoreline. With this information, you'll know exactly where to position your subjects, and whether you'll have to augment the ambient lighting with fill flash. Without the addition of fill flash, the subjects in Figure 8-1 would have been silhouetted. The flash was modified using a device similar to those shown in Chapter 7. I used a transmitter in the camera hot shoe to trigger a flash unit that was held by an assistant and angled toward the couple.

✔ **Backgrounds:** Choose an area that has a simple background that won't draw attention away from your subjects. Sand dunes with beach vegetation make a wonderful backdrop. Unless your subjects are wearing colorful clothes, avoid a background that is just sand and surf. A splash of color from the setting sun or green foliage will add interest to the photo. Shy away from buildings with lots of details. Also make sure there are no distracting elements in the background, such as utility poles or power lines. However, simple elements such as the steps of a lifeguard station can add a lot of interest to a portrait and immediately tell a story to the viewer.

✔ **Time of day:** You'll get your best portraits if you shoot during the *golden hour,* which is an hour after sunrise and an hour before sunset. This gives you wonderfully warm light which creates warm skin tones.

✔ **The weather:** If you're creating a beach portrait at sunrise or sunset, you're at the mercy of the weather. If you try to shoot the portrait on a day when there's not a cloud in the sky, the resulting image will be dull and lifeless. If your subject is available on a moment's notice, call her up when you notice an interesting sky that will enhance the image. If you're forced to photograph on a cloudless day, or an overcast day, make sure you've got some color in the background to add life to the image.

✔ **Look for natural frames:** You can use foliage or other natural elements to frame your subject. Other possibilities are stairways, palm trees, a window in an abandoned beach house, and so on.

✔ **Tell a story:** Not all of your beach portraits need to be posed. When you're photographing a subject on the beach, or by the ocean, you can create a wonderful candid photograph of your subject doing something. For example, you could photograph a child building a sand castle or playing in the surf as the sun sets. (See Figure 8-2.)

✔ **Lighting:** If your subject is backlit, you'll have to use a reflector or fill flash to illuminate the shadows, as I did in Figure 8-1. Or you can use existing lighting to create a silhouette, as I did in Figure 8-2.

If your subject is facing the sun, he'll probably be squinting. Tell your subject to close his eyes and open them on the count of three. Take the picture immediately after he opens his eyes.

✔ **Camera settings:** When you shoot a portrait on the beach, your first choice should always be Aperture Priority mode. Use the largest aperture (low f-stop number) to create a soft, out-of-focus background. If you're not comfortable shooting in Aperture Priority mode, switch to Portrait mode. Switch to a single auto-focus point and make sure your subject's eyes are in focus. Don't use a wide-angle focal length unless you're photographing a large group of people at the beach. Using a focal length that is the 35mm equivalent of 85mm or greater will yield a pleasing portrait. Combined with a large aperture (low f-stop number), this focal length gives you a background that is recognizable but doesn't draw the viewer's attention from your subjects.

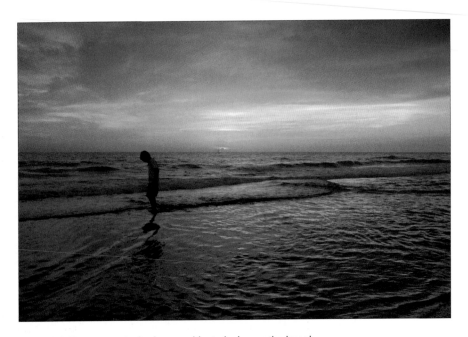

Figure 8-2: Create a portrait of your subject playing on the beach.

Don't zoom in too close. You're shooting a beach portrait, so be sure you include enough of the background that viewers will know the picture was taken at a beach.

When you photograph people on the beach, sand is everywhere. Be careful not to get any sand on your hands, which, according to one of Murphy's Laws, will inexorably get into your camera. A single grain of sand can wreak havoc with the motor used to zoom your lens to different magnification levels. Salty air is also a factor. If you notice a salty tang to the air, when you get home, be sure to wipe your camera down with a damp cloth that has almost been wrung dry.

When you're photographing subjects on white sand, the camera may end up giving you a less-than-desirable exposure. For example, the sand may be too bright, and your subjects may be too dark. Review the image on the LCD monitor after taking the picture. If areas of the image are overexposed, use exposure compensation to correct the exposure as outlined in Chapter 3. Depending on the scene, you may have to decrease exposure to properly expose the sand, and use fill flash to properly expose your subject.

Photographing Subjects in Your Hometown

Observant photographers know all the photogenic spots in the town in which they live. If you don't know the photogenic spots in your hometown, or you've recently moved, network with other photographers to find the photography hot spots where you live. You may live in a town that's chock full of historically significant buildings, or perhaps you live in an area with lots of recently constructed buildings. Either way, with a bit of work, you can mine interesting places to photograph your subjects from the field of gold that is the town in which you live. The following list presents a few ideas to consider when creating portraits in your hometown.

- **Consider what your subject likes to do.** Before choosing a location, find out what hobbies or interests your subject has. For example, if your subject likes track and field, photograph him at a local high school track. Position your subject behind a runner's starting gate. Include part of the bleachers to add another visual clue to your image. You may want to photograph him in his running clothes.

- **Choose the right location.** If you're not choosing a location based on your subject's interest, choose a location that viewers will identify with the town in which you and your subject live. For example, you might consider taking a picture of your subject on the steps of the county courthouse. Another possibility is to include a readily identifiable statue in the background. Botanical gardens are also great locations for portrait photo shoots.

- **Shoot in historical places.** Another great location is a place in your town that's on the historical register. This adds a local element to the picture that viewer's from your hometown are bound to recognize. Figure 8-3 depicts a portrait shot at Tampa University, which was formerly The Tampa Hotel, built in the late 1800s.

- **Incorporate architectural elements.** When choosing a location for a location shoot, look for interesting architectural elements that you can use to draw viewers into the picture or frame your subject. Windows, doorways, stairways, and arches are interesting elements to include in a picture.

- **Highlight local flora and fauna.** Do you have a type of tree or flower that is associated with the town in which you live? If so, include it in your portrait. For example, if you live in Washington, DC, schedule a photo shoot with your favorite subject when the cherry blossoms bloom.

- **Find a neutral background.** When you arrive at your desired location, look for a background that viewers can identify as being in your town, but avoid busy backgrounds with patterns that clash with your subject's clothing. If you have no option other than to photograph your subject against a busy background, make sure she's far enough away from the background so that a large aperture will soften the background. Review the image on the LCD monitor. If the background clashes, ask your subject to move away from it and make sure you move an equal distance from the background, as well.

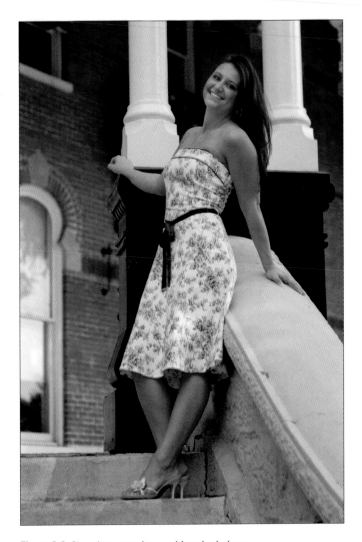

Figure 8-3: Shooting portraits at a historical place.

✔ **Work with weather and lighting conditions.** Don't shoot the portrait in bright sunlight. Either photograph your subject in a shaded area, or photograph during the golden hour, which is one hour after sunrise or one hour before sunset. If the sky is in your images, try to plan your photo shoot during a time of day when there will be clouds in the sky. This adds another element of interest to the picture. When you shoot in open shade or on an overcast day, consider using fill flash to add some sparkle to your subject's eyes and fill in the shadows.

If you have no choice other than to photograph your subject in direct, harsh light, use a diffuser, as outlined in Chapter 7, to soften light and

shadows. If your subject's back is to the sun, you'll have to use fill flash to illuminate your subject.

✔ **As always, use the optimal camera settings for your portrait.** When you shoot a portrait in town, or for that matter, anywhere, choose Aperture Priority mode and use the largest aperture (lowest f-stop number) to create a pleasing out-of-focus background. If you're not comfortable shooting in Aperture Priority mode, switch to Portrait mode. Switch to a single auto-focus point and focus on your subject's eyes. Don't use a wide-angle focal length unless you're photographing a large group of people. In addition to not being a pleasing choice for a portrait of a single person, a wide angle focal length gives you a greater depth of field. Using a focal length that is the 35mm equivalent of 85mm or greater will yield a pleasing portrait which, when combined with a large aperture, yields you a background that is recognizable, but does not draw the viewer's attention from your subject.

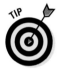

✔ **Have a backup plan.** You never know what may happen when you got to a location. It might rain, the place might be crawling with tourists, or your ideal shooting location is being remodeled. If you encounter these, or any other problems that would prevent the shoot from happening, go to your backup location.

Capturing Informal Portraits

An *informal portrait* is any portrait that's not created using studio lighting. You can create informal portraits of friends and relatives in the town they live in doing the things they love to do. When you create an informal portrait, you're telling a story about your subject.

When you create an informal portrait, you're photographing like a photojournalist. You're with the subject when she's either at work or at play. You're the fly on the wall, ready to press the shutter button to capture the quintessential photograph of your subject doing what she loves. Sometimes you can do this quickly, and other times you'll have to spend an extended amount of time with your subject to capture the full scope of what she does. Informal portraits are also known as *environmental portraits*. You're photographing your subject in her environment where she's totally at ease and in command of her game.

Here are some ideas for informal portraits:

✔ **Don't rush the photo shoot.** Let your subject get into his routine. Just sit back calmly and observe. When your subject starts doing something interesting, compose the scene and take the picture.

✔ **Don't suggest poses.** Just let your subject start to make her magic, doing whatever she does. When you let nature run its course, you'll capture natural hand movements and expressions.

✔ **Focus on your subject's eyes.** You'll be able to accurately capture his expressions as he concentrates on the task at hand. When creating portraits, it's always good practice to switch to a single auto-focus point.

✔ **Use selective focus.** If your subject uses a tool in her work, such as a paintbrush, choose a large aperture, a focal length that's the 35mm equivalent of 85mm or larger, and switch to a single auto-focus point. Lock the exposure on the subject's paintbrush as she moves it from palette to the canvas. The canvas will be in soft focus, as will the subject's face, but the face will still be recognizable. Selective focus draws attention to the tool of your subject's trade, thereby creating a compelling informal portrait. Here's a portrait of a businessman getting ready to shake hands. Selective focus is used to render his hand in sharp focus, yet his face is still recognizable. (See Figure 8-4.)

Purestock

Figure 8-4: Using selective focus.

Creating Candid Portraits

Candid portraits are similar to informal portraits; the portrait isn't photographed using backdrops or studio lighting. The difference between a candid portrait and an informal portrait is the location. You're not photographing the subject at his place of work or performing his favorite hobby or pastime. You're capturing a photograph of your subject doing something funny or endearing. You can capture a candid portrait almost anywhere. All you need is to have camera in hand and be alert enough to realize when your subject's getting ready to do something interesting.

Children are also great subjects for candid portraits. Photograph your child at play, when he's taking music lessons, or studying. Children have a tendency to act like hams in front of a camera. If your child goes over the top, put the camera down and let him get involved in what he's doing. When he's focusing more on his activity than you, pick up the camera again and start taking pictures. (See Figure 8-5.)

Purestock

Figure 8-5: Children are great subjects for candid portraits.

Here are a few candid photography tips:

- **Use a standard focal length lens.** A standard focal length lens, which is the 35mm equivalent of 50mm, lets you include some of the area in which you're photographing your subject. The extra information adds to the story. When you compose your image, back up and examine the scene through your viewfinder or LCD monitor. When you see an interesting composition with just enough elements to identify the area in which you're taking the picture, press the shutter button.

- **Don't use your largest aperture.** When you want to add some elements from the environment to your candid portrait, use a smaller aperture than you normally would use for shooting a portrait. For example, if the largest aperture on your camera is f/2.8, change to f/4.0 when creating candid portraits. The added depth of field tells something about the area in which the image is photographed, but the background is still softer than you'd want when photographing a landscape. You're giving the viewers a hint about the surrounding area, yet the center of interest is your subject, who is in sharp focus.

- **Spend some time with your subject.** Unless you know your subject very well, he'll be a bit nervous when you first start taking pictures. With time, this will pass, and he will start to relax and act normally. That's when the photo opportunities begin, so make sure you've got your camera ready.

- **Get your subject to relax.** Some people find it very hard to relax when they know they're being photographed. Establish a rapport with your subject, as outlined in Chapter 4.

- **Agree on a location.** Does your subject have some kind of routine or ritual? Does she go for a walk every evening with her dog? Does she take yoga classes? Meet your subject on location, fade into the background, and wait for something interesting to happen.

- **Use a small camera.** Even though your subject knows you're photographing him, a digital SLR with a telephoto zoom lens is intimidating. If you own a small point-and-shoot camera that delivers good image quality, use it when you want to create your candid portraits. You will get a larger depth of field with a point-and-shoot camera, so be sure to keep this in mind when choosing the location as even distant elements will be sharper than they would if you were shooting with a digital SLR using the same focal length and f/stop.

- **Pre-focus the camera.** When your subject starts doing something interesting, look away and pre-focus the camera on a subject that's the same distance from your camera as your subject. Keep the shutter button pressed halfway and watch your subject from the corner of your eye. Move the camera toward your subject when he does something you want to capture digitally, and press the shutter button the rest of the way.

✔ **Shoot from the hip.** When you raise the camera to your eye, it's a dead giveaway that you're going to take a photo of your subject. Unless you're quick, his expression will change when he sees you pointing the camera at him. If your camera has a swivel monitor, place the camera at waist level and compose your picture. When your subject does something interesting, press the shutter button. You can also rest your camera on the edge of a table and compose the scene through the LCD monitor and remain alert. When your subject does something interesting, take a picture.

✔ **Wait until your subject's occupied.** If someone starts talking to your subject, she drops her guard and looks at the other person. This is a great time to capture a candid photo of your subject with a natural expression on her face.

You'll get great candid portraits if you're ready and focused on your subject. This doesn't mean you have to have the camera at your eye at all times. Do your best to blend in and let your subject get used to your presence.

Shooting Portraits of Wildlife

Many photographers pore through magazines like *National Geographic* and *Audubon* with envy. Wildlife photography represents the beauty of nature, something you can capture with your digital camera. All you need is a digital camera with a zoom lens, and you're ready to shoot some wildlife. The beauty of shooting wildlife with a camera is that the wildlife lives to see another day, and you've got a wonderful memento of your encounter. Some areas of the world are closer to wildlife than others. But if you have the slightest interest in photographing wildlife, you can do so from just about anywhere in the world. The following sections are devoted to tips and techniques for photographing wildlife in nature and in city parks and zoos.

Photographing birds and wildlife in state parks

If you live in a state that has wildlife reserves and state parks, you can get some wonderful photos of animals and birds in their natural habitat. For a small fee, you can enter a state park and explore. Most state parks give you a map with hiking trails and points of interest. The park rangers can also be helpful and tell you where to find the hot spots for nature photography. Wildlife photography is challenging, but the end results are well worth the effort.

The easiest way to find spots to photograph wildlife near your home is to type into your favorite search engine the phrase *state park*, followed by the name of the town or county in which you live. Other good sources of information are the salespeople in your local camera store, or members of a local camera club. I live in an area where there are many state parks. I recently moved here, but I had the good fortune to find a photography

buddy who has shown me many of the wonderful wildlife hot spots near my home. Here are some of the things I've learned about photographing wildlife in a state park:

- ✔ **Use a long lens.** Unless you're photographing large animals, you'll need a long lens with a focal length that is the 35mm equivalent of 300mm or greater. Most state parks are animal sanctuaries from civilization. The animals are wary of human beings. A long lens is the only way you'll be able to get close-ups of the animals.

- ✔ **Choose the proper shutter speed.** When you're photographing wildlife with a long lens, camera shake is magnified. Choose a shutter speed that is equal to the reciprocal of the 35mm equivalent of the lens you're using. If you're using a 300mm lens, that means you should choose a shutter speed that is at least 1/300 of a second. You can shoot at a slightly slower shutter speed if your camera or lens is equipped with image stabilization. You may have to increase the ISO to get the proper shutter speed, especially if you're photographing wildlife in a forest or in dense foliage. A tripod is also useful to stabilize the camera.

- ✔ **Use a large aperture (small f-stop number).** When you're creating wildlife portraits, the shallow depth of field you get using a large aperture ensures that your viewer's attention is drawn toward the animal, not the background.

- ✔ **Switch to a single auto-focus point and focus on the animal's eyes.** If the eyes are out of focus, you've missed the shot. When you're shooting wildlife with a long lens and using a large aperture, you've got a very shallow depth of field, which makes accurate focus a necessity. If the animal's eyes are in focus, your viewer assumes the entire animal is in focus, even with a shallow depth of field.

- ✔ **Always travel with a buddy.** Many of the animals in state parks are fairly innocuous. However, some of the inhabitants can be dangerous if you're not on your toes. Many state parks have bears, alligators, and other animals that can be hazardous to your health when provoked. While you're in the moment photographing a bird, your buddy can watch your back and make sure a dangerous animal isn't sneaking up on you. Consider the following image of an alligator feeding. (See Figure 8-6.) These animals can leave the water at incredible speed and are very dangerous when they're breeding. Fortunately, I was a long way from this toothy critter. I captured the image with a 500mm lens.

- ✔ **Never feed the animals.** You may be tempted to feed an animal to coax it within range. Not only does this put you in potential danger, it also causes the animal to lose its fear of humans.

- ✔ **Look for changes.** When you're photographing animals in the wild, they blend in with the scenery and can be hard to spot. Blending with the background helps the animal hide from potential predators. Look for changes in color and slight movements as you hike on a trail or drive down a park road.

Figure 8-6: Exercise extreme caution around wildlife.

✔ **Travel out and back.** Arrive at the park early and drive the length of the park looking for potential hot spots for wildlife photography. If you follow my sage advice and travel with a buddy, he can drive on the way out, and you can drive on the way back. This gives you both an equal opportunity to capture some great photos.

✔ **Use your vehicle as a blind.** If you're traveling in a white van or SUV, the vehicle can double as a blind. When you see something interesting, park the vehicle and exit from the side opposite the animal you want to photograph. You can photograph from the front of the vehicle, and your buddy can photograph from the back of the vehicle. I recently used this technique in a state park and was rewarded with a wonderful photo of a deer. (See Figure 8-7.) This was the second photo I took. The deer heard the click of the shutter and raised her ears. She ran off after the second shot. You can also park the vehicle by the side of the road in an area where you've seen wildlife before. Stand on the side of the vehicle that's opposite the area where you expect the animals to appear. Wait patiently and look through the vehicle windows. When you see something interesting, quietly walk to the front or back of the vehicle and take the picture.

✔ **Know your subject.** Animals are somewhat predictable. After you photograph an animal species for a while, you get to learn its habits. An animal generally moves its head in the direction it's about to travel. Another benefit to knowing your subject is being able to figure when they'll stray from cover to feed.

✒ **Protect yourself.** In addition to keeping a safe distance from dangerous animals, make sure you're wearing the proper clothing. If you're hiking on a narrow trail, or through underbrush, wear long pants and hiking boots. Remember to use sunscreen to protect your skin. And make sure you're properly hydrated. Even if you're just going out for a short afternoon jaunt, pack a cooler with a couple of bottles of water and some snacks to keep your energy up. If you leave the vehicle and go for a hike, carry a bottle of water with you. Some camera backpacks have compartments in which you can carry a bottle of water without endangering your camera gear.

Wildlife photography is a lot of fun. The trick is to practice until you're perfect. Shoot lots of pictures and get to know the wildlife sanctuaries, state parks, and animal preserves near your home. Visit them over and over until you know the lay of the land and its inhabitants like you know your own neighborhood. Then you're well on your way to creating wonderful wildlife portraits.

Figure 8-7: Stay hidden from the animals you want to photograph.

Creating animal portraits at the zoo and in city parks

If you don't have wildlife preserves or state parks with wildlife near where you live, you can still get some interesting pictures of wildlife at the nearest zoo, or at a city park. Most major cities have a zoo, and many cities have parks with birds and other wildlife. Visiting nearby zoos or city parks is a great way to photograph wildlife when you live in a metropolitan area. It's also a bit safer than roaming through the woods. In the upcoming sections, I show you some techniques for photographing animals in a zoo or city park.

Photographing animals at the zoo

If you live in a big city or don't have nature reserves near where you live, you can still get some great shots of wildlife at your local zoo. A city zoo can be a home to a diverse group of animals, from exotic birds to primates like monkeys or orangutans. But zoos are busy places with fences and crowds. Below are a few tips for getting great shots of wildlife at your local zoo:

- Visit the zoo on an off day when there will be fewer crowds to contend with.

- Visit the zoo early in the morning, or late in the afternoon when the light is better. You won't get good results if you try to photograph animals in the afternoon when the sun produces harsh shadows.

- Know when the animals are fed. They're likely to be more active prior to feeding time. You may be able to get this information from the zoo.

- When you find an animal you want to photograph, make sure there are no humans in the frame. Also make sure there are no signs in the picture or other items that would be a dead giveaway that the picture was taken at a zoo.

- If the animal is behind a glass enclosure, press your camera right up to the glass to eliminate glare and any possible reflection.

- Photograph the animal at his level. If you photograph the animal from above, it's a dead giveaway you're in a zoo. If the animal is below you in an enclosure, wait until he walks to a higher level and then take the picture.

- Use a telephoto lens and choose a large aperture (small f-stop number). Move around to compose the best possible picture, zoom in on the animal, and then patiently wait until the animal strikes up an amusing pose and take the picture. Hang around for a few minutes, and the animal may do some other interesting things. (See Figure 8-8.)

- If there are objects such as fences, posts, or other telltale signs the image was photographed at a zoo, crop them out in your image-editing program.

- Photograph your children with animals at the petting zoo. Most zoos have an area where young children can interact with animals and pet them. This can be the source of some wonderful photos of your kids learning about animals.

✔ Be patient. Animals have their own agenda. If the animal is asleep when you get to his habitat, or not doing anything interesting, wait a few minutes until something interesting does happen.

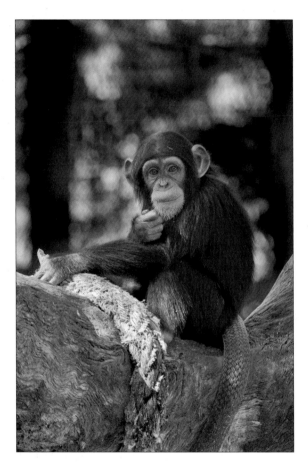

Figure 8-8: Photographing wildlife at your local zoo.

The best way to get great shots from your local zoo is to visit often and shoot lots of images. After a few visits, you'll know your way around, the zoo attendants will recognize and help you, plus you'll know more about the habits of the critters that live at the zoo.

Photographing birds in city parks

If you live near a city with lakes, you may be near a hot spot for bird photography. Many cities protect birds within city limits and create sanctuaries where the birds can breed and raise their young. If the lake is in the middle of

a crowded city, it can be difficult to get a good picture without telltale signs of civilization in the background. To get good photographs of birds in a city park, try these techniques:

- ✔ **Go early in the morning or late in the afternoon.** You'll have better light to work with at these times of day. The harsh midday sunlight isn't a good solution for any type of subject, including birds.

- ✔ **Use a telephoto lens with a large aperture (low f-stop number).** Using a telephoto lens enables you to photograph the birds from a distance. Even protected birds in a city park will be spooked by the sight of a human at close range. The large aperture helps to blur out the background, thereby minimizing buildings and other signs of civilization.

- ✔ **Get down to the bird's level.** You'll get a more natural-looking photo if you drop down to the bird's level. This often means kneeling in wet grass. Make sure you wear an old pair of jeans when you photograph birds. It's also a good idea to look before you kneel, so you don't land in a pile of bird poop.

- ✔ **Photograph on a cloudy day or a foggy morning.** A cloudy day gives you wonderfully diffuse light without harsh shadows. If the day is completely overcast, you have no shadows. And if you photograph birds in heavy fog, the resulting images won't show any signs of civilization. (See Figure 8-9.)

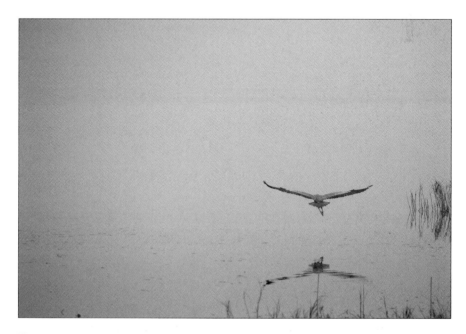

Figure 8-9: Using fog to erase signs of civilization at a city park.

✔ **Take one shot and move closer.** Get as close as you think you can without spooking the bird and then take a picture. With one picture in the bank, move closer and take another. If you approach the bird cautiously, you won't spook him and may end up getting an extreme close-up.

Bird photography is a lot of fun. When you find a great place to photograph birds, visit the place often and learn the habits of the birds. You can also go online to learn a lot about the birds that inhabit your local park. Many city parks also have informative signs or displays with pictures of the birds you'll see in the area, with information about the fine-feathered friends as well.

Photographing Portraits in Your Home or Office

*Y*ou can create portraits anywhere as long as you've got a subject and a photogenic — or for that matter, Plain Jane — background. But if you really want to tell something about your subject, photograph him in his home or in his office. Viewers of the photo can learn a lot more about your subject because of the background and surrounding objects. This type of photography has its rewards as well as challenges. In this chapter, I show you techniques for creating interesting portraits of your subject where he works and lives.

Becoming the Family Photojournalist

You've got a digital camera and know how to use it. So use it. Photograph any of your family's meaningful moments, such as birthdays, anniversaries, and so on. Photograph the everyday events as well. Life is short.

If you have both very young and very old relatives, the young relatives may have a hard time remembering the older members of your family when they're no longer on this mortal plane. But if you take your camera with you wherever you go and photograph your family and relatives at family gatherings, parties, or just being themselves in their homes, you create a legacy for your immediate relatives and future generations. If you're meticulous about archiving your work, it will stand the test of time. For more information about archiving your work, see Chapter 10.

You'll know which events are important to you and your family. If your family is religious, you'll want to take pictures of special events such as baptisms and Bar Mitzvahs. Birthdays, graduations, and anniversaries are no-brainers. But what separates your work from the boring, ho-hum shots of the smiling graduate or the birthday girl blowing out her candles are the types of shots you take. Don't get me wrong; those shots are important, but a photojournalist doesn't capture a single moment for each event. A photojournalist captures events behind the scene, such as the graduate's mother hugging her son after the ceremony.

You should also get photos of family members going about their daily activities. And make sure to capture photos of people's hobbies, the technologies they use, and so on. Text messaging is currently a very cool way for adolescents to keep in touch with their family and friends. Photos of young people using current technology or fads will be interesting in 20 or 30 years as the technology evolves. It will also be a source of amusement for the person in the photo. (See Figure 9-1.)

Being the family photojournalist is fun and rewarding. Your relatives may object to your poking the camera in their faces at every moment, no matter how important or how trivial. But they'll come to appreciate your dedication to the family when a family member moves or a loved one passes on.

After a while, you'll end up with hundreds, maybe thousands, of photos of your family. You can use the photos to create special gifts like calendars, coffee table books, coffee mugs, mouse pads, and much more. You'll find an endless resource for photo products online.

Figure 9-1: Family photojournalists take pictures of everything.

Creating Formal Portraits in Your Home

Formal portraits are posed, and the subject is usually photographed against a background or backdrop. You can create formal portraits in the comfort of your own home. All you need is a relatively large room with a blank wall, and you're ready to start creating portraits. It's also a good idea to have a formal chair or a stool upon which your subject can sit.

Formal portraits are usually created in studios with multiple backgrounds, props, studio lighting, and so on. Purchasing lighting equipment and backgrounds is all well and good for a professional photographer, but if you're shooting portraits only occasionally, purchasing expensive equipment and accessories isn't economically feasible, unless you've recently won the lottery or inherited a large sum of money. Even so, it's still not practical to invest a lot of money in something you don't use frequently. You can get good portraits in your home using relatively inexpensive equipment. The portrait in Figure 9-2 was created in my home studio, which consists of a backdrop and two lights. In the next sections, I show you some ways to create portraits in your home on the cheap.

Figure 9-2: Creating portraits in a home studio.

Using backdrops and backgrounds

Every formal portrait has some type of background or backdrop. Professional photographers buy their backdrops and backgrounds from companies that do nothing but create backdrops and backgrounds. You can find online vendors by typing *photography backgrounds and backdrops* in the search field of your favorite search engine. You can also pick up fairly inexpensive backgrounds by doing a search on eBay.

Most photography backgrounds are made of muslin. The backdrops are made of a heavier fabric upon which paint is applied. The paint can be abstract patterns or something that simulates a scene. If you do decide to purchase a commercial background or backdrop, purchase one that has grommets. The grommets are used to attach the backdrop to a rod. In my last house, I screwed two hooks into the ceiling and placed a piece of conduit through the hooks. I put shower curtain holders over the conduit and snapped them into the grommets on the backdrop. With this setup, I could put a backdrop up in a matter of minutes. When the photo shoot was over, I removed the backdrop from the conduit, and then I removed the conduit from the hooks in the ceiling.

If you're adventurous, you can create your own backdrops. You can find interesting fabrics for backgrounds and backdrops at your local fabric store. Purchase a piece of muslin fabric approximately 9 x 9 feet, some fabric dye, and then use the time-honored tie-dye technique to create a unique backdrop. You can find tutorials about creating backdrops by typing *DIY photography backgrounds* into the search field of your favorite search engine. Take the DIY info with as many grains of salt as you wish, but make sure the author posts some pictures of the process and the end result. A picture is worth a thousand words.

If you create formal portraits only every now and again, you can improvise to create a backdrop. All you need is a bed sheet. Bed sheets come in many different colors, and they're suitable backgrounds for head-and-shoulders shots. You can use push pins to hang the bed sheet on a wall. Straighten the sheet to remove as many of the wrinkles as possible. If you've got some stubborn wrinkles, try using Downy Wrinkle Releaser.

When you're ready to start shooting photos, ask your subject to move several feet in front of the backdrop, and use a large aperture (low f-stop number). This combination renders the background as an out-of-focus blur, which has the added benefit of blurring any wrinkles.

Creating a makeshift studio

You can create a makeshift studio in a large room. All you need is a blank wall, onto which you'll hang a background or backdrop, and a nearby window. You can quickly create a makeshift studio by following these steps:

1. **Move any large furniture and other obstacles away from the wall on which you're going to add your background or backdrop.**

2. **Adhere your background or backdrop to the wall.**

 I find that large pushpins are perfect for this. They don't leave huge holes in the wall, and they do a good job of holding your backdrop or background in place. The only exception is if you're using a heavy commercial backdrop. In that case, you'll have to invest in a backdrop stand.

3. **If needed, place a sheet over the window to diffuse the light.**

 If you're photographing on a cloudy day, or you have sheer curtains, this step isn't needed. Now you have one light source.

 But if you're photographing in a dark room, you'll need some way to illuminate the shadow side of your subject's face. Room lights are never a good option because you can't direct the light. Your best bet is a reflector of some sort.

If you don't have a lot of light coming in through the window, you may end up with a slow shutter speed. If this is the case, mount your camera on a tripod.

After you set up your studio, position your subject, choose your largest aperture, point your camera at your subject, and then press the shutter button halfway. Your camera will meter the scene and tell you what shutter speed will be used. If the shutter speed is too low, mount the camera on a tripod, or choose the highest ISO at which your camera can take relatively noise-free pictures. You may still have to use a tripod when choosing a higher ISO, but at least your subject won't have to remain motionless for too long.

4. **Position your subject.**

 If you're doing a head-and-shoulders portrait, have your subject sit on a stool or kitchen chair. Make sure the chair isn't visible in the viewfinder. It's also a good idea to have your subject move away from the backdrop, if possible. This minimizes the appearance of any wrinkles in the backdrop. Moving your subject farther from the backdrop also helps eliminate your subject's shadow on the backdrop. The best advice is to examine everything carefully in your viewfinder and LCD monitor before you decide on the final position from which your subject will be photographed.

5. **Add a reflector to bounce light back into the shadow side of your subject's face.**

 You can use a commercial reflector, as outlined in Chapter 7. A 4 x 8-foot piece of Styrofoam, which you can purchase from your local building supply store, also doubles as a great reflector. You can use a chair to hold the piece of Styrofoam in place.

6. **Adjust the position of the reflector.**

 Move the reflector closer to your subject to bounce more light into the shadows, or away from your subject to bounce less light into the shadows. If you're working solo, you can gauge your results by the amount of light on the shadow side of your subject's face. You can see the results in your viewfinder, LCD monitor, or by eye. If you have an assistant, tell him which direction you want the reflector moved.

7. **Add some fill flash.**

 If you're shooting with only natural light, fill flash will add some sparkle to your subject's eyes. In addition to the window light and the reflector, this is almost like working with three lights. Make sure you use some kind of device to diffuse the flash, as outlined in Chapter 7. Alternatively, you can bounce the flash off a white ceiling.

Your makeshift studio setup should resemble Figure 9-3.

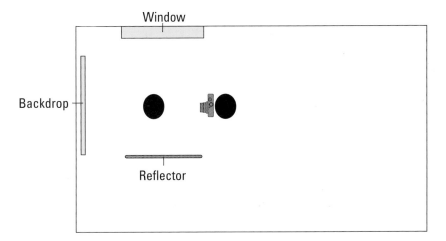

Figure 9-3: Creating a makeshift studio.

Studio lighting kits

If you're really adventurous, you can create great portraits with a studio lighting kit. Studio lighting kits come with one, two, or three lights, light stands, and umbrellas. For a basic head-and-shoulders portrait, you can get by with a one-light kit. If you're photographing more than one person or want more control over your lighting, consider picking up a two-light set.

If you use a one-light setup, position the light to one side of your subject and point the light at a 45-degree angle. This illuminates one side of your subject and casts the other side of your subject in deep shadow. You can fill in the light on the shadow side of your subject using a commercial reflector. A good alternative is a 4 x 8 piece of Styrofoam. Move the reflector closer to or farther from your subject to vary the amount of light that is reflected to the shadow side of your subject. Figure 9-4 shows a one-light setup as described here.

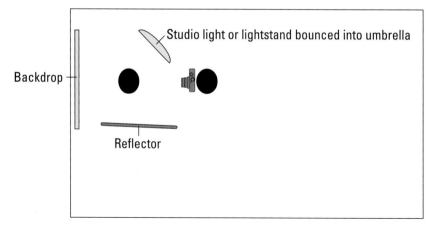

Studio light or lightstand bounced into umbrella

Backdrop

Reflector

Figure 9-4: Using a one-light setup for portrait photography.

If you use a two-light setup, position the lights equidistant from your subject and point each light at a 45-degree angle. One light will be the main light, and the second light will be the fill light. Decrease the power of the fill light by 25 percent. Figure 9-5 shows a two-light setup as described here.

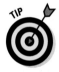

TIP

If you have three studio lights, place one behind and to the side of your subject. Point the light at the backdrop to illuminate it. If you're using a white backdrop, you can decrease the power of the main and fill light, and keep the third light at 100 percent power. You may have to experiment a bit to get the

right ratio, but when you do, the white background will be blown out to solid white, which makes selecting the background very easy in an application like Photoshop Elements.

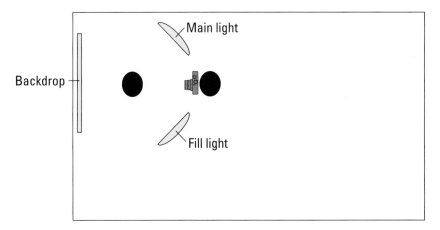

Figure 9-5: Using a two-light setup.

Creating Informal Portraits in a Home or Office

When you capture an informal portrait of a friend or loved one, you're photographing the person doing an everyday task, such as cooking or cleaning, working, or doing something they love, such as a hobby. To create informal portraits in your home, all you need is a camera and knowledge of your subject. Informal portraits are similar to candid portraits, but your subject is aware of the fact that you're photographing him. Informal portraits aren't posed. Your job as a photographer is to get your subject involved with whatever activity it is you're going to photograph him doing. Once your subject is engrossed with the task at hand, you can begin taking pictures. Here are a few things to consider when creating an informal portrait:

- **Let your subject relax.** Sit back calmly and observe your subject as he gets into his routine. When he starts doing something interesting, take the picture.

- **Don't suggest poses.** Just let your subject start doing whatever she does. When your subject starts focusing on the task at hand, you'll capture natural expressions and hand movement. (See Figure 9-6.)

- **Focus on your subject's eyes** and you'll be able to accurately capture his expressions as he works. When creating portraits, it's always good practice to switch to a single auto-focus point to ensure that your subject's eyes are in focus.

Figure 9-6: Creating an informal portrait.

✔ **Use natural lighting** if possible. If you're taking pictures in the subject's home, use window light when at all possible — and if necessary, augment the lighting with a reflector or fill flash.

✔ **Capture the big scene.** If your subject is doing something that involves equipment or nearby objects, zoom out so you can see the tools of his trade. As you're composing the picture, pay attention to what's in your viewfinder. If the scene looks cluttered, either physically remove some objects or zoom in until you see the image you envision.

✔ **Choose the proper aperture.** If your portrait involves a subject and one piece of machinery, or a tool, use a large aperture. If there are supporting players in your cast, such as a chef's utensils, cookware, and kitchen,

choose a slightly smaller aperture and focus on your subject. Your subject will be in sharp focus, and the area in front of and behind her will be out of focus — yet the items will still be recognizable.

✔ **Use selective focus.** If your subject uses specialized tools in his work, choose a large aperture (low f-stop number) and switch to a single autofocus point. Lock the focus on the subject's tool as he works. The tool will be in sharp focus, and your subject will be out of focus but recognizable. If your subject is too out-of-focus for your taste, switch to a slightly smaller aperture.

Creating a Slice-of-Life Portrait

A slice-of-life portrait isn't a picture of a person; it's a picture of things he owns and uses in his profession. A slice-of-life portrait can also be a photograph of things he uses in his favorite hobby or pastime. In essence, a slice-of-life portrait is a still life that immediately tells the viewer something about the owner of the things in the photograph. If the viewer knows the owner of the objects, the slice-of-life portrait is instantly recognizable. (See Figure 9-7.)

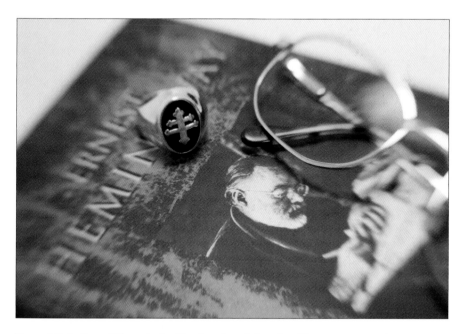

Figure 9-7: A slice-of-life portrait with a loved one's favorite objects.

Here are a few tips for creating a slice-of-life portrait:

- **Lighting:** Window light is ideal for any type of still life photography. Alternatively, you can use bounce flash or photograph the still life outdoors on a cloudy day. You can also use one of the flash modifiers mentioned in Chapter 7 to get soft, diffuse light for your still life.

- **Number of elements:** Don't empty your subject's desk drawer, dump it on the table, and expect to get an artistic still life. Limit the still life to five items or fewer. It's always better to use an odd number of objects for a slice-of-life portrait. For some slice-of-life portraits, even one item is sufficient, as long as it speaks volumes about its owner.

- **Contrast:** Contrast adds interest to a slice-of-life portrait. The contrast can come from the lighting, or from the objects used in the portrait. If the subject has varying interests, populate the image with items that are in direct contrast with each other. You can also use light and dark objects to provide contrast.

- **Background:** The background for your still life should be simple and not distract from the image. Place the objects on a black or white background and you'll have a glare-free background that doesn't detract from the objects in your image. Alternatively, a nice piece of wood with simple grain can be a good background for a slice-of-life portrait with tools.

- **Inspiration:** When your goal is to create a slice-of-life portrait, interview your subject and ask him about the important things in his life, career, family, and so on. With this information, you can scour his office or home to find objects for your portrait. Use your creativity to find the items you think tell the best story about your subject, based on your interview. If you know your subject well, the job will be easier. However, you may want to include a question about his favorite objects to make sure you nail the portrait.

- **Lens:** Most objects used for this type of portrait are fairly small. Therefore, you'll have to use a macro (close-up) lens to get close enough. Many point-and-shoot cameras have a macro button, perhaps with a flower icon on it. Your camera manufacturer may also have available a close-up attachment that screws into the accessory threads of your camera lens.

Part III
Editing and Sharing Your Portraits

In this part . . .

Many beginning and intermediate photographers don't know what to do with their images. If you download your images to the computer and then forget about them, this part of the book is for you. Even if you do something with your images after you download them to your computer, you can still benefit by reading all or some of this part.

I get the ball rolling by introducing you to Photoshop Elements, which in my humble opinion offers a tremendous amount of bang for the bucks you dish out for the program. In Chapter 11, I show you how to retouch your images. The final chapter in this section shows you how to print your portraits and create slide shows and wall art.

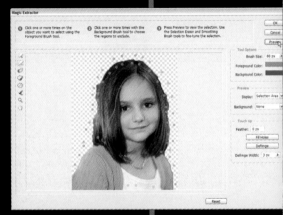

Editing with Photoshop Elements

Your images do you absolutely no good if you keep them on the memory card. It's really inconvenient to drag the camera out every time you want to show someone what you've photographed. You also run out of memory cards real quick — I know this is a case of the blindingly obvious, but some of you may not have used a digital camera before. In this chapter, I show you how to get the images out of the camera and into your computer. I also show you some basic editing techniques, such as resizing and cropping images. If your camera didn't ship with image-editing software, or you have image-editing software other than Photoshop Elements 8, a word of warning: the next three chapters are written specifically for Photoshop Elements 8. However, even if you don't own Photoshop Elements, you will find useful information here.

Introducing Photoshop Elements 8

Photoshop Elements 8 is a powerful image-editing program. You use the application to tweak your photos, color-correct images, and so on. You also use the program to organize your images into collections. The following sections are dedicated to organizing and editing your images in Photoshop Elements 8.

Getting to know Photoshop Elements 8

When you first launch Photoshop Elements, you have a choice to make: which workspace to select, Organize or Editing. The choice depends on what you're using the application for. If you're using the application to sort, rename, and find images, choose the Organize workspace. In this workspace, you can also back up your image collection, manage your catalog of images, add images to the catalog, and much more. You can also edit images you select from the Organize workspace. I refer to the Organize workspace (see Figure 10-1) in upcoming sections. I introduce you to the Editing workspaces in the section, "A Tale of Two Editing Workspaces," later in this chapter.

Small Thumbnail

Rotate Right | Thumbnail Slider

Rotate Left | Single Photo View

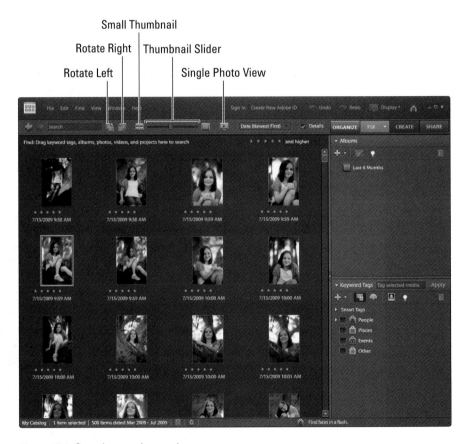

Figure 10-1: Organize your images here.

Downloading your images

After you finish a photo shoot, your first step is to get your images into your computer. Many cameras have a USB port and cable you can use to download your images. This, however, depletes the camera battery and is also fairly slow. A much better method of downloading your images is to use a card reader. There are a lot of different card readers on the market, and many of them support multiple memory card formats. Find one that matches your memory card type. The following steps show you how to download images using a card reader and a Windows operating system:

1. **Connect your card reader to the computer.**

 Figure 10-2 shows a SanDisk card reader attached to a laptop computer.

2. **Insert a card into the reader.**

 Windows makes a noise to notify you that media has been attached. (If you have Windows Vista, it makes a really annoying noise, in my humble opinion.) Shortly after the notification, a window also appears, giving you options. (See Figure 10-3.) The default option for a Windows operating system is shown.

Photo courtesy of SanDisk

Figure 10-2: Downloading images to your computer.

Figure 10-3: Choosing the right downloading option.

3. Choose Organize and Edit Using Adobe Elements Organizer 8.0.

The Elements Organizer – Photo Downloader dialog box appears. (See Figure 10-4.)

4. Specify the following settings:

- *Location:* Click the Browse button and navigate to the desired location where you want to save your photos. I advise that you set up a main folder on your hard drive for all of your digital images, and then create subfolders for the years. For example, my main image folder is called Digital Images. I set up a new subfolder for each year.

- *Create Subfolder(s):* The default option is the Shot Date. This is a good way to keep your images organized. However, I recommend you go one step further and choose the Custom Name option from the drop-down menu. When you do this, a text field appears beneath the first drop-down menu, allowing you to specify a new name. I name my folders with the date of the shoot, followed by the place or person I photographed. For example, if I photograph a girl named Dawn on November 25, 2009, I name the folder 112509_DAWN. This keeps the folders organized by date and makes it easy to locate a specific folder of images.

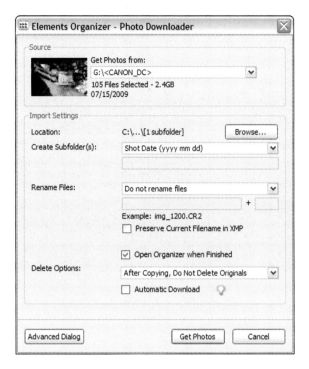

Figure 10-4: Downloading images to your computer.

- *Rename Files:* The default option doesn't rename files. If you select this option, your camera will use a default naming option that isn't very user friendly; it will name all your files with an acronym like IMG or DSC, followed by a four-digit number. If you want to stay organized, choose one of the renaming options from the drop-down menu. My favorite is Shot Date (yy mm dd) + Custom Name. I use the subject's name for the custom name. Choosing this option will give you image names like 112509_DAWN_ followed by a 4-digit number.

- *Preserve Current Filename in XMP:* This option records the current filename (the default name from your camera) as metadata in an XMP file. *Metadata* is data from your camera such as the date the image was shot, the focal length, shutter speed, and so on. This information is automatically generated by your camera along with the filename according to the naming conventions used by your camera manufacturer. An XMP file is a small data file that records this information. It is stored in the same folder in which the image is saved. When the image is opened, Photoshop Elements reads the metadata from the XMP file.

- *Open Organizer when Finished:* This option opens the Elements Organizer after the download is finished, where you can do further organizing.

- *Delete Options:* Choose one of the options from the drop-down menu. The default option doesn't delete the originals. There's also an option to verify and delete originals, which verifies that the images have downloaded properly. However, I recommend that you stick with the default option and format your cards in the camera after downloading them. Your camera is better equipped to optimally format your memory cards for future use.

- *Automatic Download:* This option automatically downloads images whenever you insert a card in your card reader or connect a camera to the computer. I recommend that you leave this option deselected so you can rename your photos and specify the folder in which they're saved.

5. Click Get Photos.

Photoshop Elements downloads the images into the specified folder and opens the Organizer (if you specified that option).

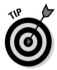

You can perform other tasks when downloading photos by clicking the Advanced Dialog button. In the Advanced section of the Elements Organizer dialog box, you can specify which images are included in the download, rotate images, fix red-eye, apply copyright information, and so on. For more information on the Advanced options, check out *Photoshop Elements 8 For Dummies,* by Barbara Obermeier and Ted Padova (Wiley Publishing).

Organizing your work

After you download images into the Organizer, you can perform other steps to organize your images even further. You can rank your images, add keywords to your images, select images to add to an album, and much more. In the upcoming sections, I show you how to get your ducks in a row.

Ranking images

If you've imported lots of pictures, it's hard to know which ones to edit. You can make things easy on yourself by ranking your imported images so that the fine distinctions between images become more obvious.

I generally make two passes. In the first pass, I give the best images a 3-star rating. Then I press the icon above the image thumbnails to filter the images and show photos with 3-star and higher ratings. To do this, press the third star icon and then choose And Higher from the drop-down menu. On the next pass, I give the best of those images a 4-star rating. On the final pass, I filter the images to show only 4-star ratings and higher. The images I'm going to edit get a 5-star rating.

The following steps show you how to separate the wheat from the chaff and select a group of candidates you want to edit.

1. Drag the slider to increase the size of the thumbnails.

You find the slider at the top of the Organizer above the thumbnails. The default view of the Organizer shows the imported images as thumbnails, very small thumbnails. This doesn't really give you a chance to see the minute details in each image. I prefer to see the whole image. (See Figure 10-5.) You can quickly do this by double-clicking an image. Alternatively you can click the blue square to the right of the thumbnail size slider.

2. Rank the first image.

You can rank an image by clicking one of the stars beneath the image, or by pressing the number on your keyboard. You can rank images between 1 and 5, with 1 being the worst image and 5 being the best.

3. Navigate to and rank the next image.

If you're viewing individual thumbnails, click the desired thumbnail and then rank it. You can also click a star under any thumbnail to rate it. However, it's hard to get a good look at an image without magnifying it. If you're viewing images at full magnification, press the right-arrow key to navigate to the next image.

4. Continue ranking images until you've ranked all from the shoot.

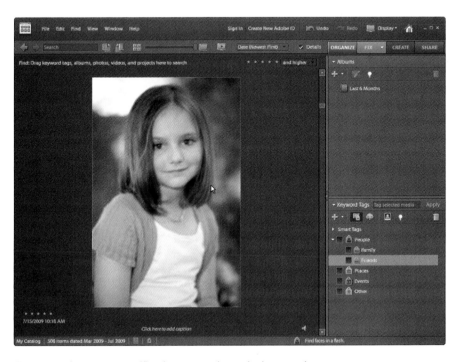

Figure 10-5: Increase magnification to get a better look at your images.

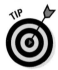
TIP

After ranking images, you can filter them by clicking a star to the right and above the images. You can also choose a viewing option from the drop-down menu. The default option is to view images of a certain rank and higher. You can choose to view only images with that rank, or images that are the chosen rank and lower.

Adding keywords to images

Keywords keep you organized, especially when you want to find images. I add keywords to all images, regardless of their rank. You never know when you can use a 3-star image you normally wouldn't edit as part of a collage. Keywords make it easy to find images. For example, if you take photos of Aunt Milly, you'd use `Milly` as a keyword. When you have hundreds of images of Aunt Milly spread over the course over several months or years, some stored in different folders, the keyword of her name will make it easy for you to locate all pictures of Milly.

Photoshop Elements has some keyword categories built in. This is a book about portrait photography, so our concern when it comes to keywords is people. The People keyword category is divided into Family and Friends. You can add your own keywords to these categories, and apply them to images as follows:

1. **On the Keyword Tags panel, click the keyword category under which you want to create the keyword.**

 Don't click the space next to the keyword. That's used to find images with that keyword.

2. **Click the green plus sign (+).**

 The Keyword drop-down menu appears. (See Figure 10-6.)

3. **Choose New Keyword Tag from the drop-down menu.**

 This opens the Create Keyword Tag dialog box. (See Figure 10-7.)

4. **Enter the keyword text in the Name field.**

 We're portrait photographers. The name of the person in the photograph would be logical.

5. **Click OK.**

 The new keyword is added to the group, with a question mark for an icon. The icon changes as soon as you apply the keyword to an image.

6. **Continue adding keywords as needed.**

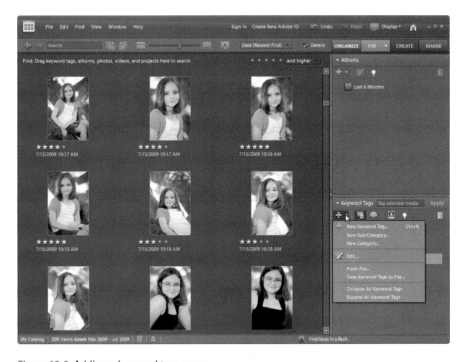

Figure 10-6: Adding a keyword to a group.

To add a keyword to one or more images, follow these steps:

1. **In the Organizer, select the images to which you want to apply the keyword.**

 You can select a single image or multiple images. To select contiguous images, Shift+click the first and last images. To select noncontiguous images, Ctrl+click each image to which you want to apply the keyword.

2. **Drag the keyword over the selected images.**

 The keyword tag is applied to the selected images, and the keyword tag icon changes to the last picture to which the keyword was applied. Each image to which a keyword is applied has a triangular blue icon to the right of its thumbnail. Pause your cursor over the icon to see which keyword(s) have been applied to the image.

3. **Continue applying keywords as needed.**

 That's right; you can apply multiple keywords to an image. For example, you might want to include the place where the image was photographed as a keyword.

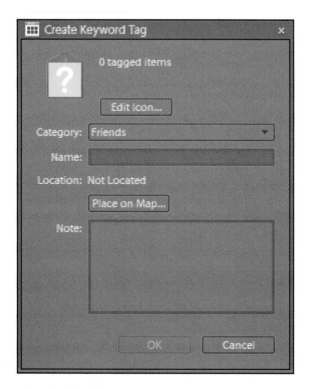

Figure 10-7: Creating a new keyword.

To find images to which a keyword has been applied, follow these steps:

1. **On the Keyword Tags panel, click the arrow to the left of the parent keyword category.**

 This expands the category and displays all keywords assigned to the category.

2. **Click the blank square to the left of the keyword.**

 All images with that keyword are displayed.

Choose Display⇨Date to view images by date. In this mode, you have access to all images you've imported. You can display images by day, month, or year.

Creating albums

Albums are collections of your favorite photographs. You can add to an album any time you import images. You can also find images that match certain criteria and add them to an album.

To create an album, follow these instructions:

1. **On the Albums panel, click the green plus sign (+).**

 The Albums panel drop-down menu appears. (See Figure 10-8.)

2. **Choose New Album.**

 This opens the Album Details panel. (See Figure 10-9.)

3. **Enter a name for the album in the Album Name text box.**

 Choose any name that does a good job of describing the photos you plan to add.

4. **Drag images into the Content box to include them in the album.**

5. **After you finish creating the album, click Done.**

 The album now appears on the Albums panel. Click the album title to display the images.

Click the Pencil icon to edit a selected album at any time. This opens the Album Details panel.

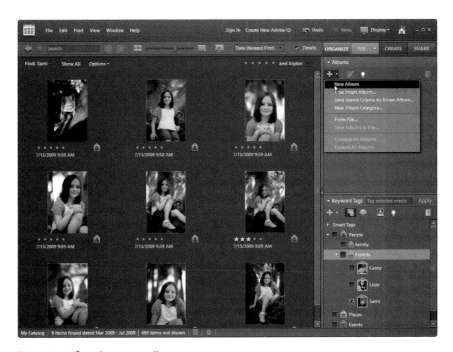

Figure 10-8: Creating a new album.

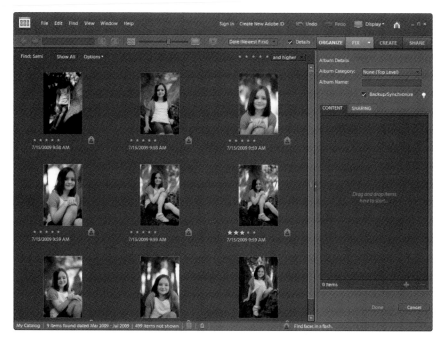

Figure 10-9: It's all in the details.

Processing RAW files

If you use your camera's native RAW mode, you capture everything the camera saw with almost no processing. All other image formats are processed in the camera and compressed. With the RAW format, you have tremendous latitude. You can adjust the exposure, recover lost highlights, and more. You process a RAW image in the Adobe Camera Raw application that is part of Photoshop Elements. After you process the image, you can open the image in Photoshop Elements to further fine-tune the image. To process a RAW file, follow these steps:

1. **Launch the Organizer workspace and select the image you want to process.**

2. **From the Fix drop-down menu choose Full Photo Edit, or Quick Photo Edit.**

 The desired editing workspace is loaded, and the Adobe Camera Raw application launches. (See Figure 10-10.)

3. **You can process your images using the following tools from the toolbar at the top of the Adobe Camera Raw dialog box:**

 • *Zoom:* Use this tool to zoom in. Click inside the image to zoom to the next highest level of magnification. Press Alt and click your

mouse to zoom out. You can also click and drag around the area you want to examine. As you drag, a rectangular marquee appears, signifying the area you'll be examining in closer detail.

- *Hand:* Use this tool to pan around the image after magnifying it.

 You can press the spacebar when using any other tool to momentarily access the Hand tool. When you release the spacebar, you revert to the currently selected tool.

- *White Balance:* Use this tool to adjust the image's white balance. Normally the camera automatically adjusts white balance, or you can manually adjust it using camera options as shown in Chapter 3. However, if you don't like the results from the camera, click an area that you know should be black, white, or gray. If you don't get the results you want, click another area.

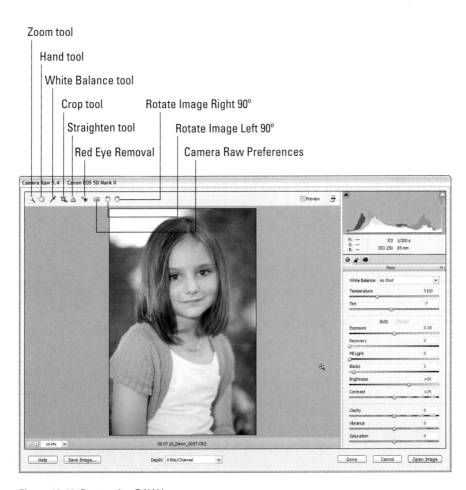

Figure 10-10: Processing RAW images.

- *Crop:* Use this tool to cut out a specific part of the image. The tool's default mode allows you to crop to any portion of the image without preserving the image's aspect ratio.

 You can also choose a specific aspect ratio from the drop-down menu. For example, if you're going to print the image on 8 x 10-inch paper, you'd choose the 4 to 5 option. You can also choose Custom to open a dialog box that enables you to crop to a custom ratio — or a size measured in pixels, inches, or centimeters — by entering values in text boxes. After choosing an option, click and drag inside the image to display a crop rectangle. You can modify the size to which you crop by dragging one of the perimeter handles, or click and drag inside the rectangle to move it to another position. Double-click inside the rectangle to see the cropped image.

- *Straighten:* Use this tool to straighten the image. Click and drag along a line you know should be vertical or horizontal and then release the mouse button to straighten the image.

- *Red Eye:* Click this tool, and the display changes to reveal the tool's adjustable parameters. Accept the default options, or drag the Pupil Size slider to increase or decrease the pupil size relative to the eye. Drag the Darken slider to increase or decrease the amount by which the pupil is darkened. When you finish setting the parameters, drag the tool over the eye and part of the surrounding face, and Adobe Camera Raw removes any traces of red-eye it finds.

- *Camera Raw Preferences:* Click this icon to open the Camera Raw Preferences dialog box. In this dialog box, you can determine whether initial sharpening is applied to your images, whether to apply auto-tone adjustments, and so on. Based on previous experience, I suggest you accept the default options and never venture inside this dialog box.

- *Rotate Left:* This tool rotates the image 90 degrees counter-clockwise.

- *Rotate Right:* This tool rotates the image 90 degrees clockwise.

- *Magnification:* Click the plus sign (+) to zoom to the next highest level of magnification, or click the minus sign (–) to zoom out to the next lowest level of magnification. Alternatively, you can select a value from the Magnification drop-down menu.

4. On the Basic panel, you can modify the following settings:

- *White Balance:* Accept the default, As Shot, to use the white balance from your camera. Alternatively, you can choose an option from the drop-down menu. Auto will usually get the job done if the camera goofed. You can also drag the Temperature slider to the right to warm the image, or to the left to cool the image. Drag the Tint slider right to add a magenta tint to the image, or left to add a cyan tint to the image.

5. On the Basic panel, you can also click Auto.

When you click Auto, Adobe Camera Raw applies the settings it deems optimal for the image. If you don't like the results, you can modify any of the following:

- *Exposure:* Drag the slider right to increase the exposure, or drag it left to decrease the exposure. Press Alt while dragging the slider to place a black overlay on the image. If you see any colors appear, you have blown-out highlights for that color channel. If you see pure white, you've lost all details in the highlights for the area indicated.

- *Recovery:* Drag the slider to the right to recover blown-out high-lights. Press Alt while dragging the slider to show a black overlay on the image. The areas that are blown out will be indicated by a color. Drag the slider until the color disappears.

- *Fill Light:* Drag the slider to the right to add light to the shadows. This is sort of like fill flash, which I tell you about in Chapter 7. It works quite well as long as you don't exceed a value of 20.

- *Black:* Drag the slider to the right to darken shadow areas, or drag it to the left to lighten them. Hold down the Alt key while dragging to display a white overlay. If you see any colors appear as you drag the slider, you're losing detail in that color channel. If you see black, you're losing all detail in that area.

- *Brightness:* Drag the slider to the right to brighten the image, or drag it to the left to darken it. This option adjusts the brightness of the image midtones without affecting the image exposure. Use this option when the image is otherwise properly exposed with a good distribution of pixels from shadows to highlights, but you want to make the image darker or brighter.

- *Contrast:* Drag the slider to the right to increase contrast; to the left to decrease contrast.

- *Clarity:* Drag the slider to the right to add contrast to the midtones in your image. This adds more punch to your image.

- *Vibrance:* Drag this slider to make all colors pop, with the exception of skin tones. This is an ideal way to enhance your image without destroying the subtle pink and red hues of skin tones.

- *Saturation:* Drag this slider to increase saturation of all colors in the image. I recommend not using this for portraits because it saturates the skin tones. If you want the colors in the image to pop, use the Vibrance slider.

6. In the panel on the right, click the Detail icon.

This opens the Detail panel (see Figure 10-11). In this tab you adjust image sharpening and specify the amount noise reduction that will be applied to the image. Camera Raw has some defaults that you can modify to suit your image.

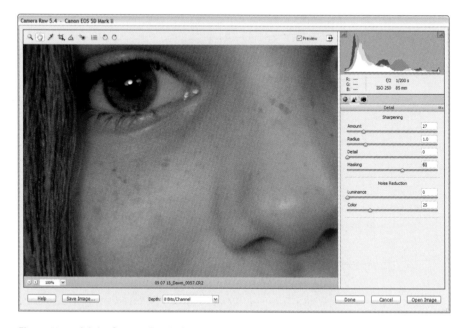

Figure 10-11: Adobe Camera Raw's Detail tab.

7. **Adjust Sharpening.**

You can modify the following parameters:

- *Amount:* This determines the amount of sharpening applied to the image. Zoom to 100 percent and pan to an area with detail. Press the Alt key while dragging the slider. When zoomed to 100 percent, this momentarily displays the image as black and white, which makes it easier to see the effects of your sharpening. For a portrait, I never exceed a value of 50.

- *Radius:* This determines the distance from an edge to which the sharpening is applied. For a portrait, I almost always leave this at the default setting of 1.0.

- *Detail:* This determines how much sharpening is applied to the details in your image, such as strands of hair, teeth, and so on. Zoom to 100 percent and pan to an area with details. Press the Alt key while dragging the slider to the right. This places an overlay over the image. As you increase the value, you'll see more details appear. Don't overdo this setting because you'll also sharpen details like fine skin wrinkles. If you used a high ISO setting (I tell you about ISO in Chapter 3) when shooting the picture, drag the slider to 0 so you don't increase sharpness of details like noise.

- *Masking:* This applies a mask to part of the image, which determines which areas of the image are sharpened. By default,

sharpening is applied to the entire image, even defects such as digital noise. Sharpening digital noise isn't a good thing because it makes the noise more readily apparent in the sharpened image. So you can use masking to avoid sharpening digital noise.

To apply masking, zoom to 100 percent and then pan to an area of the image that contains details. Press Alt and drag the slider. When you first press Alt, you see a white overlay on the image. As you drag the slider to the right, you begin to see shapes. Some of the shapes look like digital gibberish. This is the noise. Drag the slider until you see details appear, such as your subject's eyelashes or the strands of her hair. You've applied enough masking when you can clearly see the details and nothing else. I find a value between 60 and 70 is perfect for portraits.

8. Adjust Noise Reduction settings.

This determines how much noise reduction is applied to the image. The default settings work well for most images. However, if you've used a high ISO setting to capture the image, you may need to adjust these settings:

- *Luminance:* Zoom to 100 percent and then pan to an area with a lot of shadows. If you see areas with clumps of gray color, this is luminance noise. Drag the slider to the right until the noise starts to disappear. When you remove luminance noise, you also soften details in the image.

- *Color:* Zoom to 100 percent and pan to an area with a uniform color. If you see random specks of color, this is noise. Drag the color slider to the right until the noise disappears. Don't overdo it or you'll lose details.

9. Finalize your editing.

At this stage, you've completed all of the work. Use the three buttons at the bottom-right corner of Adobe Camera Raw to determine what happens next.

- *Done:* Click this button to apply the settings to the image, save the information with the file, and exit Adobe Camera Raw. The information that tells Camera Raw how to process the image is saved as an XMP file. When you next open the image in Adobe Camera Raw, the settings are applied to the file.

- *Cancel:* Click this button to exit Adobe Camera Raw without applying the settings to the image.

- *Open Image:* Click this button to open the image in the editor you specified in Step 2.

If you press Alt, the Cancel button becomes the Reset button. Click the button to erase all of your settings without leaving Adobe Camera Raw.

A Tale of Two Editing Workspaces

Your camera does a great job of capturing digital images. But like their film counterparts, digital images generally need a bit of work. Photoshop Elements is your digital darkroom. This application can do marvelous things for images that aren't quite up to snuff. You can also use the application to enhance images and add special effects using filters. The program has so much to offer, I can only skim the surface in the following three chapters. If you want a soup-to-nuts serving of Photoshop Elements 8, consider purchasing *Photoshop Elements 8 For Dummies,* by Barbara Obermeier and Ted Padova (Wiley Publishing).

Photoshop Elements has two ways you can edit images. One is called the Quick Photo Edit. This is ideal for tasks like removing red-eye, removing a color cast, adjusting white balance, and sharpening an image. The Quick Fix is great when you need to make only minimal changes on an image. If you want the "Full Monty," you use the Full Photo Edit workspace. In addition to the tasks just mentioned, you can add layers to your image, enhance your images with filters, and so on. In the upcoming sections, I show you how to edit an image in each workspace.

Exploring the Editing workspace

The Photoshop Elements 8 Editing workspace has lots of tools, panels, and so on. It also comes with a plethora of commands that do everything from changing the size of an image to applying filters to images. When you want to get creative and adventurous, the Full Photo Edit workspace is your port of call. The Full Photo Edit workspace (see Figure 10-12) is divided into the following sections:

- **Title bar:** Lets you sign into your Adobe account; create a new Adobe ID; reset panels; Undo or Redo the last step performed; open the Organizer; display the Photoshop Elements splash screen; and minimize, maximize, or close the application.

- **Menu bar:** Lets you access the various menu groups. Click a menu title to expand the group. The menu groups are as follows:

 - *File:* These menu commands are used to open images, save images, open recent files, print files, and so on.

 - *Edit:* These menu commands are used to undo or redo commands; cut, copy, and paste; change color settings; and so on.

 - *Image:* These menu commands are used to rotate, transform, crop, and resize images, and so on.

 - *Enhance:* These menu commands are used to fix defects in images, apply color corrections, adjust lighting and color, convert images to black and white, and so on.

- *Layer:* The commands in this group are used to create layers, add adjustment layers, merge layers, and so on.

- *Select:* The commands in this group are used to refine selections made with tools, select the entire document, select layers, and so on.

- *Filter:* The commands in this group are used to correct camera distortion, add artistic effects to images, stylize images, and so on.

- *View:* The commands in this menu are used to zoom in, zoom out, view rulers, view the grid, and so on.

- *Window:* The commands in this menu are used to display panels, display open images, hide panels, and so on.

- *Help:* The commands in this menu group are used to summon online help, view video tutorials, get support, and so on.

✔ **Option bar:** Contains settings for the tool you're currently using. Use drop-down menus or text fields to vary the settings for the currently selected tool. At the right side of the Option bar, you find buttons to Edit, Create, and Share images. When you click the Create or Share button, the Panels bin changes to display the options you have for creating objects such as photo books, calendars; and the like; or sharing photos using an online album, e-mailing photos, and so on.

✔ **Tools:** This part of the workspace contains the tools you use to edit your images, make selections, add text, and so on.

✔ **Project bin:** Displays thumbnails of all images currently open in the Editing workspace.

✔ **Panels bin:** Displays the panels that you're currently working with.

Editing an image in the Quick Fix workspace

When you need a quickie, this is the place to take your images. In the Quick Fix workspace, you can use automatic adjustments and then tweak them manually. To edit an image in the Quick Fix workspace, follow these steps:

1. **Launch the Photoshop Elements Organizer.**

 Your most recent import is displayed. To find other images, switch the Date view by choosing Date View from the Display drop-down menu in the upper-right corner of the Organize workspace.

2. **Select the image you want to edit.**

3. **Choose Quick Photo Edit from the Fix drop-down menu.**

4. **Choose an option from the View drop-down menu.**

 I prefer to work with the Before and After (Horizontal) view mode. (See Figure 10-13.) This gives you an accurate representation of the changes being applied to your image. The Quick Fix workspace looks similar to

the Full Edit workspace, but you have fewer tools with which to work. Many of the menu commands are dimmed out, which means you can access them only in Full Edit mode. The Panels bin is home to the Quick Fix options.

5. **Implement one or all of the following quick fixes:**

- *Smart Fix:* Click the Auto button to apply general corrections for color balance. This fix also enhances shadows and highlights, if needed. You can also drag the slider to manually apply Smart Fix. Use this option if you don't get the desired results. You can also click the grid to the left of the Amount slider to reveal thumbnails of the image, with different amounts of Smart Fix applied. Pause your cursor over a thumbnail, and the image changes. Click the thumbnail to apply the change.

Tools Panels bin

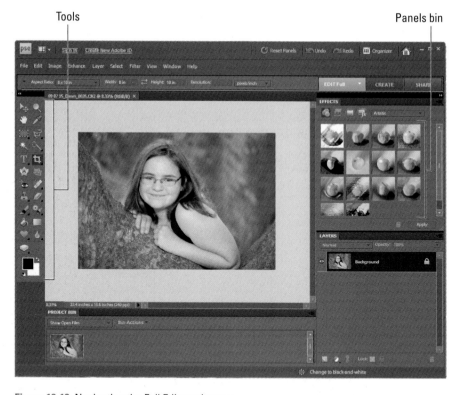

Figure 10-12: Navigating the Full Edit workspace.

- *Lighting:* Click the Levels Auto button to automatically adjust the shadows and highlights to improve the image. Click the Contrast Auto button to automatically improve image contrast. If the changes are not to your liking, you can manually adjust the lighting

by dragging the Lighten Shadows, Darken Highlights, or Midtone Contrast sliders. You can click a grid to the left of each slider to reveal thumbnail images with different amounts of each fix applied. Pause your cursor over the image to see the changes on your image. Click the thumbnail to apply the change.

- *Color:* Click the Color Auto button to automatically adjust the color tones in the image. If you're not happy with the results, drag the Saturation slider to the right to increase image saturation, or left to decrease saturation. However, when you change saturation, you're changing all colors and hues. If you increase saturation, you end up with unrealistic skin tones. You can also change the hues in the image by dragging the Hue slider. Drag the slider left to changes the hues to a bluish color, or right to change the hues to a greenish color. Again, this is a global correction and not ideal for portraits.

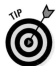

If you're new to image-editing, choose Guided Photo Edit from the Fix drop-down menu. This opens the image in the Guided Photo Edit workspace where you can choose the task you want to complete from a list.

If you only need to perform a simple edit, click the Fix button to reveal buttons that perform tasks such as Auto Smart Fix, Auto Color, and so on.

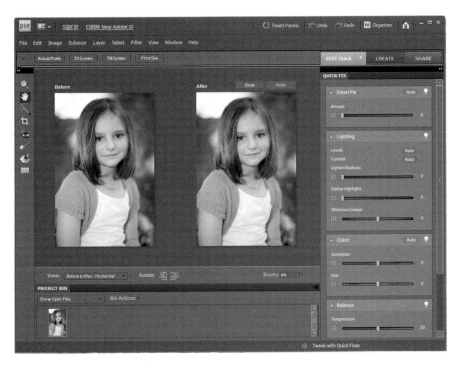

Figure 10-13: Editing an image in the Quick Fix Workspace.

Resizing and Cropping Your Portraits

Your camera has a set size and resolution for the images it captures. The size depends on the resolution of the camera in megapixels. You can use Photoshop Elements to resize your images prior to exporting them for e-mail, posting them on a Web site, or creating prints. To do so, you specify the image size and resolution. You can also crop your images to a specific aspect ratio, or a specific size. The following sections tell you everything you need to know about resizing and cropping images but were afraid to ask.

Understanding image size and resolution

Your camera has a maximum dimension at which it captures images and a set resolution. You can change the size and resolution using your camera menu. However, unless you're using images for the Web, I recommend you capture images at your camera's maximum size and resolution. The maximum size and resolution for my Canon G10 is 4416 x 3312 pixels with a resolution of 240 pixels per inch (ppi). That equates to a print size of 18.4 x 13.8 inches. To get the maximum print size for your camera, divide the dimension in pixels by the resolution.

Resizing images

You can resize images to a specific size. Resizing is also known as *resampling*. You can resample images to a smaller size with no loss of fidelity. However, if you try to increase the size of an image, you're asking the image-editing application to redraw pixels, which causes image degradation. To resize images, follow these steps:

1. **Open the image you want to resize in either the Quick Fix or Full Edit workspace.**

2. **Choose Image⇨Resize⇨Image Size.**

 This opens the Image Size dialog box. (See Figure 10-14.)

3. **In the Document Size section, enter the desired resolution.**

 You'll get your best results on most printers if you specify a resolution of 300 pixels per inch.

4. **Enter the desired size in either the Width or Height text box.**

 As long as you accept the default option to Constrain Proportions, Photoshop Elements supplies the other value. If you don't accept the Constrain Proportions option, your image will be distorted.

5. **Choose an option from the Resample Image drop-down list.**

 Bicubic Sharper is always the best when you're resampling to a smaller size.

6. Click OK.

Photoshop Elements resizes the image.

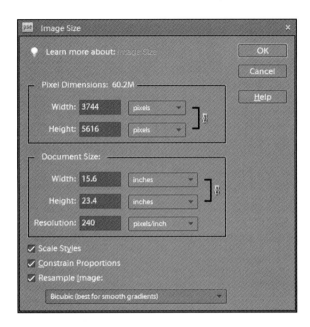

Figure 10-14: Resizing an image.

You can also change the image size by changing resolution. Deselect the Resample Image option and enter the desired resolution. If you enter a smaller resolution, the document size (print size) becomes larger. If you enter a higher resolution, the document size becomes smaller.

Color Correcting Images

Tricky lighting conditions fool the best digital cameras. If you've got a portrait that has a color cast, the image needs to be color corrected. For example, if your camera didn't get the white balance right when you photographed in an area that has fluorescent lighting, your subject may look a little green around the gills. To remove a color cast like this, follow these steps:

1. In the Organizer, select the image you want to edit, click the Fix button, and then click Full Photo Edit.

This opens the image in the Full Photo Edit workspace.

2. **Choose Enhance⇨Adjust Color⇨Remove Color Cast.**

 The Remove Color Cast dialog box appears. (See Figure 10-15.)

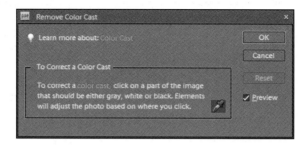

Figure 10-15: Removing a color cast from an image.

3. **Click an area inside the image that you know should be jet black, pure white, or neutral gray.**

 Photoshop Elements removes the color cast based on the area you clicked. If the first click doesn't modify the image to your satisfaction, click a different area.

4. **Click OK to remove the color cast.**

If you prefer to do things quick and easy, you can let Photoshop Elements take the reins and remove the color cast on its own. Choose Enhance⇨ Auto Color Correction.

Sharpening Photos

Images captured by a digital camera are a little soft. This has nothing to do with the camera lens, but has everything to do with the camera sensor. Fortunately, you can sharpen your digital images in Photoshop Elements using the Adjust Sharpness command. Photoshop Elements has other commands to sharpen images, but the Adjust Sharpness command does a better job of identifying edges, which means you won't end up sharpening noise or random pixels that shouldn't be sharpened. To sharpen a photo using the Adjust Sharpness command, follow these steps:

1. **In the Organizer, select the image you want to edit, click the Fix button, and then click Full Photo Edit.**

 This opens the image in the Full Photo Edit workspace.

2. Zoom to 100 percent magnification.

You can use the Zoom tool's 1:1 button or the keyboard shortcut Ctrl + Alt + 0 to zoom to 100 percent. When you sharpen an image, you should always view the image at 100 percent magnification.

3. Choose Enhance⇨Adjust Sharpness.

The Adjust Sharpness dialog box appears. (See Figure 10-16.)

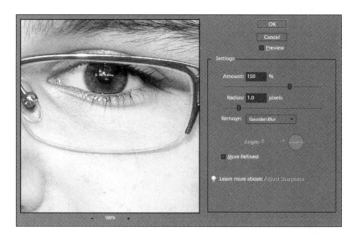

Figure 10-16: Using the Adjust Sharpness command.

4. Specify the Amount value.

You can use the slider to select a value, or enter the value in the text field. This value determines the amount of sharpening that's applied to the image. As you drag the slider, the image updates in real time. If any halos appear on the edges, you've over-sharpened the image. When you sharpen a portrait, don't go over the top. Your goal is to enhance the image, not to draw attention to skin texture and wrinkles. The value you use depends on your subject, the camera lens, and your personal taste.

Click the Preview check box to disable the preview of the sharpening on your original image, which enables you to see the unsharpened image. Click the check box again to see the effects of the sharpening on your image.

5. Specify the Radius value.

This value determines the distance from each edge to which the sharpening is applied. If you specify too low a value, the sharpening effect will not be noticeable; too large a value, and halos appear around the edges.

6. **Choose an option from the Remove drop-down menu.**

Your choices are Gaussian Blur, Lens Blur, and Motion Blur. Lens Blur is the best option for digital photographs. However, you can use Motion Blur if you moved the camera while taking the picture. When you choose Motion Blur, you can specify the angle by dragging a slider. Drag the slider until you see the sharpest image possible. Use Gaussian Blur for close-ups.

7. **Click the More Refined check box.**

This option processes the command slower for more accurate results.

8. **Click OK to sharpen the image.**

Cropping images

You can crop images to remove unwanted items, such as too much background or other distracting elements. You can also crop an image to a specific size and resolution. To crop an image, follow these steps:

1. **Launch the Photoshop Elements Organizer and choose the image you want to crop.**

2. **From the Fix drop-down menu, choose Full Photo Edit, or Quick Photo Edit.**

Your choice depends on how much work you need to do to the image. If all you want to do is crop the image and apply minimal edits, choose Quick Photo Edit.

 3. **Select the Crop tool.**

4. **Choose an option from the Aspect Ratio drop-down menu on the Option bar.**

The default option is No Restriction, which lets you crop the image to any aspect ratio. You can also choose to crop the image while maintaining the aspect ratio (use Photo Ratio) or choose one of the preset sizes, such as 4 x 6. Alternatively, you can enter the desired dimensions in the Width and Height text fields.

5. **Enter the desired image resolution in the Resolution field.**

If you're cropping images for the Web, enter 96 or 72 pixels per inch. If you're cropping an image for print, specify 300 pixels per inch, or the resolution specified by the printing service you're using.

6. **Drag inside the image to specify the crop area.**

The crop area is signified by a border of dotted lines and eight handles. (See Figure 10-17.) The handles are used to resize the area to which the image is cropped.

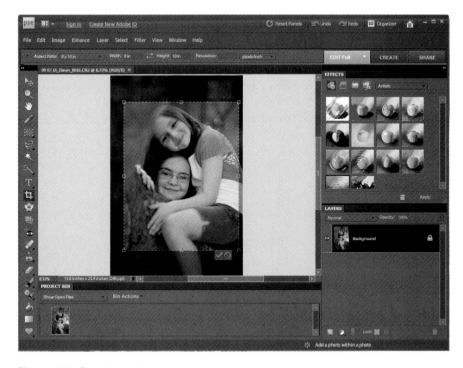

Figure 10-17: Cropping an image.

7. **Adjust the size of the crop rectangle.**

 Drag the corner handles to resize the width and height at the same time. Drag the handle in the middle of the top or bottom of the crop rectangle to change the height, or drag the handle in the middle of the right or left side of the crop handle to change the width. If you're cropping your image to a size or aspect ratio, dragging any handle changes the size of the rectangle proportionately.

8. **Click inside the crop rectangle and drag to change its position.**

9. **When the crop rectangle is the desired size, click the green check mark below the lower-right corner of the rectangle to crop the image.**

 You can also click the red circle with the diagonal slash to remove the crop rectangle and leave your image as is.

10. **Save your work.**

 When you make changes to an image, I advise you to save it with a different filename in order to preserve the original. For more information on saving your work, refer to the sections "Saving Your Work" or "Saving for the Web" later in this chapter.

TIP

If all you need to do is crop the photo, click the Fix button and choose Crop from the Photo Fix options menu. This opens a dialog box with a crop rectangle that you can resize. You can also choose from one of the presets.

Saving Your Work

After you edit an image, it's time to save it. You can save your image in any format supported by Photoshop Elements. If you're editing a RAW file, your only option is to save to a different format.

1. **Perform the desired edits on your image.**

2. **Choose File⇨Save.**

 The Save As dialog box appears. (See Figure 10-18.)

Figure 10-18: Saving your work.

3. **Enter a filename for the image in the File Name text box.**

 It's advisable to give the image a different filename than the original.
 If you give the image the same filename and save it in the same folder,

you'll overwrite the original. If you don't enter a filename, Photoshop Elements automatically adds the following to the original: _edited-1 (for the first edit). If you don't rename your images, I advise you to accept the default filename Photoshop Elements gives the image. This prevents overwriting the original.

4. **Choose a folder in which to save the image from the Save In drop-down menu.**

 By default, Photoshop Elements saves images in the same folder as the original. You can save your work in any folder, or you can create a new folder in which to save your edited images.

5. **Choose from the following options:**

 - *Include in the Elements Organizer:* Accept this default option, and the saved file will be included in the Photoshop Elements Organizer.

 - *Save in Version Set with Original:* This option stacks the saved file with the original in the Organizer. The most recently saved image in the version set appears on the top of the stack. If you deselect this option, the edited image is saved beside the original.

 - *Layers:* If the image has layers and you save to a file format that supports layers, this option is selected by default. If the selected file format doesn't support layers, the layers are flattened.

 - *As a Copy:* If your image has layers and you deselect the option to save the image with layers, this option is selected by default.

 - *ICC Profile:* Saves the image with the same color profile as the original.

6. **Choose a format from the Save as Type drop-down menu.**

 Photoshop Elements supports many file types. Unfortunately, a full-blown explanation of each file type is beyond the scope of this book. Most online print sources prefer the JPEG format, which is what I show you in the upcoming steps.

7. **Click Save.**

 If you accept the default option to save the edited image in a version set with the original, a dialog box appears, telling you about version sets. After choosing a file format, the dialog box changes to reflect the options for the file format. Figure 10-19 shows the options for the JPEG format.

8. **Specify the image quality in the Quality text box.**

 JPEG is a *lossy format,* which means the image is compressed and information is lost. The default image quality option is 7, which creates a medium-size file with good image quality. If you're printing the image, choose a quality of 10 or higher.

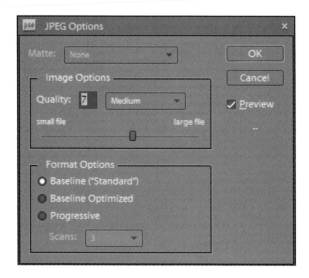

Figure 10-19: Options for the JPEG file format.

9. **Choose from the following format options:**

 - *Baseline ("Standard"):* This option works well for print and for the Web.

 - *Baseline Optimized:* This option yields good image quality, but it applies a bit more compression. Choose this option when file size is a concern.

 - *Progressive:* Choose this option for Web images. This option loads the image into the browser in stages. The first stage gives the viewer an idea of what is to come. With each stage, the image quality improves. When you choose this option, the Scans drop-down menu becomes available. Choose the number of scans from the drop-down menu. The default option loads the image in three stages (scans). You can specify as many as five scans.

10. **Click OK.**

 Photoshop Elements saves the image.

Saving for the Web

If you're saving an image for e-mail or posting to a Web site, you use the Save for Web command. This command lets you examine the image with different compression settings as compared with the original. To save an image for the Web, follow these instructions:

1. **Resize the image.**

 When you send an image via e-mail or post an image to a Web site, image size and resolution are important. Your camera's default size and resolution is way too big for e-mail or posting to a Web site. Resize the image to a width of 640 pixels or less, and specify a resolution of 72 or 96 pixels per inch.

2. **Choose File⇨Save for Web.**

 If you don't resize the image, a warning appears, telling you the image is too large for the Web. If you've resized the image, the Save for Web dialog box appears. (See Figure 10-20.)

3. **Choose an option from the Preset drop-down menu.**

 Your options include the GIF, JPEG, and PNG formats. The GIF format isn't suited for photorealistic images, and the PNG format isn't supported by all browsers. Therefore, choose one of the JPEG formats. JPEG Medium is a good option for Web and e-mail.

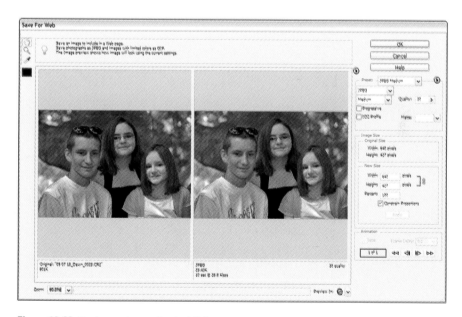

Figure 10-20: Saving an image for the Web.

4. **If desired, tweak the Quality.**

 Specify a lower image quality for a smaller file size. When you specify a lower quality, examine the image on the right side. The easiest way to specify image quality is to click the arrow to the right of the text box, which reveals the Quality slider. Drag the slider to the left to specify a lower image quality. When you release the slider, the data below the image in the right window refreshes to show the file size at the specified quality setting. When the image quality is no longer acceptable, drag the slider to the right until it improves and you've found the lowest possible quality setting for the image. The image file size and download time with a connection speed of 28.8Kbps is displayed below the Web-optimized image.

5. **If desired, choose these options:**

 • *Progressive:* Displays the image in stages.

 • *ICC Profile:* Saves the current ICC profile with the image. When you save images for the Web, they should always have the sRGB color profile. If for any reason they don't, choose Image⇨Convert Color Profile⇨Convert to sRGB Profile before using the Save for Web command.

 • *Matte:* This option determines transparency for Web pages. This option is needed only when you're displaying a banner with text and other elements on a Web site over a color background, and it isn't applicable for portraits.

6. **If desired, enter new values for Width or Height.**

 Enter one value, and Photoshop Elements calculates the other as long as you have the Resize Proportionately icon (it looks like chain link) enabled.

7. **Click OK.**

 The image is saved for the Web.

Archiving Your Work

Your computer is a mechanical piece of equipment. Like a car, it will fail, and it will fail at the least opportune moment. If you have hundreds of images on your computer and your hard drive decides to self-destruct, your images are lost. You may be able to recover them using a data-recovery service, but why spend the money when you can archive your images and restore them when needed? You can back up your Photoshop Elements catalog to a CD, DVD, or hard drive by following these steps:

1. **Launch the Organizer workspace and then choose File⇨Backup Catalog to CD, DVD, or Hard Drive.**

 The Backup Catalog to CD, DVD, or Hard Drive dialog box appears. (See Figure 10-21.) Your choices are Full Backup or Incremental Backup. When you back up for the first time, you need to perform a full backup. After the initial backup, use an incremental backup. When you do an *incremental backup,* Photoshop Elements compares the source drive on your computer to the previous backup. New files from the catalog are added, and old files that have been changed are updated during the incremental backup.

2. **After choosing the backup option, click Next.**

 The Destination Settings section of the Backup Catalog Wizard appears. (See Figure 10-22.)

3. **Select the destination drive from the available drives listed in the Select Destination Drive section.**

 This is a list of available drives on or attached to your computer. I strongly suggest you back up to an external drive, CD, or DVD. If you back up to your computer hard drive, and it fails, the backup is worthless.

Figure 10-21: Specifying the backup destination.

4. **In the Options section, specify the following options:**

- *Name:* Enter a name for the catalog or accept the default name: My Catalog.

- *Write Speed:* This option is available if you back up to a DVD or CD drive. The maximum speed is selected by default. If desired, choose another option from the drop-down menu.

- *Backup Path:* This option is available if you're backing up to a hard drive. You can browse for an existing folder or create a new folder.

- *Previous Backup file:* This option is available when you do an incremental backup. Navigate to and select the original backup file.

5. **Click Done.**

Photoshop Elements backs up the image files and the associated data to the specified folder.

If you ever need to restore the catalog, choose File⇨Restore Catalog from CD, DVD, or Hard Drive. After you invoke the command, you'll be prompted to locate the backup file and then specify where to restore the files.

Figure 10-22: Choosing the destination.

Retouching Your Portraits

In This Chapter

▷ Removing a background

▷ Creating a background

▷ Retouching your portraits

▷ Retouching portraits of older subjects

*1*f every person you photograph has a peaches-and-cream complexion, and you photograph all of them against a perfect background, you can go out and shoot more portraits instead of reading this chapter. But if you're like most of us, your subjects have some subtle flaws they'd rather not see in a portrait. Perfectionists can spend hours retouching an image, removing every single imperfection they see. But people aren't perfect. The trick is to retouch a portrait just enough to make your subjects look their best without making them look inhuman — and without spending hours to achieve that goal. In this chapter, I introduce you to the joys of retouching.

Editing Non-Destructively

When you use a Photoshop Elements tool or menu command, the results almost always change the original pixels in some way, shape, or form. For that matter, any tool or command used in most image-editing program changes pixels. So what happens when good pixels turn terribly wrong? Well, you have the Undo command, but image-editing programs allow you only a limited number of uses of that command. Some image-editing applications allow you to increase the number of times you can use the Undo command, but this takes up system resources, resources you should be using to edit your images.

So, when your editing goes horribly wrong, you may end up starting from scratch again, which sucks up your valuable time. However, if you take advantage of the tools that programs like Photoshop Elements have to offer, you can edit non-destructively. To edit non-destructively in Photoshop Elements or similar applications, you need the option to create layers. You can have clear layers, upon which you add text, make marks with drawing tools, and so on. But when you're retouching images, you work with duplicates of the original layer. You do all of your editing and retouching on one or more duplicate layers. If you don't like the end results, just delete the duplicated layer, and you've still got your original layer intact.

To create a layer that's a carbon copy of the Background layer in the Photoshop Elements Full Photo Edit workspace, follow these steps:

1. **On the Layers panel, click the layer you want to duplicate.**

 Your original image has only one layer, the Background layer, and it is selected by default.

2. **Choose Layer⇨Duplicate Layer.**

 The Duplicate Layer dialog box appears. (See Figure 11-1.)

Figure 11-1: Creating a new layer.

3. **Enter a name for the layer in the As text box.**

 Enter a name that reflects the purpose for which you're using the layer. If you're retouching an image, **Retouch** is a good choice.

4. **Click OK.**

 Photoshop Elements creates a new layer.

5. **To apply changes to the layer, select it by clicking it on the Layers panel.**

 The selected layer is highlighted on the Layers panel. (See Figure 11-2.)

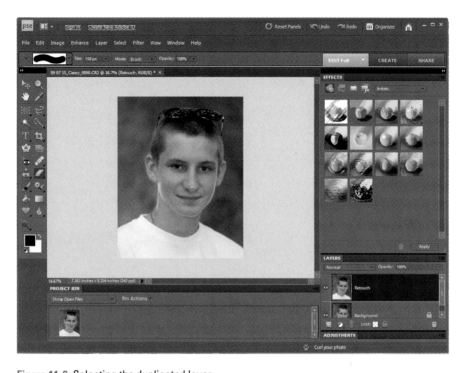

Figure 11-2: Selecting the duplicated layer.

6. **Click the eyeball icon to the left of a layer to hide it.**

7. **To delete a selected layer, click the Delete icon that looks like a trash can.**

 Alternatively, if you prefer to work with menu commands, you can choose Layer➪Delete Layer.

8. **After editing a layer to perfection, click the Lock icon on the Layers panel.**

 A lock icon appears next to the layer, indicating that you can't do any work on it. Click the Lock icon again to unlock the layer.

9. **After you've finished editing the image, choose Layer➪Flatten Image.**

 Use this command only after all of your edits are done. If, for any reason, you need to stop your work and resume at a later date, save the image using Photoshop Element's native .psd format. When you save an image in the * .PSD format, you have access to any layer you've created when you open the document again. If you flatten the image, the layers are merged into the background layer. For more information on saving images, see Chapter 10.

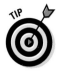

TIP

If you like keyboard shortcuts, press Ctrl+J to duplicate the background layer without opening the Duplicate Layer dialog box. This creates a carbon copy of the original layer, with the name Layer 1. If you want to rename the layer, click its name on the Layers panel and then enter the desired name.

Removing the Background

Did you ever take a perfect photograph of someone in front of a less than perfect background? If so, you'll be happy to know that you can extract a subject from a background in Photoshop Elements using the Magic Extractor. The command does an amazingly good job of extracting a subject from its background. To extract a subject from a background, follow these steps:

1. **In the Organizer, select the image you want to edit, and then choose Full Photo Edit from the Fix drop-down menu.**

 Photoshop Elements opens the image in the Full Photo Edit workspace.

2. **Choose Layer⇨Duplicate Layer.**

 The Duplicate Layer dialog box appears.

3. **Enter a name for the layer.**

 Extraction is a good name.

4. **Press OK.**

 Photoshop Elements creates a duplicate layer. If the extraction isn't perfect, you still have the original image as a backup from which you can start anew.

5. **Choose Image⇨Magic Extractor.**

 The Magic Extractor dialog box appears. (See Figure 11-3.)

6. **Select the Foreground Brush tool and click inside the subject you want to extract from the background.**

 When you have a complex image with many colors, such as the one shown here, click several times to accurately define the borders of the area you want to extract. If you're working with an image with large dimensions, increase the Brush Size so you can see your work. The default size of 20 pixels barely shows up on large images.

7. **Select the Background tool and click inside the area you want to remove.**

Background Brush tool

Foreground Brush tool

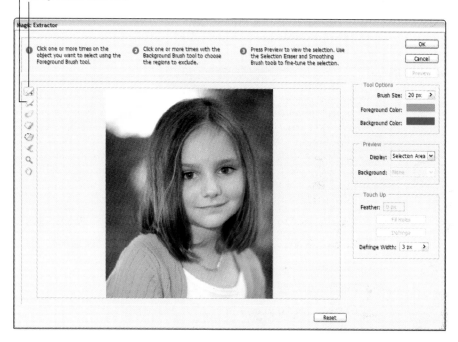

Figure 11-3: Extracting a subject from the background.

When you have an image with lots of colors, and some that are similar to your subject, click as many areas as possible to accurately define what you don't want after the extraction. (See Figure 11-4.)

8. **Fine-tune your work with the Point Eraser tool.**

The tool works like a standard eraser. Drag it over the points you need to erase.

9. **Click Preview.**

The Magic Extractor does its thing and extracts your subject from the background. (See Figure 11-5.) Be patient, as this step may take some time.

Point Eraser tool

Add to Selection tool

Remove from Selection tool

Hand tool

Zoom tool

Figure 11-4: Defining the area you want to extract.

10. Clean up the extraction using the following tools:

- *Add to Selection:* Use this tool to paint in any areas that were removed but need to be in the final final image. For example, if part of the person's face or hair was extracted, you use this tool to add them back to the image.

- *Remove from Selection:* Use this tool to erase any areas that you don't want in the final extraction.

- *Smoothing Brush:* Use this tool to smooth any jagged edges.

Smoothing tool

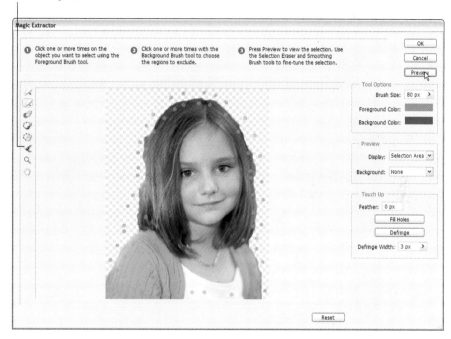

Figure 11-5: Previewing the extraction.

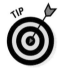

Use the Zoom tool to zoom in on areas you need to clean up. You can then use the hand tool to pan to different areas of the image.

11. Use the following Touch Up options to fine-tune the extraction:

- *Fill Holes:* Click this button to fill any holes in the extraction.

- *Defringe:* Click this button to smooth the edges of the extraction.

12. Click OK.

The Magic Extractor does its thing and closes.

13. On the Layers panel, click the eyeball icon for the Background layer.

The Background layer is hidden, and you can examine the extraction. (See Figure 11-6.) In this case, some further work is needed because of the little girl's fly-away hair.

14. On the Layers panel, Ctrl+click the Extraction layer.

Photoshop Elements creates a selection based on the layer content.

15. **Choose Select⇨Refine Edge.**

 The Refine Edge dialog box appears. (See Figure 11-7.)

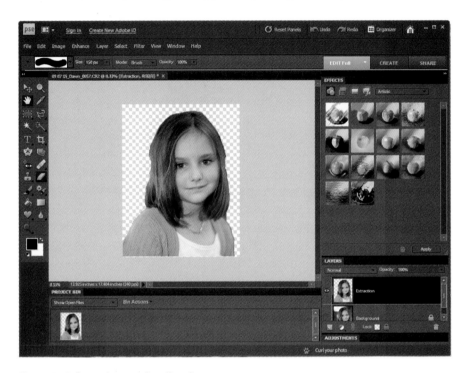

Figure 11-6: Surveying your handiwork.

16. **Enter values for Smooth, Feather, and Contract/Expand.**

 The values are in pixels and differ depending on the size of your image. Click the red chain icon to view a red overlay on the image. This shows you what the refined edge looks like and updates in real time as you change values. Your goal is to smooth the edges and decrease the size of the selection to remove any rough edges.

17. **When you're satisfied with the refined edge, click OK.**

 Photoshop Elements refines the edge.

18. **Press Ctrl+J to create a new layer based on the selection.**

 The new layer is slightly smaller than the extraction layer.

19. **Click the eyeball icon on the Extraction layer.**

The only visible layer is the one you created based on the selection. If the results are pleasing, you're ready to replace the background as shown in the upcoming section. If the results aren't acceptable, delete the duplicate of the extraction layer and repeat Steps 14 through 18, this time entering different values in Step 16.

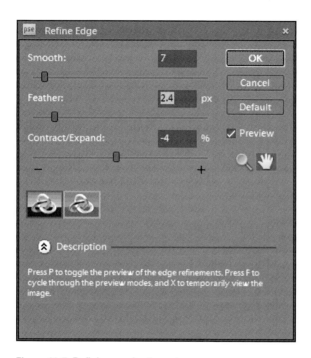

Figure 11-7: Refining a selection edge.

Creating a Digital Background

After you extract an object from the background, you can replace the background. You can replace the background using a photo that's the same size, or you can create a background in Photoshop Elements. To create a background in Photoshop Elements, follow these steps:

1. **Extract a subject from its background.**

 OK. I'm making an assumption that you read the previous section. If you didn't, please read the section "Removing the Background," which precedes this section.

2. **Select the Background layer.**

 That's the layer with your original image. By making this selection, you create the digital background on top of this layer.

3. **Click the Adjustment Layer icon (the circle that's half gray and half white), and choose Solid Color.**

 The Pick a Solid Color dialog box appears. (See Figure 11-8.)

Figure 11-8: Adding a solid color background.

Alternatively, you can replace the background with a *gradient*, which is a blend of two or more colors. To replace the background with a gradient, choose Gradient in this step.

4. **Select a color.**

 You can enter values in the HSB or RGB fields, or you can drag the slider next to the vertical color swatch to select a hue, and then drag inside the square to set the saturation and brightness. Alternatively, you can move your cursor outside the dialog box and into the image, when you'll see an eyedropper icon. Click inside the image to sample a color.

5. **Click OK.**

 Photoshop Elements adds the solid-color layer to the image. (See Figure 11-9.)

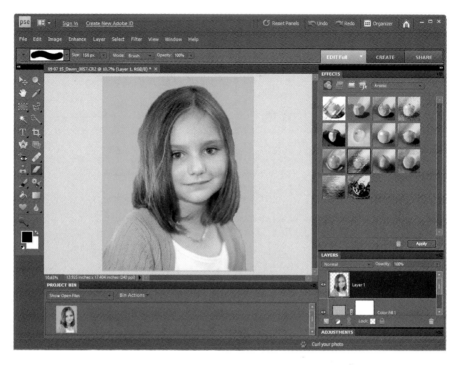

Figure 11-9: Adding a color background to an image.

Retouching Your Portraits

Unless you're photographing professional models who have had makeup meticulously applied by professional makeup artists, you're going to have some issues with your images. If you photograph children and teenagers, you'll have to deal with blemishes — a.k.a. *zits*. Other issues you'll have to deal with are skin texture and character lines. Skin texture and character lines are fine if you're photographing Clint Eastwood, but if you're photographing your wife, or any female friend, texture and wrinkles are not a good thing. As if that wasn't enough to think about, there's also the issue of retouching portraits of middle-aged people and older folks. How much retouching do you do and still make it look real? I show you how to address these issues and more in the upcoming sections.

Of course it's a good idea to discuss retouching with your subject. When a client hires me to photograph a portrait of them, I always discuss retouching after I'm finished with the photo shoot. That gives me time to observe the

subject carefully and get to spot any potential flaws that may detract from the photograph. I avoid getting technical. I tell them what can be accomplished, and then ask them if there are any areas they'd like me to retouch.

Softening skin

When you photograph someone with a sharp lens, you capture every subtle nuance of your subject, and some not so subtle nuances. When you photograph a woman and your lens reveals a lot of texture, this is not a good thing. Many photographers have a technique for softening skin. The trick is to get silky looking soft skin without the Barbie Doll look. The following steps show you how to achieve this goal:

1. **In the Organizer, select the image you want to edit, and then choose Full Photo Edit from the Fix drop-down menu.**

 Photoshop Elements opens the image in the Full Photo Edit workspace.

2. **Choose Layer⇨Duplicate Layer.**

 The Duplicate Layer dialog box appears.

3. **Enter a name for the layer.**

 Skin Softening makes sense to me.

4. **Click OK.**

 Photoshop Elements creates a new layer.

5. **Choose Filter⇨Blur⇨Gaussian Blur.**

 The Gaussian Blur dialog box appears. (See Figure 11-10.)

6. **Enter a value of 6 in the Radius text box and click OK.**

 The blur is applied to the entire layer. However, you still want to see sharp details around areas like your subject's hair, eyes, eyebrows, and so on. Note that this value is for a full-sized image as it comes from the camera. If you're editing an image that's 10 megapixels or less, you may have to use a smaller value. In a nutshell: If you don't like the results, undo the step and then repeat with a different value.

7. **Select the Eraser tool.**

 That's right; you're going to erase the areas to which you don't want the blur applied.

8. **Click the drop-down arrow to the right of the currently selected brush and choose a soft brush tip from the menu. (See Figure 11-11.)**

 Soft-edged brush tips have icons that are blurry around the edges. This effectively blends the remaining pixels on the layer you're working on with the pixels on the underlying layer instead of creating a harsh edge that's a dead giveaway that you've edited the image.

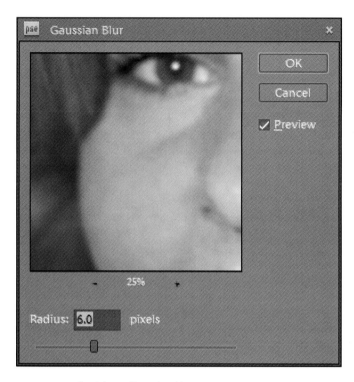

Figure 11-10: Applying a Gaussian blur.

Figure 11-11: Choosing a soft brush tip.

9. **Click the eyeball icon to the left of the Background layer.**

 The Background layer is hidden from view. This makes it easier to erase the areas you don't want blurred on the Skin Softening layer.

10. **Erase the areas you don't want blurred.**

 Erase the hair, eyes, eyebrows, and other details that you want to remain sharp. You may have to resize the brush several times while erasing. Remember, you can press the right bracket key (]) repeatedly to increase brush size, or the left bracket key repeatedly to decrease brush size.

11. **Click the blank spot to the left of the Background layer.**

 The Background layer is revealed. The skin looks good, but it looks like a plastic Barbie Doll.

12. **Select the Skin Softening layer and change the blend mode to Darken.**

 The skin looks soft, but realistic, and not plastic.

13. **When you've finished editing the image, choose Layer⇨Flatten Image.**

 The image is flattened to a single layer and ready for saving to the format of your choice.

Removing blemishes

Your subjects will appreciate it if you remove any blemishes, such as pimples. If you photograph adolescents, pimples are a fact of life. Photoshop Elements gives you two tools for removing blemishes: the Spot Healing Brush tool and the Healing Brush tool. The Spot Healing Brush tool samples the pixels surrounding the area you're repairing. This tool is useful when you've got small areas to repair like pimples. When it comes to slightly larger areas, or the surrounding pixels are not similar to the area you want to repair, you use the Healing Brush tool. This tool gives you complete control over the healing process because you choose the area from which Photoshop Elements heals the target area.

To give your subject a squeaky-clean complexion with the Spot Healing Brush tool, follow these steps:

1. **In the Organizer, select the image you want to retouch.**

2. **Choose Full Photo Edit from the Fix drop-down menu.**

 The retouching tools aren't available in Quick Photo Edit mode.

3. **Press Ctrl+J to duplicate the Background layer.**

 If you do your retouching on a duplicated layer and it doesn't turn out as you planned, you can delete the duplicated layer and still have your original image intact.

4. **Zoom in on the area you want to retouch.**

5. **Select the Spot Healing Brush tool.**

 This tool looks like a Band Aid with a small circle beside it.

6. **Move your cursor over the area you want to retouch, and then size the brush.**

 You can change the brush size by entering a value in the Options bar, by pressing the right bracket key (]) repeatedly to increase the brush size, or by pressing the left bracket key ([) repeatedly to decrease the brush size.

7. **Click the blemish to remove it.**

 Photoshop Elements samples the surrounding area and uses the information to remove the blemish. (See Figure 11-12.)

Figure 11-12: Removing blemishes with the Spot Healing Brush tool.

To remove a blemish with the Healing Brush tool, follow these instructions:

1. **Repeat Steps 1 through 4 in the preceding list.**

2. **Select the Healing Brush tool.**

 The Healing Brush tool occupies the same space on the toolbar as the Spot Healing Brush tool. Click the triangle in the lower-right corner of the tool to reveal a fly-out menu that reveals the Spot Healing Brush tool and the Healing Brush tool.

3. **Move your cursor over the area you want to retouch, and then size the brush.**

4. **Alt+click an area of clean skin.**

 Sample an area of skin with the same texture as the area you're repairing.

5. **Click the blemish to remove it.**

Enhancing your subject's eyes

The eyes are the windows to the soul, and usually the first thing you notice when you look at a portrait. When I retouch a portrait, I brighten the whites of the eyes and apply a bit of sharpening as well. This makes the eyes stand out in the image. Whether your subject is a child or a senior citizen, this simple process almost always gives you a better portrait. To enhance your subject's eyes, follow these steps:

1. **In the Organizer, select the image you want to retouch.**

2. **Choose Full Photo Edit from the Fix drop-down menu.**

 The tools you need to enhance the eyes are available only in Full Photo Edit mode.

3. **Press Ctrl+J to duplicate the Background layer.**

4. **Zoom in on your subject's eyes.**

5. **Select the Dodge tool.**

 The Dodge tool is used to brighten areas.

6. **In the Option bar, change the Exposure value to 25%.**

 The default value, 50%, is way too bright for this task. Your goal is to brighten the whites, not replicate the "deer in the headlights" look.

7. **Resize the brush if necessary.**

 You can increase the brush size by repeatedly pressing the right bracket key (]), or decrease the brush size by repeatedly pressing the left bracket key ([).

8. **Click and drag inside the whites of your subject's eyes.** (See Figure 11-13.)

 After brightening the whites of the eyes, you can draw further attention to your subject's eyes by applying some sharpening.

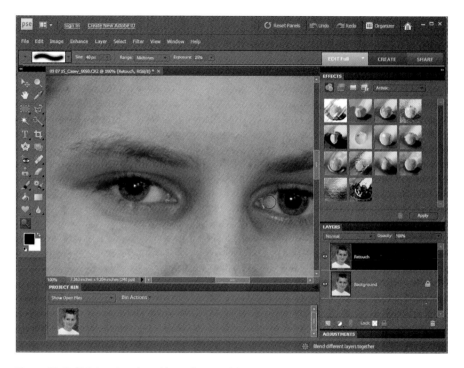

Figure 11-13: Brightening the whites of your subject's eyes.

9. **Choose Enhance⇨Adjust Sharpness.**

 The Adjust Sharpness dialog box appears.

10. **Enter a value of 150 in the Amount text box, as shown in Figure 11-14.**

 You'll see the results in the dialog box. If the sharpening looks too severe, reduce the amount to a value between 100 and 125. The other defaults for sharpening are perfect for this purpose.

11. **Click OK to apply the sharpening.**

 Unfortunately, the sharpening is applied to the entire image. But the fact that you're doing your retouching on a layer means you can erase everything on the layer but the eyes.

12. **Select the Eraser tool and choose a brush tip with a soft edge from the Brush Presets drop-down menu.**

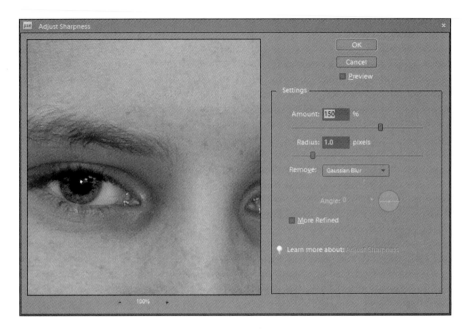

Figure 11-14: Sharpening the eyes with the Adjust Sharpness command.

A brush with a soft edge blends the pixels from the layer you're erasing with the pixels from the underlying layer. A brush tip with a hard edge leaves a harsh edge, which is a dead giveaway that the image has been edited.

13. **Resize the brush to suit your image.**

You can increase the brush size by repeatedly pressing the right bracket key (]), or decrease the brush size by repeatedly pressing the left bracket key ([).

14. **Erase everything but the eyes.**

This works better if you have a digital tablet and stylus.

15. **After you finish editing the image, choose Layer➪Flatten Image.**

Photoshop Elements flattens the image to a single layer.

On the Layers panel, click the eyeball icon for the background layer. This momentarily hides the Background layer so you can see exactly what you're erasing.

Retouching portraits of older subjects

When you photograph someone with lots of miles on the odometer, retouching is a touchy subject — redundancy intended. After all, nobody really expects someone who's pushing 60 to look like a 20-year old. If someone looks at a

portrait of an older person with flawless skin and no wrinkles and then sees the actual person, it's obvious that some digital hanky-panky has been applied to the image. The trick is to retouch the portrait enough to make it look like the photo was taken when the person was extremely relaxed, and extremely well rested. Here's how to retouch a photo of an older person:

1. **In the Organizer, select the image you want to edit, and then choose Full Photo Edit from the Fix drop-down menu.**

 Photoshop Elements opens the image in the Full Photo Edit workspace.

2. **Choose Layer⇨Duplicate Layer.**

 The Duplicate Layer dialog box appears.

3. **Enter a name for the layer.**

 Retouch is a good name.

4. **Use the Healing Brush and/or Spot Healing Brush tool to remove blemishes and age spots.**

 If you don't know how to use these tools to remove blemishes, refer to the section, "Removing blemishes," earlier in this chapter.

5. **Zoom in on the eyes.**

6. **Select the Healing Brush tool.**

7. **Alt+click an area of skin with no wrinkles that is about the same texture as the area around the eyes.**

8. **Resize the tool if necessary.**

 The tool should be slightly bigger than the wrinkles you're healing.

9. **Click and drag across the fine wrinkles around the eyes.**

 Drag the tool across the wrinkle in one motion. (See Figure 11-15.)

10. **Continue healing other wrinkles and character lines.**

 Remember to sample a new area each time, one that matches the texture in the area you're repairing.

11. **Select the Retouch layer on the Layers panel.**

12. **Reduce the layer opacity until you start to see a trace of the wrinkles.**

 I find somewhere between 70 and 80 percent works well. (See Figure 11-16.) Your goal is to create a believable retouching job.

13. **After you finish editing the image, choose Layer⇨Flatten Image.**

 Photoshop Elements flattens the image to a single layer.

If your subject has flaws or character traits he wants you to eliminate, do this work on another layer and leave the layer opacity at 100 percent.

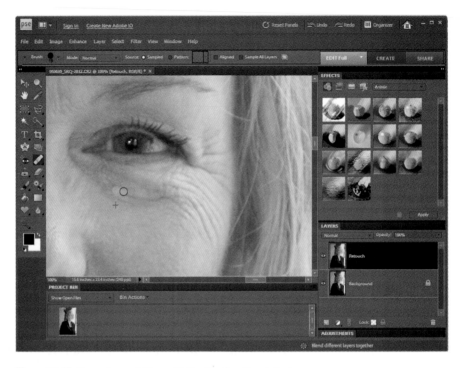

Figure 11-15: Removing wrinkles with the Healing Brush tool.

Figure 11-16: Reducing the layer opacity.

Sharing Your Images

*A*fter you get your photos into the computer and edit them to pixel perfection, it's time to share your portraits with friends, relatives, and, of course, the person in the photograph. You have lots of ways to share images, and you can do most of them using Photoshop Elements. In fact, there are so many ways you can share images that I won't be able to show you all of them in one chapter. But I show you the ones I think are important. In addition, I introduce you to some third-party companies you can use to turn your portraits into wall art.

Sending Photo Mail

Sending photos via e-mail is a wonderful way to keep friends and relatives up to date with the important events in your life. Whether you're shooting portraits of friends, or portraits of family members, you can easily share your photos by sending them as Photo Mail by following these steps:

1. **Launch the Photoshop Elements Organizer workspace.**

2. **Select the photo you want to send.**

 You can locate a photo using the Find command, or by clicking the applicable keyword tag. You are assigning keywords to your photos when you download them, aren't you?

3. **Click the Share button.**

The options for sharing photos appear.

4. **Click Photo Mail.**

The right pane of the Organizer changes and shows the Photo Mail options. A thumbnail of the photo appears along with the estimated size and download time . (See Figure 12-1.) At this time, you can also drag other photos from the Organizer into the Photo Mail dialog box.

Figure 12-1: This photo is going to be sent via e-mail.

You may be tempted to send lots of photos in one e-mail message. If you send more than two or three photos, the message will take a long time to download, especially if your recipient has a slow Internet connection.

5. **Click Next.**

The Organizer refreshes and shows you additional options. (See Figure 12-2.)

6. **Select a recipient from your recipient list.**

Photoshop Elements has a Contact Book. You can add people to your Contact Book by clicking the man-shaped icon to the right of the Select Recipients title. The Contact Book gives you the option of adding new contacts by importing contacts from vCard Files, Microsoft Outlook, or Outlook Express. The Contact Book is quite easy to use.

You can also access the Contact Book in the Organizer by choosing Edit⇨Contact Book.

7. **If desired, modify the message.**

 You can delete the default message and type your own, or add to the default message.

8. **After Selecting one or more recipients and modifying the message, click Next.**

 The Stationery and Layouts Wizard appears, (See Figure 12-3.) The Stationery and Layouts Wizard lets you choose a frame from one of the categories.

Contact Book icon

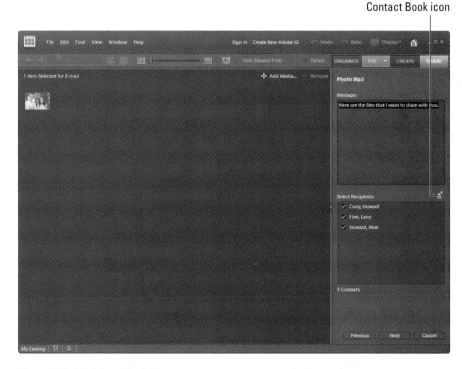

Figure 12-2: Decisions, decisions.

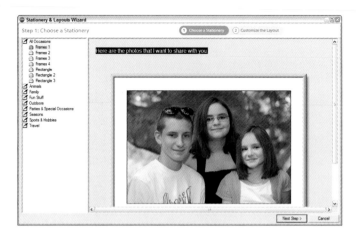

Figure 12-3: Choosing a frame for your photos.

9. **Select a frame for the photo.**

 There are several categories of frames on the side of the dialog box. When you choose a new frame, the preview changes.

10. **Type a caption below the photo.**

 To add a caption to the photo, click (Enter Caption Here) and then type your caption. Alternatively, you can select the default caption and then press Backspace to delete the caption.

11. **Click Next Step.**

 The Wizard refreshes. Now you have options to customize the layout by selecting a different background color, changing the photo size, changing the layout if you're sending multiple photos, changing the font family and font color, changing the border style and color, and deciding whether or not to include a drop shadow with the Photo Mail. (See Figure 12-4.)

12. **Click Next.**

 The photo is handed off to your default e-mail application with the recipients' e-mail addressee(s) already inserted in the To: field, along with the Subject (Here are the photos that I want to share with you.) and message.

13. **Click Send.**

 The photo mail is sent into Cyberspace at the speed of light. To Cyberspace and beyond!

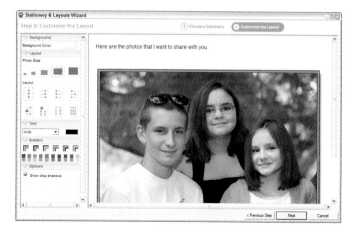

Figure 12-4: Customizing the layout.

Printing from Photoshop Elements

Creating prints you can share with friends and relatives is an ideal way to show your prowess as a portrait photographer. Give prints to people you've photographed as a token of your appreciation for letting you take their photograph. Who knows? The person may ask you how much extra prints cost. If you've taken pictures of a family, give the family a print of the best image from your shoot. The family members may get excited and order other prints for their friends and relatives. Prints are also great for holiday greeting cards and the like. You can easily print your images from Photoshop Elements by following these steps:

1. **Launch the Photoshop Elements Organizer workspace.**

2. **Select the photo you want to print.**

3. **Click the Create button and choose Photo Prints.**

 The panel refreshes to show the Photo Prints options.

 You can also use the Photo Print options to upload and order prints through Shutterfly and Kodak Gallery.

4. **Click the Print with Local Printer button.**

 The Prints dialog box appears. (See Figure 12-5.)

5. **Select a printer from the Select Printer drop-down menu.**

 The drop-down menu lists all the printers available from the computer and local network.

Figure 12-5: Printing one copy of an image.

6. **Accept the default Printer Settings options or click the Change Settings button.**

 The default settings are fine in most instances. If you click Change Settings, you see a dialog box that contains a list of parameters you can modify for the selected printer. When you're done with that dialog box, click OK.

7. **Choose an option from the Select Paper Size drop-down menu.**

 Select the size that matches the media in your printer.

8. **Accept the default Individual Prints option in the Select Type of Print drop-down menu.**

 You can also print a contact sheet or a print package. I show you how to create these options in upcoming sections.

9. **Select a size from the Select Print Size drop-down menu.**

10. **Decide whether you want to crop the image to fit the size and media.**

 If you crop to fit, you lose information from the image. If you deselect this option, the image will be displayed in the window at its original aspect ratio, and it will be sized to fit the longest dimension of the print size.

 If you're printing the image for a specific paper size, open the image in one of the edit workspaces and use the Crop tool to crop the image to the print size.

11. **On the Print X Copies of Each Image line, click the spinner arrows to determine the number of copies to print.**

12. **Click the Page Setup button.**

 This opens a dialog box with setup options for the selected printer. When you're done, close the dialog box by clicking OK.

13. **Click Print.**

 Photoshop Elements sends the information to your printer, which prints the image.

Creating a Picture Package

Photoshop Elements has a variety of printing options. One option is to create a *picture package*. When you create a picture package, you print multiple copies of the same image on the same sheet of paper at different sizes. This option is handy when you're creating prints for friends and relatives. They can choose how to use the images on the page. For example, they may frame one of the images, use another in a scrapbook, and use others for wallet inserts. To create a picture package, take these steps:

1. **Launch the Photoshop Elements Organizer workspace.**

2. **Select the photo you want to print.**

 You can also select multiple photos when you create a picture package. The following steps assume you're using one photo for the picture package.

3. **Click the Create button and choose Photo Prints.**

 The panel refreshes to show the Photo Prints options.

4. **Click the Print Picture Package button.**

 The Prints dialog box appears, as shown in Figure 12-6.

5. **Choose a printer from the Select Printer drop-down menu.**

 This menu shows a list of all printers connected to your computer or available from the local network.

Figure 12-6: Creating a picture package.

6. **Accept the default Printer Settings or click the Change Settings button.**

 If you click Change Settings, a dialog box with parameters you can change for the selected printer appears. This dialog box lets you change settings that are related to the printer you select. After changing the desired settings, click OK to exit the dialog box.

7. **Select an option from the Select Paper Size drop-down menu.**

 Choose a size that matches the media in your printer media tray.

8. **For the Select Type of Print drop-down menu, accept the Picture Package option.**

9. **Choose a layout from the Select a Layout drop-down menu.**

 This menu lists the presets for the picture package option.

10. **Choose an option from the Select a Frame drop-down menu.**

 The default option prints the images with no frame. If you choose a different option, the image thumbnails update to give you a preview of the images with the selected frame.

11. **Select the Fill Page With First Photo check box.**

 This option fills the picture package with the image selected. (See Figure 12-7.) You can also create a picture package with multiple images. For information on every Photoshop Elements printing option, consider purchasing *Photoshop Elements 8 For Dummies* by Barbara Obermeier and Ted Padova (Wiley Publishing).

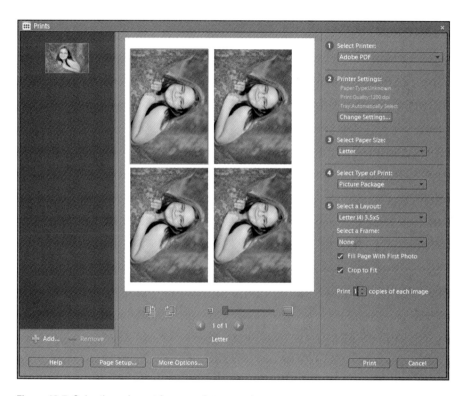

Figure 12-7: Selecting a layout for your picture package.

12. **Decide whether you want to crop the images to fit the images in the picture package.**

 If you accept the default option and the images are a different aspect ratio than the images in the picture package, the images are cropped to fit.

13. **On the Print X Copies of Each Image line, click the spinner arrows to determine the number of copies to print.**

14. **Click the Page Setup button.**

 This opens a dialog box with setup options for the selected printer. When you're done, close the dialog box by clicking OK.

15. **Click the Print button.**

 Photoshop Elements sends the information to your printer, which prints the picture package.

Creating a Contact Sheet

The beauty of digital photography is that you can take lots of pictures, store them on memory cards, and download them to your computer. The curse of digital photography is that you can take lots of pictures, store them on memory cards, and download them to your computer. You end up with a lot of photos on your computer, and after you separate the wheat from the chaff, you end up with lots of images that you think are keepers. But if you're going to print images from the shoot for your subject, she may not share the same opinion as you. Instead of printing lots of images from the shoot and letting your subject decide which ones to print, you can create a sheet with small images and let her choose the ones she likes best. This neat sampler is known as a *contact sheet.* You can easily create a contact sheet from Photoshop Elements as follows:

1. **Launch the Photoshop Elements Organizer workspace.**

2. **Select the photos you want on the contact sheet.**

 Ctrl+click the desired photos. You can select as many photos as you want. Photoshop Elements prints more than one contact sheet if necessary.

3. **Click the Create button and choose Photo Prints.**

 The panel refreshes to show the Photo Prints options.

4. **Click the Print with Local Printer button.**

 The Prints dialog box appears.

5. **Select an option from the Select Printer drop-down menu.**

 The drop-down menu lists all printers connected to your computer and or the local network.

6. **Accept the default Printer Settings options or click the Change Settings button.**

The default settings work great in most instances. If you click the Change Settings button, you see a dialog box that contains a list of options for the selected printer. Accept the default options, or modify them to suit your preference. After making the desired changes, click OK to exit the dialog box.

7. **Choose an option from the Select Paper Size drop-down menu.**

 Select the size that matches the media in your printer.

8. **Choose the Contact Sheet option from the Select Type of Print drop-down menu.**

 The dialog box refreshes to show the default layout using the selected photos. (See Figure 12-8.)

9. **Accept the default for the Crop to Fit check box, which is selected.**

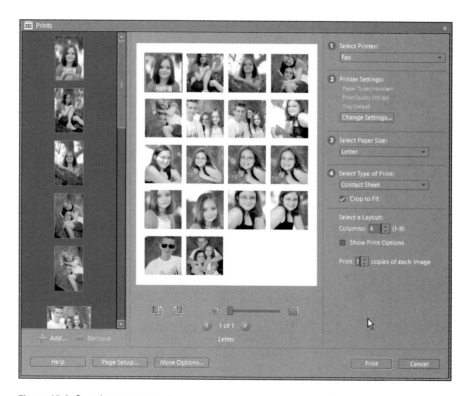

Figure 12-8: Creating a contact sheet.

This option crops the images to fill in a square. If you deselect this option, the images fill the square space using the default aspect ratio of the images, which leaves a white area around the smaller dimension. I almost always deselect this option in order to get a look at the entire image.

10. **In the Select a Layout section, specify the following options:**

 • *Columns:* Click the spinner arrows to increase or decrease the number of columns in the contact sheet. After you make a change, the thumbnails in the dialog box update in real time to reflect your change.

 • *Show Print Options:* Select this check box to reveal the following options: Date, which prints the current date under each image; Caption, which prints the image caption under each image; Filename, which prints the filename under each image, and Page Numbers, which prints the page number when you create a contact sheet with enough images to require multiple pages.

 • *Print X Copies of Each Image:* Click the spinner arrows to print multiple copies of each contact sheet.

11. **Click the Page Setup button.**

 This opens a dialog box with setup options for the selected printer. When you're done, close the dialog box by clicking OK.

12. **Click the Print button.**

 Photoshop Elements sends the information to your printer, which prints the contact sheets.

Using third-party papers

There are lots of companies that manufacture paper for printing digital images. Some of them are more economical than the paper available from your printer manufacturer, and others are available to create fine art prints. For example, there are papers with a high rag contact that make your images look like artwork instead of photos. When you print images from Photoshop Elements, the printer determines how much of each ink is laid down on the paper to create the resulting image. However, when you use third-party paper (paper not manufactured by the company that made your printer), your printer has no way of knowing how much ink to lay down to replicate what you see on your computer screen. When this is the case, you need to get an ICC profile for the paper and your printer. Many manufacturers of fine art photo paper (such as Ilford and Hahnemühle) have profiles you can download for your printer and their paper. They also supply instructions on where the profile needs to be stored on your system, and how to use the profile with many popular image-editing applications such as Photoshop Elements and Photoshop.

Showing Off with a Slide Show

You can create a very cool slide show using images from your Photoshop Elements Organizer workspace. You determine how long each slide is displayed, the transition between slides, and so on. To create a slide show, first you need to do some setup work, and then you can add some fancy tricks. When your slide show is all set up to your liking, you can output it for sharing. The following sections cover all these tasks.

Setting up a slide show

Before you can output a slide show, you need to set some parameters for your slide show and select the images. It may seem like a lengthy process, but the results are well worth it. To set up your slide show, follow these steps:

1. **Launch the Organizer workspace.**

2. **Select the images for your slide show.**

 To select a range of images, Click+ Shift the first image, and then Click + Shift the last image. The first and last images will be selected as well as the images in-between. To select individual images, Ctrl+Click each image you want to include in the slide show.

3. **Click the Create button and then click the Slide Show button.**

 The Slide Show Preference dialog box appears. (See Figure 12-9.) This dialog box appears the first time you choose to create a slide show.

4. **Choose an option from the Static Duration drop-down menu.**

 This option determines the duration for which each slide is displayed.

5. **Choose an option from the Transition drop-down menu.**

 The default option is Fade, which in my humble opinion is perfect for portraits. Experiment with the other options to see what's possible. I advise you not to select the Random option, which creates a disjointed, and amateurish-looking slide show.

6. **Choose an option from the Transition Duration drop-down menu.**

 This option determines the amount of time it takes to transition from one slide to the next.

7. **Accept the default background color of black or click the Background Color swatch to choose a different color. If you accept the default color, go to Step 9.**

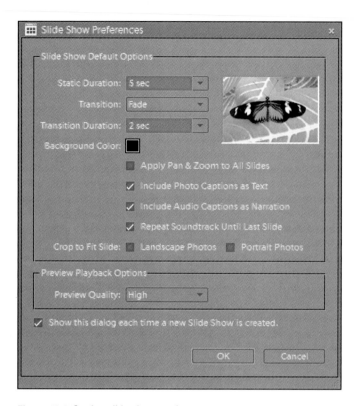

Figure 12-9: Setting slide show preferences.

If you decide to venture beyond the "Bad in Black" background and click the Background Color swatch, the Photoshop Elements Color Picker is displayed, as shown in Figure 12-10. Drag the slider on the right to select the hue; click inside the well to select a color.

8. Click OK to apply the new background color.

9. Select or deselect the following check boxes:

- *Apply Pan & Zoom to All Slides:* This option causes each slide to move and changes the magnification. This is similar to the Ken Burns effect.

- *Include Photo Captions as Text:* Displays photo captions as text beneath each slide.

- *Include Audio Captions as Narration:* If you've added audio captions to any slide, the caption is added as audio narration.

- *Repeat Soundtrack Until Last Slide:* Repeats the soundtrack if added until all slides have been displayed.

10. **Next to Crop to Fit Slide, select a cropping option: Landscape Photos or Portrait Photos.**

 You can crop landscape photos to fit the slide show dimensions, or crop portrait photos to fit the slide show dimensions.

Figure 12-10: Selecting a background color for the slide show.

11. **Choose an option from the Preview Quality drop-down menu.**

 The default option previews your slide show as high-quality images. If your computer is older, the time required to build the preview may be shorter if you choose a lower-quality option.

12. **Accept the option to show the dialog box each time you create a slide show.**

 This gives you the option to change slide show parameters for each show. Deselect this check box if you want to use the same options for all shows.

13. **Click OK.**

 The preferences are saved, and the Slide Show Editor appears. (See Figure 12-11.)

14. **Click the Save Project button.**

 This opens the Elements Organizer dialog box, which is self-explanatory.

15. **Enter a name for the slide show and click Save.**

 This step saves the project in the Photoshop Elements Organizer workspace, which means you can edit the show at any time.

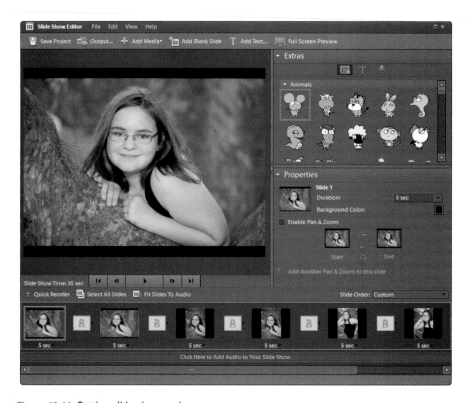

Figure 12-11: Setting slide show options.

Adding pizzazz to your slide show

Now that you've done the preliminary setup, it's time to add some panache to your slide show. In this section, I show you how to add additional media to the show, create title slides, and more. Here's what you need to do:

- ✔ **Add media.** If desired, click the Add Media button and choose an option from the drop-down menu. This option enables you to add media from the Elements Organizer or from a folder on your computer.

- ✔ **Add a blank slide.** If desired, click the Add Blank Slide button. This step adds a blank slide after the currently selected slide. You can use a blank slide as an intro to your slide show.

- ✔ **Add text.** Click the Add Text button. The default text is displayed on top of the currently selected slide, and the Edit Text dialog box appears. Enter the desired text and click OK. The text is displayed on top of the slide. You can drag the text to the desired location.

✓ **Change the order of the slides.** Drag a slide from the film strip at the bottom to change the order in which it plays. This is a quick and easy way to change the order of your slide show or to bring a blank title slide to the start of the slide show.

✓ **Add other extra goodies.** In the Extras section, you can add the following to any slide by clicking an icon:

- *Graphics:* This option displays graphic categories below the Extras icons. There are several categories from which to choose. Drag and drop the graphic on the slide and then use the handles to resize it.

- *Text:* This option displays the letter *T* using several different font styles. Drag the desired style over a slide, which displays text options in the Properties panel. Change the text and modify to suit your slide show. The text is displayed over the slide. This is a great option for noting the place a photo was taken or the name of the person in the photo. Click and drag the text to the desired location within the picture. You can also change the font type, color, size and so on in the Properties panel, which appears below the Extras panel.

- *Narration:* This option opens a dialog box that enables you to record an audio narration for the slide.

✓ **Modify the properties of a slide.** In the Properties panel, you can change properties for the selected slide. You can change the duration for which the slide is displayed, the background color, and enable Pan & Zoom for the selected slide. If you choose the latter option, you can change the area to which the slide is cropped as well as its position at the start and end of its duration. You can't increase the magnification of the either slide.

✓ **Use the buttons beneath the slide display to preview your show.**

You can change the duration for individual slide by choosing an option from the drop-down menu to the right of each slide. This enables you to specify a duration greater than five seconds. You can also apply the new setting to all slides.

You can change the transition between individual slides by choosing an option from the drop-down menu to the right of each transition icon. You can apply the new transition to all slides.

✓ **Add some audio.** Click the text below the slides to add audio to your show. This opens the Choose Audio files dialog box, which is self-explanatory. Navigate to the desired audio file and click Open to add it to the show.

Outputting your slide for sharing

You're almost ready to razzle and dazzle your friends and relatives with your
slide show. But first you need to decide the format in which your masterpiece
will be saved, the size of the show, and so on. To get your slide show ready
for prime time, follow these steps:

1. **Click the Output button at the top of the dialog box.**

 This step displays the Slide Show Output dialog box. (See Figure 12-12.)

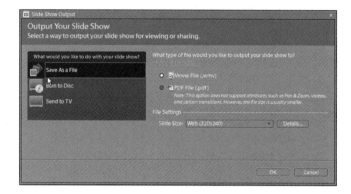

Figure 12-12: Specifying output options for your slide show.

2. **Choose one of the following options:**

 • *Save As a File:* Choose this option to save the slide show as a
 movie or a PDF file. If you choose the former, choose the slide
 dimensions from the Slide Size drop-down menu. Click the Details
 button to see the video options, which cannot be changed, how-
 ever. If you choose PDF File, choose the slide dimensions from
 the Slide Size drop-down menu. Your other options are to play the
 file as a continuous loop while the document is open or to manu-
 ally advance from slide to slide, and to view the slide show after
 saving it.

 • *Burn to Disc:* Enables you to burn the slide show to disc as a self-
 executing Video CD (VCD format) that can be run on a computer or
 a DVD player that supports the format.

 • *Send to TV:* Creates a file that enables you to view the slide show
 on a TV using Window XP Media Center Edition.

3. **Click OK.**

 A dialog box appears, prompting you for a filename and location in
 which to save the file.

4. **Enter a filename. specify a location, and then click Save.**

Creating Wall Art

Your digital portraits get better as you practice your skills. When you get images you're really proud of, you're ready to take the next step and display your work as wall art. If you have a digital camera that's capable of capturing images with a resolution of 8 megapixels or larger, you have the raw ingredients for creating wall art. You can have your images printed by online services such as Shutterfly (www.shutterfly.com) or MPIX (www.mpix.com). Both services offer a wide variety of options for your digital portraits. You can find additional online printing services, but the aforementioned services create good images with a quick turnaround.

When you want to create a different statement for your digital portraits, consider turning one of your portraits into a photo canvas. Photo canvasses are stunning and look great framed or on stretchers. When you choose to have your image on a canvas with stretchers, the image wraps around the stretchers and stands off the wall to make an impressive display of your work. I call on Artistic Photo Canvas (www.artisticphotocanvas.com) when I want to display one of my photos as a canvas. Figure 12-13 shows canvasses displayed on a wall.

Figure 12-13: You can create photo canvasses from your images.

Part IV
The Part of Tens

The 5th Wave By Rich Tennant

"Hey – let's put scanned photos of ourselves through a ripple filter and see if we can make ourselves look wierd."

In this part . . .

In this part of the book, you'll find three chapters. In each chapter, you'll find ten tidbits of information, which, if you do the math on your abacus, amounts to a total of thirty tidbits. You'll find ten tricks and tips that you can use while editing images. You'll also find ten digital photography tips and tricks. And in the final chapter of the book, you'll find ten online resources for digital photography equipment, photo sharing, and so on.

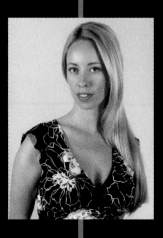

Ten Editing Tips and Tricks

*E*diting portraits can be a lot of fun. It can also be a serious time drain. Sometimes you start working on an image and just get sucked in. Before you know it, half an hour has passed. My motto has always been: "Why work harder if you can work smarter?" In this chapter, I present ten tips and tricks for editing your images.

Replacing a Background

If you've got a portrait with a boring background, like a clear blue sky or a plain white wall, you can easily remove and replace the background. If you've got an image with a solid-colored background that you want to replace, follow these steps in Photoshop Elements 8:

1. **Launch Photoshop Elements in Editing mode, choose File⟶Open, and then navigate to the image you want to edit.**

2. **Choose Layer⟶Duplicate Layer.**

 This creates a carbon copy of the background layer. Eventually, you'll replace the contents of the background layer with a different color. In the interim, the background layer serves as a backup in case you select too much.

3. **Select the Magic Wand tool.**

4. **Adjust the Tolerance setting.**

The Tolerance setting determines how similar the colors must be before they are added to the selection. In most cases, the default setting of 32 works well. However, if in Step 5, you select too much of the area, use a lower tolerance setting. For this image, experimentation showed me a tolerance level of 5 was perfect to select the whole background. (See Figure 13-1.)

Figure 13-1: Adjusting the Tolerance setting of the Magic Wand tool.

5. **Click inside the area you want to select.**

 In this case, you want to select the background, so click anywhere inside the background. After clicking inside the area, you see a flashing border of dashes, which some graphic artists and photographers refer to as a "marching army of ants." (See Figure 13-2.)

6. **Examine the selection carefully and make adjustments as necessary.**

 Your goal is to select as much of the background as possible. If the tool selected some areas that you didn't want selected, lower the Tolerance value and click inside the area of the image you want to select again.

Figure 13-2: Making a selection with the Magic Wand tool.

If the tool didn't select enough of the background, increase the Tolerance value and click inside the image again. If the tool selected more of the image than you wanted, lower the tolerance, and then click inside the area you want to select again.

If any of the background remains unselected, you're going to have to add to the selection as shown in the following steps:

 a. Lower the Tolerance value to about 5.

 b. Shift+click inside the image to add that area to the selection.

 When you press the Shift key, you can add to the selection. Alternatively, you can press the Alt key and click inside an area to delete it from the selection.

 c. Continue adding to the selection until the entire background is included.

7. Choose Select⇨Refine Selection.

The Refine Selection dialog box appears. (See Figure 13-3.)

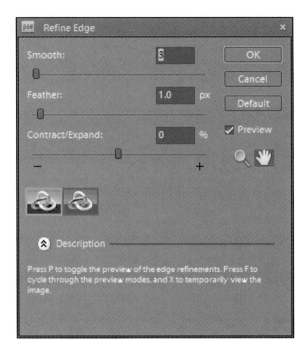

Figure 13-3: Refining the selection.

8. **Adjust the Smooth, Feather, and Contract/Expand values as needed and click OK.**

 This smoothes and shrinks the selection to ensure that none of the background is visible when you delete it.

 - *Smooth:* This control smoothes the edge of the selection. I recommend a value of 6 when you're removing a background.

 - *Feather:* This control determines the size in pixels around the end of the selection that's used to blend the selection with the adjacent pixels. Type **0** in this box when you're removing a background.

 - *Contract/Expand:* This control increases or decreases the size of the selection. When removing a background, it's a good idea to shrink (contract) the selection slightly to get rid of any nearby pixels that may be the border. A value of -2 works well to remove a background.

9. **Press the Backspace key to delete the selection.**

 The selected pixels are transported into cyberspace, or wherever pixels go when they're no longer needed.

If you still see traces of the background, press Ctrl+Z (Windows) or Cmd+Z (Mac) to undo the deletion and then repeat Steps 7 and 8 to further refine the selection until all traces of the background disappear.

10. **Click the Foreground color swatch located at the bottom of the tool bar.**

 The Select Foreground Color dialog box appears.

11. **Select a color that complements the image and click OK to close the dialog box.**

 You can select a color from the dialog box, or click inside the image to select a color from the photo.

12. **On the Layers panel, click the Background layer.**

13. **Press Alt+Backspace.**

 The background is filled with the Foreground Color. (See Figure 13-4.)

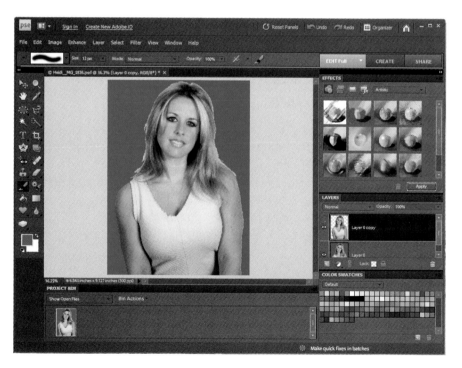

Figure 13-4: Replacing the background with a different color.

You can also use the Gradient tool to replace the background with a blend of two or more colors. A full-blown tutorial on how to use the Gradient tool is beyond the scope of this book. If you're interested in learning more about the Gradient tool and the other features in Photoshop Elements 8, consider purchasing a copy of *Photoshop Elements 8 For Dummies,* by Barbara Obermeier and Ted Padova (Wiley).

Creating a Painting Using Corel Painter 11

As far as I'm concerned, photography is an art. When you master the craft, you create more than pictures; you create images rich enough to make viewers spend a bit of time drinking it all in. The same is true when you nail a portrait. The viewer looks at it much longer than he would a snapshot. You've conveyed a message to the viewer, told a story. But I also believe that within every photographer lies a frustrated artist who would also like to create vibrant brush strokes on a canvas or watercolor paper. I was a dismal failure with watercolors, which is why I embrace photography as an art form. In fact, I had all but given up on traditional art until I purchased a copy of Corel Painter. This is a program I can use to turn my photos into something that looks like it's painted with traditional art materials — you know, brushes, oils, canvas, and the like.

Traditional artists and photographers use Corel Painter. Photographers like the application because it has an auto-painting mode. You tweak the original image and then create a clone of it. Then you use the Auto-Painting palette to create your masterpiece. The Auto-Painting palette has Smart Stroke Painting and Smart Settings features. When you enable these, you choose a brush from the Smart Brushes category. Press the Play button and Corel starts putting brush dabs on the canvas based on the original photograph. As the painting progresses, the application learns the photograph and adapts the brush strokes to follow the lines and curves of the original photograph. If desired, you can touch up the painting using one of the clone brushes. With a portrait, you want a bit more detail around the eyes, nose, and mouth, which is where I typically use one or more of the clone brushes. If you'd like to turn some of your photo masterpieces into painterly works of art, you can download a 30-day trial version of Corel Painter 11 by visiting this Web address: www.corel.com/servlet/Satellite/us/en/Product/120871684248 1#tabview=tab6.

Creating a Vignette

If you've ever seen a portrait with an oval, colored border around it, you've seen a *vignette*. A vignette is a wonderful way to enhance a portrait, and it's easy to do. To create a vignette around an image using Photoshop Elements 8, follow these steps:

1. **Launch Photoshop Elements in Editing mode, choose File⇨Open, and then navigate to the image you want to edit.**

2. **Choose Layer⇨Duplicate Layer.**

3. **Select the Elliptical Marquee tool.**

 It shares a space on the toolbar with the Rectangular Marquee tool. If the Elliptical Marquee tool isn't currently selected, click the arrow in the lower-right corner of the Rectangular Marquee tool to display the flyout menu and then select the Elliptical Marquee tool.

4. **Click and drag inside the image to create the selection.**

 Create a selection that surrounds your subject. You can press the spacebar while creating the selection to move it to a different place in the image.

5. **Release the mouse button when the selection is centered over the image and is the desired size.**

 A border of moving dashes indicates the selection. (See Figure 13-5.)

6. **Choose Select⇨Feather.**

 The Feather Selection dialog box appears. (See Figure 13-6.)

7. **Enter the desired value in the Feather Radius text box.**

 The value depends on the resolution of your image. If your camera captures 8 to 10 megapixels, use a value of about 100 pixels. The feather prevents a harsh edge around the vignette.

8. **Choose Select⇨Inverse.**

 Photoshop Elements selects the inverse of the selection.

9. **Click the Foreground Color Swatch near the bottom of the toolbar.**

 The Select Foreground Color dialog box appears.

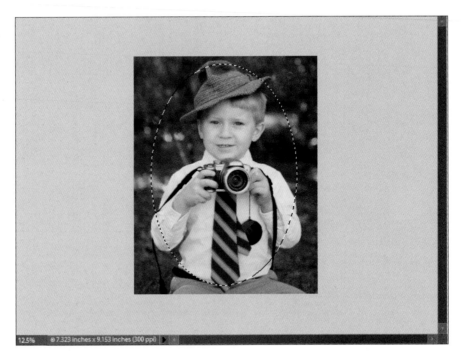

Figure 13-5: Creating an elliptical selection.

Figure 13-6: Feathering a selection.

10. **Select the desired color.**

Select a color that complements the image. You can also click inside the image to select a color.

11. **Click OK to close the dialog box.**

12. **Press the Alt key and click the mouse inside the selection to fill it with the Foreground color.**

Voilà. Instant vignette. (See Figure 13-7.)

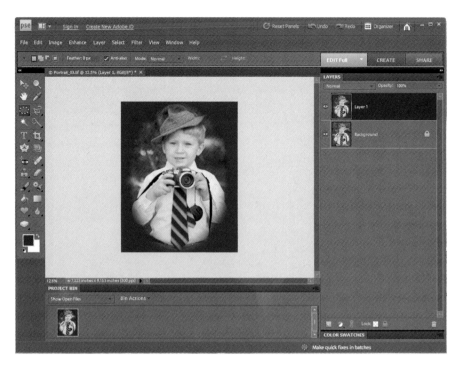

Figure 13-7: The finished vignette.

Adding a Border to a Portrait

The portraits you create with your digital camera are full bleed; the color goes all the way to the edge of the image. This is fine if you're going to matte the print and frame it. But if you're going to put the image in a frame with no matte, a border helps draw the viewer's attention to your subject. You can quickly create a border around a portrait as follows:

1. **Launch Photoshop Elements in Editing mode, choose File⇔Open, and then navigate to the image you want to edit.**

2. **Select the Crop tool.**

3. **Enter the desired values in the Width, Height, and Resolution text boxes.**

 For example, if your final print will be 8 x 10 inches with a resolution of 300 pixels per inch with a 1 ½-inch border, enter a value of **6.50** for the width, **8.50** for the height, and **300** for the resolution.

4. **Click and drag inside the image to define the area to which the image will be cropped.**

A border appears, indicating the area to which the image will be cropped. (See Figure 13-8). Somewhere along that border, you'll also see two buttons: a green check mark (accept the crop) and a red circle with a slash (cancel the crop).

Figure 13-8: Cropping the image.

If you didn't get the crop perfect, you can click and drag any of the handles on the perimeter of the crop box to change the area. Click inside the crop box to move it to a different location. Or you can click the red circle with a slash if you change your mind about cropping the photo.

5. **Click the green check mark to commit the change.**

Photoshop Elements crops the image.

6. **Choose Layer⇨Duplicate Layer.**

This creates a carbon copy of the background layer.

7. **Choose Image⇨Resize⇨Canvas Size.**

The Canvas Size dialog box appears. (See Figure 13-9.)

Figure 13-9: Changing the canvas size.

8. **Select the Relative check box.**

 This method lets you increase the canvas by a specific amount. With the default option, you specify the new dimensions of the canvas. When you choose Relative, you specify the value you want to add to the canvas.

9. **Enter a value in the Width and Height text fields.**

 The value depends on the size of your image, and the size of the frame in which you're going to put the image. If you're creating a 1 ½-inch border, enter a value of **1.5** in the Width and Height text boxes.

10. **Click the Canvas Extension Color drop-down arrow and choose White.**

 Actually, you can use any color you want. White works well with images that have dark backgrounds. Try black or a dark gray if your image has a light background.

11. **Click OK.**

 The image has a border. (See Figure 13-10.)

Figure 13-10: Adding a border to an image.

Creating a Gallery Print

When you get a portrait you're really proud of, you can create a gallery-type print. A gallery-type print shows off your best work with a bit of panache. The image will have a white border with two black strokes to draw your viewer's

attention to the image. To create a gallery-type print in Photoshop Elements 7, follow these steps:

1. **Launch Photoshop Elements in Editing mode, choose File⇨Open, and then navigate to the image you want to edit.**

 Open an image that's about the same size as the frame you're going to mount the finished image in.

2. **Determine the size of the border.**

 You need enough room to add two strokes and some text. For an 8 x 10-inch image, a 1 ½-inch border is perfect. When you're working with a larger image, you can have a bigger border and larger text.

3. **Select the Crop tool.**

4. **Enter the desired value in the Width, Height, and Resolution text boxes.**

 For an 8 x 10-inch image with a resolution of 300 pixels per inch, enter a value of **6.50** for the width, **8.50** for the height, and **300** for the resolution.

5. **Click and drag inside the image to define the area to which the image will be cropped.**

 A border appears, indicating the area to which the image will be cropped. Somewhere along that border, you'll also see two buttons: a green check mark (accept the crop) and a red circle with a slash (cancel the crop).

 If you didn't get the crop perfect, you can click and drag any of the handles on the perimeter of the crop box to change the area. Click inside the crop box to move it to a different location. Or you can click the red circle with a slash if you change your mind about cropping the photo.

6. **Click the green check mark to commit the change.**

 Photoshop Elements crops the image.

7. **Choose Select⇨Select All.**

 The image is surrounded by moving dashes to indicate your selection.

8. **Choose Edit⇨Stroke Outline (Selection).**

 The Stroke dialog box appears. (See Figure 13-11.)

9. **Accept the default color of black.**

 If you've been experimenting with stroking selections and have changed the stroke color, click the current color swatch to open the Select Stroke Color dialog box and choose black.

10. **Click the Inside radio button.**

 The stroke appears inside the selection.

11. **Click OK.**

 A 1-pixel stroke appears around the selection.

Figure 13-11: Stroking a selection.

12. **Choose Image⇨Resize⇨Canvas Size.**

 The Canvas Size dialog box appears.

13. **Select the Relative check box. Then click the drop-down arrow to the right of Inches and choose Pixels as the unit of measure.**

14. **Enter a value of 20 in the Width and Height text boxes.**

 This is perfect for an 8 x 10-inch image. If you're working with larger images, experiment with larger values. For example, 40 to 50 pixels is perfect for a 16 x 20-inch image.

15. **Accept the default extension color of White and click OK.**

 You have a small white border around the image.

16. **Repeat Steps 6 through 10 to add another 1-pixel stroke to your image.**

17. **Choose Image⇨Resize⇨Canvas Size.**

 The Canvas Size dialog box appears.

18. **Deselect the Relative check box if it's already checked.**

 By default this check box is not selected. However, if you used the Relative method of adding to the canvas on a previous image, it is selected the next time you open the dialog box. When you deselect the check box, the current dimensions of the canvas are displayed in the dialog box.

19. Enter the final dimensions of your print in the Width and Height text boxes, choose White for the canvas extension color, and then click OK.

You've got a nice white border around the image with two strokes to draw attention to the portrait. (See Figure 13-12.)

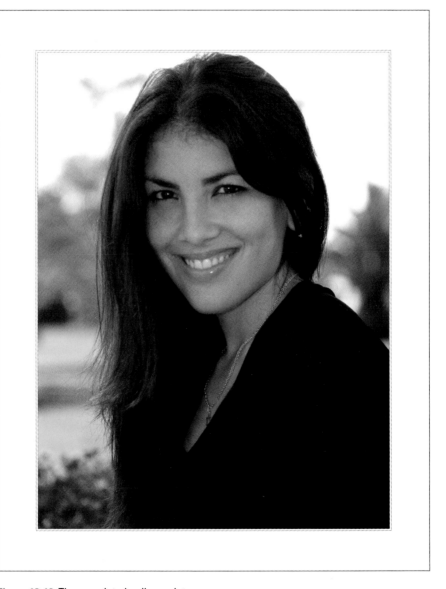

Figure 13-12: The completed gallery print.

If desired, you can use the Text tool to create a title for the image and add your name as the artist. Unfortunately, a tutorial on using the Text tool is beyond the scope of this book. For detailed instructions on using the Text tool, refer to *Photoshop Elements 8 For Dummies*, by Barbara Obermeier and Ted Padova (Wiley).

Converting an Image to Black and White

If you like the rich tones of a great black-and-white image, you can get similar results with your portraits in Photoshop Elements. It's quick and easy. The results will amaze your friends and your subject. To create a black-and-white image in Photoshop Elements, follow these steps:

1. **Launch Photoshop Elements in Editing mode, choose File➪Open, and then navigate to the image you want to edit.**

2. **Choose Enhance➪Convert to Black and White.**

 The Convert to Black and White dialog box appears. (See Figure 13-13.)

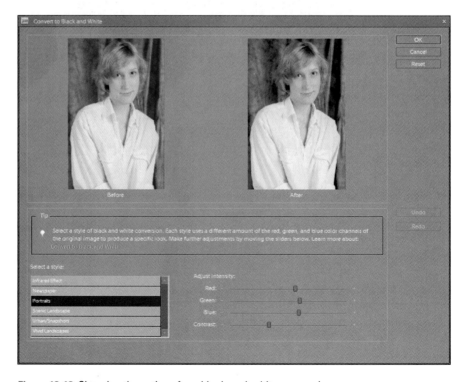

Figure 13-13: Choosing the options for a black-and-white conversion.

3. **Choose a style from the left column.**

 This is a book on portrait photography, so humor me and choose Portrait.

4. **To adjust the look, drag the sliders in the Adjustment Intensity area.**

 These sliders adjust the mix of red, green, and blue, plus the contrast. You're converting an image to black and white, but you still have three color channels to work with. Each slider adjusts how much that color channel affects the mix of the final image. The Contrast slider controls the amount of contrast in the resulting conversion. The Red slider has the greatest affect on skin tones. Black-and-white photographs are highly subjective. Experiment with the sliders and presets until you get something you like.

5. **Click OK.**

 The image is converted to black and white. (See Figure 13-14.)

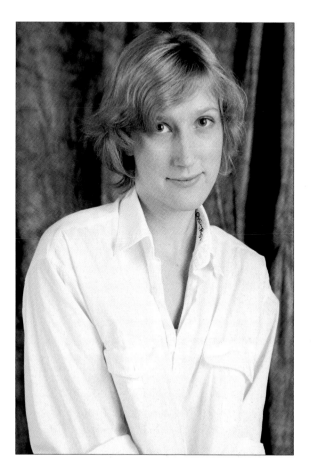

Figure 13-14: Converting an image to black and white.

Creating a Sepia-Toned Image

In the old days, photographers would add tone to a black-and-white image while developing it to make it look more colorful. The tone was like a wash of solid color over the black-and-white image. A sepia-toned image was a light beige wash over the image. You can do the same thing to your digital images, without nasty chemicals, by following these steps:

1. **Launch Photoshop Elements in Editing mode, choose File➪ Open, and then navigate to the image you want to edit.**

2. **Convert the image to black and white as outlined in the "Converting an Image to Black and White" section of this chapter.**

3. **Click the Adjustment Layer icon at the bottom of the Layers panel, and then choose Photo Filter.**

 This opens the Photo Filter panel in the panel dock. (See Figure 13-15.)

4. **Choose Sepia from the drop-down menu and then click OK.**

 You've got a nice, sepia-tone image. (See Figure 13-16.) If the sepia effect isn't strong enough, double-click the gear icon in the Adjustment layer. This opens the Photo Filter panel again. Drag the Density slider until you get the effect you want.

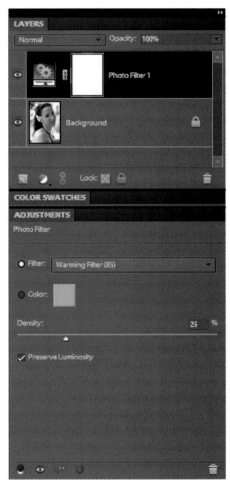

Figure 13-15: Applying a photo filter to an image.

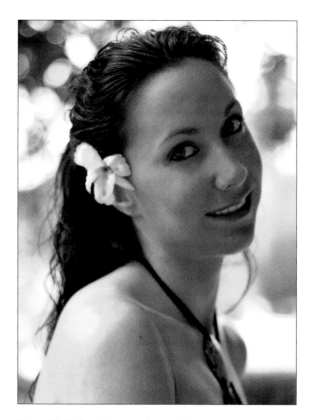

Figure 13-16: Creating a sepia-toned image.

Simulating a Hand-Tinted Image

Do you remember the hand-painted images that were all the rage in the 1940s? If you're not old enough to remember, artists would take a black-and-white image and hand tint it. It was a lot of work, and cost quite a bit of money at the time. You can achieve the same effect in Photoshop Elements without breaking a sweat by following these steps:

1. **Launch Photoshop Elements in Editing mode, choose File⇨Open, and then navigate to the image you want to edit.**

2. **Choose Layer⇨Duplicate Layer.**

 This creates a carbon copy of the background layer.

3. **Follow the steps to convert the duplicated layer to black and white, as shown in the "Converting an Image to Black and White" section of this chapter.**

4. **On the Layers panel, select the layer on which you performed the black-and-white conversion.**

5. **Move your cursor over the Opacity title until you see a finger with arrows pointing in both directions.**

 This is the infamous Photoshop Scrubby Slider. (See Figure 13-17.)

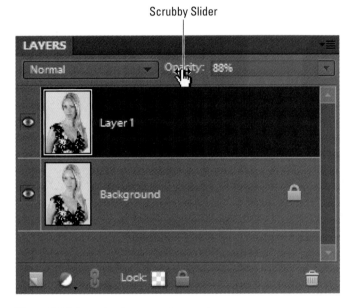

Figure 13-17: Lowering layer opacity.

6. **Drag left to lower the opacity of the layer.**

 As you drag the slider left, you begin to see some of the color from the underlying layer. The exact value is a matter of personal preference. I find that somewhere around 60 percent gives you pleasing results. (See Figure 13-18.)

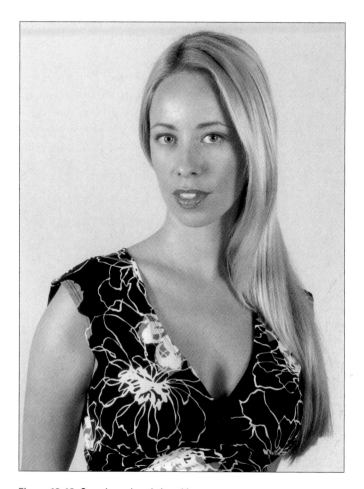

Figure 13-18: Creating a hand-tinted image.

Using a Digital Tablet and Stylus

A *digital tablet and stylus* (an electronic drawing device and tool) give you ultimate control when making selections in any image-editing program. Trying to make a selection with a mouse is like trying to use a sledge hammer to drive home a finishing nail. After connecting the tablet to your computer via a USB port, you use the stylus to make selections, draw lines, or do anything else you previously did with a mouse, but with much greater accuracy. After all, a pencil or crayon was the first thing you used to make marks on paper when you were a kid. The stylus feels very natural in your hand, and using it soon becomes second nature. You may be able to purchase a tablet and stylus

from your local office supply store or a national chain like Best Buy. You can purchase a tablet and stylus online as well. The preferred tablet of many photographers is made by Wacom (www.wacom.com), a company that offers several different lines of tablets. If you're just getting your feet wet, try one of the tablets in Wacom's Bamboo line. (See Figure 13-19.)

Figure 13-19: Gain control over your work using a tablet and stylus.

Editing Your Photos Online

Adobe has created an online photography portal where you can edit, share, and display your photos online. If you own Photoshop Elements 7 and Adobe Premier Elements 7, membership at Photoshop.com is absolutely free. With a basic free membership, you can store up to 2GB of photos and video online.

After you create an account at Photoshop.com, you can upload your images and organize them in folders. After uploading a photo, you can edit it online. Figure 13-20 shows a photo being edited at Photoshop.com. Editing comes in three flavors: Basic, which includes options like cropping, resizing, removing dreaded red-eye, and so on; Adjustments, which enables you to adjust white balance, sharpen images, add fill light, and so on; Advanced, which gives you options like adjusting saturation, converting the image to black and white, and so on.

Figure 13-20: Editing images at Photoshop.com.

After you edit an image, you can order a print, save it to your desktop, e-mail a link for the album to a friend, and more. You can also log in to your Facebook, Flickr, Photobucket, or Picasa account. To test-drive Photoshop. com, visit `www.photoshop.com/?wf=testdrive`.

14

Ten Photography Tips and Tricks

*P*hotography is fun, creative, and positively addictive. When you can peek into other people's worlds through your viewfinder and capture the excitement and story of their life with a portrait, you've joined the ranks of serious portrait photographers. After you master the basics, it's time to spread your wings and learn some tips and tricks to improve your portrait photography. In this chapter, I show you ten techniques to improve your photography, develop your style, improvise, and so on.

Developing Your Style

Photographers are attracted to different subjects and do things in different ways. Casual photographers tend to produce similar images, but serious photographers like to do things differently. When you seriously explore the world of portrait photography, you have a tendency to look at your subjects differently. You experiment with different lenses and vantage points, different lighting, and so on. For example, instead of using window light to illuminate your subject, use a couple of candles to create a moody portrait.

The key to developing your own style is to study the work of the masters. Study images on portrait photographer Web sites, in magazines, and in books. When you see an image you like, look at the credit for the photographer's name and visit his Web site, if he has one. You can also go to your favorite search engine and type the photographer's name in the search text box. Google is a great site for finding images from your favorite photographer. For example, enter the phrase **"Annie Leibovitz photographs"** in the Google search text box. The first result that shows up is `Image results for Annie Leibovitz photographs`. Click the link to find a treasure trove of her work.

When you find an image you like, try to figure out how the photographer achieved the look. Was it done in-camera or in an image-editing program? When I look at great photographs, I'm inspired to go out and take pictures of my favorite subject in my favorite setting. I use what I learn from examining other photographs but put my own spin on it.

Creating a Self-Portrait

If you have a digital camera with a monitor that can be swiveled toward you, creating a digital self-portrait is a breeze. Mount the camera on a tripod, adjust the tripod to the desired height — high enough to take a picture of your head and shoulders — and then swivel the LCD monitor to the area in which you'll be standing when the shutter opens. Enable your camera self-timer, press the shutter, and walk into position. You'll see yourself in the LCD monitor and be able to fine-tune your position and pose while the timer counts down.

If you don't have a swiveling monitor, you can still capture your own self-portrait. Mount the camera on a tripod, adjust the height of the tripod, and start the self-timer. After the camera captures the picture, review it on the LCD monitor to make sure that you weren't too close or far away from the camera. If you didn't get the shot you envisioned, set the self-timer and play it again, Sam.

Creating Makeshift Reflectors

Many professional photographers carry reflectors with them. You use a *reflector* to bounce light back into shadow areas of your subject's face. But what do you do if you don't have a reflector? Or you do have one, but it's at home in a closet? Improvise! Here are a couple of things you can use to bounce light into the shadows:

✔ **A windshield sunshade:** These devices are very handy because they're wide (as wide as the inside of a windshield) and very reflective. They're typically silver on one side and gold on the other. Have a friend hold the sunshade below your subject and angle it until light bounces into the shadows. You can direct your friend while you compose the scene through your viewfinder or LCD monitor. Use the silver side to bounce neutral-colored light into the shadows, or use the gold side to bounce warm light into the shadows.

✔ **A white shirt:** Ask a friend with a white shirt to move toward your subject, but out of frame. Have him move around until you see the shadows start to brighten.

✔ **A white sheet or blanket:** Have a friend place a white sheet on the ground near your subject in a position where it will bounce light back into the shadows.

Steadying the Camera without a Tripod

It's dusk. The billowing clouds are tinted in 20 hues ranging from purple to sky blue–pink. You have all the ingredients for a great shot except your tripod, which is in your closet gathering dust. Don't you just hate it when that happens? I know I do. But with a bit of ingenuity, you can still get a great shot. Here are some ways you can steady your camera without a tripod:

✔ **Place the camera near the edge of a table.** If you can see the tabletop in the viewfinder or LCD monitor, move the camera closer to the edge.

✔ **Hold the camera against a wall.** Use this technique when you rotate the camera 90 degrees (*Portrait mode*).

✔ **Lean against a wall and spread your legs slightly.** This is known as "the human tripod." Press the shutter gently after you exhale.

✔ **Carry a small bean bag in your camera bag.** Place your camera on the bean bag and move it to achieve the desired composition. You can purchase bean bags at your local camera store.

✔ **Carry a baggie filled with uncooked rice in your camera bag.** (Cooked rice is messy and will spoil.) Place your camera on the bag and move it until you achieve the desired composition.

In addition to using one of these techniques, use your camera self-timer. This gives the camera a chance to stabilize from any vibration that occurs when you press the shutter button. These techniques are also great when you're on vacation and don't have the room to carry a tripod in your baggage.

Creating a Homemade Soft-Focus Filter

Soft-focus filters are expensive, but you can create a homemade soft-focus filter. Buy an inexpensive skylight filter to fit your lens. Smear the outer portion of the lens with petroleum jelly. Apply more jelly to the outer edges of the filter but leave the middle portion clear. This gives you more diffusion at the edges of the image, while the center is relatively sharp. After you use this technique, you can either clean the filter or store it in a plastic bag. It's also a good idea to carry some disposable wipes in your camera bag so you can clean the goop off your hands after you create your homemade filter.

For a more permanent soft-focus filter, purchase an inexpensive skylight filter to fit your lens. Buy a bottle of clear, nonyellowing nail polish and paint it on the filter. The dry nail polish will diffuse the light enough to create a soft focus look that's very flattering for portraits. (See Figure 14-1.)

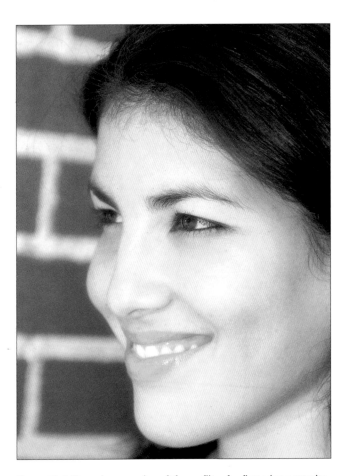

Figure 14-1: Use a homemade soft focus filter for flattering portraits.

Using a Neutral-density Filter

When you want to limit the depth of field in an image, you choose a large aperture (low f-stop number). However, if you're photographing in bright light, with many cameras, a large aperture lets too much light into the sensor, which overexposes the image. A workaround is to use a neutral-density filter to reduce the amount of light that reaches the sensor, without changing the color of the light. On a digital SLR, you screw the neutral-density filter into the threads at the end of your lens. For a point-and-shoot camera, you may have a menu option to enable a neutral-density filter.

Neutral-density filters come in varying strengths, and the stronger filters greatly reduce the amount of light that reaches the sensor. An ND.3 neutral-density filter requires increasing the exposure by one stop, an ND.6 neutral-density filter requires increasing the exposure by two stops, and an ND.9 neutral-density filter requires increasing the exposure by three stops.

Using Second Curtain Shutter Sync

When you use flash to illuminate a picture, the flash generally fires when the shutter opens. This is all well and good when you shoot at a relatively fast shutter speed. When you shoot at a slow shutter speed and use flash to augment the natural light, though, there will be motion trails in the picture caused by the movement of your subjects while the shutter is open. You'll also have a crisp rendition of your subject(s) because of the speed of the flash froze the motion. When the flash fires when the shutter opens, the motion trails move away from the subject, which looks unnatural. If your camera has the option to fire the flash just before the shutter closes, the motion trails will move toward your subject, which creates a more natural-looking image.

Creating a Digital Double Exposure

You can create an artsy-fartsy double-exposure portrait in low light. Set your camera to Aperture Priority mode and choose a small aperture (large f-stop number). Your goal is to have the shutter open for an extended period of time. Set the self-timer and walk into the frame. After the timer counts down, the shutter opens. Move into the frame and hold your position for a few seconds, and then move to another part of the frame. Hold your position until the shutter closes. This technique works well when the shutter is open for 15 to 20 seconds. Figure 14-2 shows a self-portrait of your fearless author that was taken using this technique.

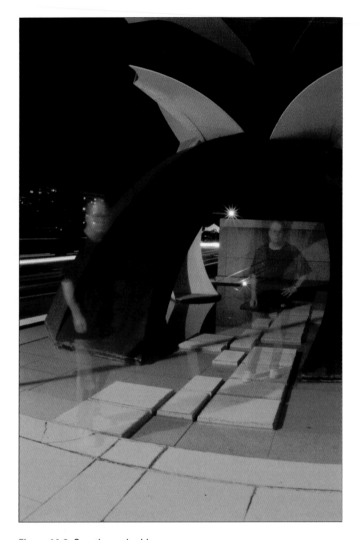

Figure 14-2: Creating a double exposure.

Calibrating Your Monitor

When you make decisions regarding white balance, color casts, and other color issues with your images, you rely upon what you see on your monitor. However, your monitor changes over time, which can result in a slight color shift. So when you still rely on the monitor to accurately portray red, green, and blue in your photos — and then you print the images, or send them to an online printer — the resulting print doesn't faithfully render what was

displayed on the monitor. That's because your monitor isn't accurately reproducing color and needs to be *calibrated.* When your monitor is calibrated the color values you choose in an application like Photoshop Elements match what you see in the real world. For example, if you choose pure red as a color for text in Photoshop Elements, the color on the monitor will match what your printer produces. Yup, another case of "What you see is what you get."

Many products are on the market for calibrating monitors. When you calibrate a monitor, you start the calibration software and then attach a device called a *colorimeter* to your screen. The software analyzes your monitor and compares the colors it generates against the accepted standards for red, green, and blue as stored with the software. After the software does its thing, it creates a *profile,* which is software that you use to get your monitor to accurately represent color.

When you calibrate your monitor, use the same lighting conditions that you normally work in. After the initial calibration, you should recalibrate your monitor every two or three months to compensate for changes as your monitor ages. One popular monitor calibration kit is Huey, manufactured by Pantone. (See Figure 14-3.) As of this writing, the Huey retails for about $90.

Photo courtesy of Pantone, Inc.

Figure 14-3: Calibrate your monitor to accurately reproduce color.

Keep It Clean

You have a great digital SLR and a bag full of great lenses, or a top notch point-and-shoot camera, but your images leave a little to be desired. Great equipment needs to be kept in tip-top shape. If you're not cleaning your equipment on a regular basis, do so to get images with greater clarity.

Unless you have a digital SLR that shakes the sensor to dislodge dust when you power up the camera, sensor dust is a fact of life. The best way to keep the inside of your camera clean is to invest in a good blower. Several blowers are on the market whose names include the generic keywords *hurricane* or *rocket*. In fact, even if you do have an all-singing, all-dancing, shake and bake sensor cleaner, you should still manually clean your sensor every now and again. Refer to your camera manual for instructions on how to manually clean your monitor.

The Giottos Rocket Blaster is shown in Figure 14-4. A good blower is made of natural rubber and features a small opening at the tip that enables you to direct a strong current of air with pinpoint accuracy. To clean the sensor, take the lens off the camera, and then choose the sensor cleaning option from your camera menu. This flips up the mirror, giving you access to the sensor. Squeeze the blower bulb several times to send a rush of air to the sensor that hopefully dislodges the dust and sends it floating to the ground. I always point the camera down when cleaning the sensor, which lets the dust drop from the camera after it's dislodged.

Never touch the sensor with the blower. And never use a blower with a CO_2 cartridge because those cartridges contain propellants that can foul your sensor.

To minimize the chances of getting dust on your sensor, always power-off the camera when changing lenses. When the camera is on, the sensor has an electrical charge that acts like a dust magnet. If you're taking pictures outdoors in a dusty environment or on a windy day, change lenses in your car or in a nearby building.

You can buy more-aggressive products available for cleaning digital SLR sensors. However, if your sensor is extremely dirty, I recommend having it cleaned by a professional. Your local camera store may offer this service.

You also need to keep your lenses clean. If a lens has smudges, fingerprints, or a fine coating of dust and pollutants, your pictures won't be crystal clear. Use a brush with fine hairs to dislodge any particles of dust and then gently rub a microfiber cloth over the lens. Make sure you purchase a good quality microfiber cloth that's designed to clean precision optics. Microfiber is 10 times thinner than silk and 100 times thinner than a human hair.

Photo courtesy of HP Marketing Corp.

Figure 14-4: Use a blower to dislodge dust from your camera sensor.

I've purchased several lens cloths from Photosilk (www.photosilk.com). Photosilk's cloths do an excellent job of keeping my lenses clean. (The cloths have a photo imprinted on one side, and you can even order Photosilks with your own photographs printed on them. I've ordered several with my company logo emblazoned on the microfiber.) Another option is to purchase a camera-cleaning kit at your favorite camera retailer that comes with a blower, lens cleaning cloth, lens cleaning solution, and lens swabs. (See Figure 14-5.)

And don't forget to be on the lookout for grime on your camera body. Just gently rub a damp nonabrasive cloth over the grime. *Never use a solvent on your camera body because it may damage the material.* If you use your camera in a salty environment (such as the beach), thoroughly soak a cloth with fresh water and then wring it until it's almost dry. Gently rub the slightly damp cloth over the camera body and lens.

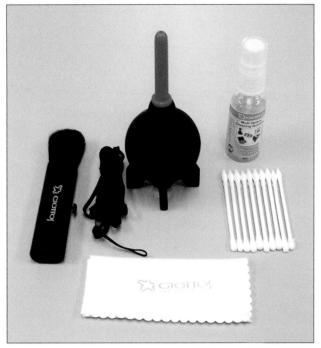

Photo courtesy of HP Marketing Corp.

Figure 14-5: You can find a camera cleaning kit at your local camera store.

I always inspect my equipment before a shoot. This is also when I clean the lenses I'll be using on the shoot. I also frequently do a test to make sure I'm not getting a dust buildup on the sensor. I take a photograph of a clear blue sky with the lens focused to its closest setting. When I open the image in Photoshop or Lightroom, the dust is readily visible as small black specks.

Ten Resources for Portrait Photographers

There are thousands of online resources for photographers. To explore each and every one would require a book as thick and heavy as a doorstop. There's a lot of good information about digital photography online, but there's a lot of junk, too. In this chapter, I try to separate the wheat from the chaff and present what I think are ten valuable resources for photographers.

Shopping 'Til You Drop at B&H Photo

There are hundreds of online retailers of photography equipment. However, if you want to get expert advice, quality equipment, great selection, and competitive prices, check out B&H Photo (www.bhphoto.com). B&H Photo is located in New York City, and I'm quite sure if I ever visited the store in person, I'd be like a kid in a candy store. I've talked to photographer friends who have visited the store, and they describe it with one word: *awesome*.

I think their Web site is equally awesome. (See Figure 15-1.) They also have a toll-free number you can call for information about products and placing orders. The sales representatives at B&H know the equipment like the back of their hands, and they don't try to sell you something you don't need.

Figure 15-1: B&H Photo's online superstore.

Checking Out Online Retailers

There are lots of reputable online retailers, and there are some that will try to sell you the moon. There are also online retailers that lure you in with a low price and then attempt to sell you extra stuff that actually comes with the camera for free. For example, a friend of mine responded to a cheap price from an online retailer. When he attempted to place the order, he was informed that the battery was an extra $100, when in fact it is included with the camera. The extra $100 brought the price in line with the reputable retailers. To avoid bait and switch and other unethical actions, visit www.resellerratings.com. Enter the name of the retailer and you'll see reviews from people who have purchased from them. The following image shows the rating for B&H Photo, which is as close to perfect as you can get. Remember that if a deal seems too good to be true, it probably is. When in doubt, check out a retailer at ResellerRatings.com.

Figure 15-2: When in doubt, check the reseller out.

Buying and Selling Stuff on eBay

Technology changes very quickly these days. If you're the type of photographer who has to have the latest and greatest gear, you've got to find a place to sell your old stuff. The ideal solution for selling anything that's technical in nature is eBay. You might call this Web site the world's largest online garage sale. When I was considering purchasing my current digital camera, I wanted to pay cash for the camera instead of charging it. I rummaged through my closets and found some technology I wasn't using that was still in demand. I put it up for auction on eBay. After one week of auctions, I had more than 70 percent of the purchase price of the camera. After buying the new camera, I auctioned off my old one. The net proceeds from my sales paid for the new camera and then some.

eBay even has free software for sellers. You can download an application called Turbo Lister from the following URL: `http://pages.ebay.com/turbo_lister/index.html`. Turbo Lister is a desktop application that enables you to create a listing at your leisure and upload it to eBay when you're done.

The trick to selling stuff on eBay is great photos and good descriptions. Make sure you don't have any typos in your listing. Before selling an item on eBay, do a search for the item and see how other people have described the item you're selling. You may also be able to get some information from the manufacturer's Web site. The following image shows a listing for a lens I just sold on eBay. I included several photos of the lens in the listing so that potential bidders could see the condition of the equipment. I also answered all questions promptly. Notice that I have 100 percent positive feedback for 192 transactions.

Figure 15-3: An eBay listing.

In addition to selling equipment on eBay, you can also find some great deals on used photography equipment. Enter the item you're looking for in the eBay search text field, and you'll see the current listings. eBay is not a buyer-beware Web site. The site has instituted a feedback system. Buyers can give feedback on any transaction. When you're considering bidding on a piece of equipment at eBay, check out the buyer's Feedback Rating. If he has a rating close to 100 percent, and 40 or 50 recent transactions, you can rest assured that he's not selling junk and is carefully packing the merchandise as well as shipping it promptly.

Sharing Your Photos on Flickr

If you don't know how to create a Web site, or don't have the inclination to create a Web site, you can still display your work online. There are several Web sites you can use to show your work online. Flickr (www.flickr.com) seems to be one of the most popular. After you set up an account at Flickr, you can upload your photos. You can also join one or more Flickr groups, which are communities of photographers who have interests in specific photo subjects or styles. Flickr is a great way to get feedback on your work from site visitors and other photographers. With a free account, you can upload two videos (90 seconds in duration with a maximum of a 500MB file size) and 100MB of photos with a maximum file size of 10MB per photo, each month. (With a paid account, you can upload much more.) If you resize your photos to be Web friendly in an application like Photoshop Elements, you can upload a lot of photos each month. The following image shows the Flickr photo stream of an avid photographer.

Figure 15-4: Strut your stuff at Flickr.

Creating Photo Books at Blurb

If you'd like to see your work in a custom photo book, you can make this a reality by visiting Blurb (www.blurb.com). Blurb is a popular online portal for creating and selling photo books. You can create a great looking photo book using Blurb's free BookSmart software, which you can download for free from this URL: www.blurb.com/make/booksmart. After you create your book, you can upload the photos to Blurb directly from the BookSmart software. You can also create a custom book in an application like Adobe InDesign and upload it as a PDF. After you upload the book, you have 14 days to place an order for it. Blurb offers hardcover and soft cover books in the following sizes: 7 x 7 inches, 10 x 8 inches, 12 x 12 inches, and 13 x 11 inches. You can also upgrade to premium paper. The minimum number of pages is 20, and the maximum number of pages you can put in a book is 440. You can put multiple photos on a page using BookSmart templates or using your own software.

You can also choose the option to make your book public after ordering one copy. When you make a book available to the public, you can specify the selling price. Figure 15-5 shows a book I created from photos I took at a classic car show. Quite a few copies of this book have been ordered online. When your book sells, Blurb sends you the difference between your selling price and their established price minus a small handling fee.

Figure 15-5: Create a custom book at Blurb.com.

Finding Inspiration at Photo.net

Sometimes you need to recharge the batteries and get a little inspiration before photographing your next subject. When I need a creative spark, I look no further than Photo.net. This Web site features the work of many photographers. You'll find varying degrees of talent among the photographers who post images at this site. A safe bet is to go to the home page and view some of the Daily Photo Sampling From Our Member's Work thumbnails. (See Figure 15-6.) When you click a thumbnail, you see a larger image. Alternatively, you can enter a phrase like *portrait* in the search box and peruse the results.

There are some tasteful artistic nudes on this Web site. If you're offended by artistic photos of the human body, don't visit this Web site.

Figure 15-6: Recharge your creative batteries at Photo.net.

Researching Digital Cameras at Digital Photography Review

If you're ready to buy your first digital camera, want to buy a second camera, or decide to upgrade to a better camera, it's a good idea to do as much research as possible. I always begin my search by visiting manufacturers'

Web sites. Sometimes, I'll hear about a new camera that piques my curiosity. Before I plunk down my hard-earned cash on any camera, I always go to www. dpreview.com to see what they have to say about the camera. At this Web site, you'll find authoritative reviews on many of the new cameras. If you're surfing eBay for a used camera and you find an interesting older model, you may find a review of that camera at Digital Photography Review as well. Figure 15-7 shows a review of one of Nikon's new cameras. Notice the drop-down menu above the camera image. There are a total of 35 pages of information for this camera, with sample images. If you want to cut to the chase, select Conclusion from the drop-down menu and you can read the pros and cons as noted by the reviewer.

Figure 15-7: Getting the lowdown on a new camera at DPReview.com.

Getting Quality Prints at Mpix

Looking at pictures on a computer monitor or a Web site is all well and good, but when you get a great portrait, you should display your work in a proper frame on your wall, or your subject's wall. If you want great prints at a reasonable price, check out Mpix (www.mpix.com). This online printer

offers high-quality prints in a wide variety of sizes, and other goodies such as custom frames and greeting cards. They offer three different papers. Print sizes start at 1.75 x 2.5 inches and go up to a whopping 24 x 36 inches. When you've got an image that you want to display on a wall, or print for a friend or relative, visit www.mpix.com.

Finding Tutorials at YouTube

YouTube is a video-sharing Web site. In the early days, the quality of the videos and the subject matter was definitely amateurish. However, YouTube has come a long way since its inception. Now you can find high-quality videos on a wide range of topics, including digital photography. The Web site is absolutely free for viewers and those who want to upload their own videos. Visit the site and type a phrase like *portrait photography* in the search text box. In a few seconds, you'll see a list of videos on the topic. (See Figure 15-8.) Click the thumbnail to view the video.

Figure 15-8: Surfing for knowledge at YouTube.

Viewing Tutorials at Adobe TV

In addition to creating two of the best image-editing applications on the planet — Photoshop and Photoshop Elements — Adobe also provides a wealth of resources. At their main Web site (`www.adobe.com`), you can find support for any Adobe product. You can search their knowledge base for answers to a question, post a question in a forum, and so on. Adobe also has a subdomain that is chock full of videos about their products. Visit `http://tv.adobe.com` and you'll find videos from Adobe evangelists such as Julieanne Kost on a wide variety of topics pertaining to Adobe software. You can also search for information by entering a phrase in the search text box. Figure 15-9 shows the results for the search term *photoshop elements*. Visit this site often. New videos are posted on a regular basis.

Figure 15-9: View informative videos about Adobe software at tv.adobe.com.

Index

● *G* ●